DUCHAMP IS MY LAWYER

DUCHAMP
IS MY LAWYER

THE POLEMICS, PRAGMATICS, AND POETICS OF UBUWEB

KENNETH GOLDSMITH

Columbia University Press | New York

Columbia University Press
Publishers Since 1893
New York Chichester, West Sussex
cup.columbia.edu

Library of Congress Cataloging-in-Publication Data
Names: Goldsmith, Kenneth, author.
Title: Duchamp is my lawyer : the polemics, pragmatics, and poetics
of UbuWeb / Kenneth Goldsmith.
Description: New York : Columbia University Press, [2020] |
Includes bibliographical references and index.
Identifiers: LCCN 2019058881 (print) | LCCN 2019058882 (ebook) |
ISBN 9780231186940 (hardcover) | ISBN 9780231186957 (paperback) |
ISBN 9780231546911 (ebook)
Subjects: LCSH: UbuWeb. | Arts—Experimental methods—
Computer network resources.
Classification: LCC NX260 .G65 2020 (print) |
LCC NX260 (ebook) | DDC 700.285—dc23
LC record available at https://lccn.loc.gov/2019058881
LC ebook record available at https://lccn.loc.gov/2019058882

Columbia University Press books are printed on permanent and
durable acid-free paper.
Printed in the United States of America

Cover design: Lisa Hamm

I often tell people that Duchamp is my lawyer.
He's the legal premise to validate
what I'm doing.

VIRGIL ABLOH

For the Custodians

CONTENTS

CONTENTS

INTRODUCTION

THE BACK DOOR

There's a back door to the Museum of Modern Art (MoMA) in New York City that few know about. Invisible to the bustling crowds at the main entrance on Fifty-Third Street, it's desolate except for the occasional noisy school group or quiet academic researcher entering and exiting. There're no admission fees or snaking queues, only a lonely intern sitting at a desk. If you sign in and take the elevator to the top floor, you'll find the MoMA Library. It was there in the late 1970s that a librarian named Clive Phillpot created a policy unlike any other in the history of the museum. Without asking permission, he decreed that anybody could mail anything to the MoMA Library, and it would be accepted and become part of the official collection. There was no limit to what could be sent, nor were there specifications of size, medium, or provenance. No judgments were made about quality either. The artist could be world famous or completely unknown—it made no difference. Once something was sent, no questions were ever asked. Whatever was received was accepted.

Phillpot estimates that between 1977 and 1994 he got anywhere from 100,000 to 200,000 artists into the MoMA collection this way.[1] Bob Dylan once said, "I had gotten in the door when no one was looking. I was in there now and, there was

nothing anybody from then on could do ever about it."[2] Similarly, Phillpot's gesture was so under the radar that the front door—the museum administration and curatorial wing—paid no attention to it. And once they did, it was too late; nobody was going to return all those crates and boxes that had piled up over the years, never mind remove hundreds of thousands of artists from the database. While some artifacts from those acquisitions are quite valuable and are often on display in the galleries, most of them languish in MoMA's remote storage facility out in Queens, stacked up in the boxes they were originally sent in. And they're all still part of MoMA's collection.

Sometimes the back door was used to get artworks into the museum. In 1991, Chuck Close was asked to curate an *Artist's Choice* exhibition. Close decided to choose a selection of portraits from MoMA's collection, and he wanted to include Ray Johnson, who at the time was—unbelievably enough—still not actually in the MoMA collection. So to get himself in, Johnson stuffed a funky photocopied cartoon of Willem de Kooning into an envelope and mailed it off to Phillpot, courtesy of the library. Sure enough, the cartoon was entered into the MoMA collection with the credit line "Gift of the artist. The Museum of Modern Art Library, Special Collections"—therefore eligible to be included in Close's show.

The back door is a powerful tool. While all eyes are elsewhere, magical things can happen in the margins. Andy Warhol once said that if you want to collect something in New York, you have to find out what it is that nobody else wants and collect that. Before long, everyone will want it. He was right—once he began collecting ugly ceramic cookie jars, everyone started collecting them. By the time he died, his cookie jar collection, which he paid pennies for, sold at auction for a quarter of a million dollars. Warhol was a back-door collector. Out of the watchful eye of the front door and free to write its own ticket, the back door

plays by its own rules. Unburdened by official policy, it can quietly reshuffle the deck according to intuition, whim, and desire. While the front sparkles with glamour and sexy commodities, the back door favors that which is economically worthless but historically priceless. Trading in ephemera and ideas, the back door is unlocked and unguarded, for it's assumed that there's not much worth stealing inside that rear door—often a correct hunch. Yet because the back door is always open, its ideas are infinitely democratic, transferrable, and replicable as well as free to all. At once playful—even prankish—and deadly serious, the back door is perverse, embracing contradiction and impurity. It's also wildly utopian, proposing to make the impossible possible. What begins as a hunch or proposition over time becomes serious. If you do something wrong for long enough, it eventually becomes right—paradoxically transforming the back door into the new front door.

Marcel Duchamp once made a door hinged between two frames that was always open and always shut. The door closed one entrance when it opened the other, thereby contradicting the French proverb *"Il faut qu'une porte soit ouverte ou fermée* [A door must be either open or closed]." It is both and neither at the same time. Writing to André Breton, Duchamp said, *"Pour moi il y a autre chose que oui, non et indifférent—C'est par example l'absence d'investigations de ce genre* [For me there is something other than yes, no, and indifferent—there is for example the absence of investigations of this kind]."[3] Open and closed, pirate and legitimate, serious and playful, UbuWeb has attempted to model itself on Phillpot's back door and Duchamp's pendulous door, resulting in a decades-long investigation into the absence of an investigation.

• • •

Founded in 1996, UbuWeb is a pirate shadow library consisting of hundreds of thousands of freely downloadable avant-garde

artifacts. By the letter of the law, the site is illegal; we openly violate copyright norms and almost never ask for permission. Most everything on the site is pilfered, ripped, and swiped from other places, then reposted. We've never been sued—never even come close. UbuWeb functions on no money—we don't take it, we don't pay it, we don't touch it; you'll never find an advertisement, a logo, or a donation box. We've never applied for a grant or accepted a sponsorship; we remain happily unaffiliated, keeping us free and clean, allowing us to do what we want to do, the way we want to do it. Most important, UbuWeb has always been and will always be free and open to all: there are no memberships or passwords required. All labor is volunteered; our server space and bandwidth are donated by a likeminded group of intellectual custodians who believe in free access to knowledge. A gift economy of plentitude with a strong emphasis on global education, UbuWeb is visited daily by tens of thousands of people from every continent. We're on numerous syllabuses, ranging from those for kindergarteners studying pattern poetry to those for postgraduates listening to hours of Jacques Lacan's *Séminaires*. When the site goes down from time to time, as most sites do, we're inundated by emails from panicked faculty wondering how they are going to teach their courses that week.

The site is filled with the detritus and ephemera of great artists better known for other things—the music of Jean Dubuffet, the poetry of Dan Graham, the hip-hop of Jean-Michel Basquiat, the punk rock of Martin Kippenberger, the films of John Lennon, the radio plays of Ulrike Meinhof, the symphonies of Hanne Darboven, the country music of Julian Schnabel—most of which were originally put out in tiny editions, were critically ignored, and quickly vanished. However, the web provides the perfect place to restage these works. With video, sound, and text remaining more faithful to the original experience than, say, painting or sculpture, Ubu proposes a different sort of

revisionist art history based on the peripheries of artistic production rather than on the perceived, hyped, or market-based center.

For example, although famous for his megalithic metal sculptures, Richard Serra has made a lot of important video art. The museum narrative enforces this invisibility. In Serra's retrospective at the MoMA in New York in 2007, there was no sign of his essential videos *Television Delivers People* (1973) and *Boomerang* (1974), both frequently visited resources on UbuWeb. Similarly, Salvador Dalí's obscure psychedelic film *Impressions de la Haute Mongolie—hommage á Raymond Roussel* (1976) is the only film besides *Un chien Andalou* (1929) that he completed in his lifetime. It's also the only movie you'll ever watch about Upper Mongolia, giant hallucinogenic mushrooms, and a urine-soaked pen.[4] Nearly impossible to see in theaters or museums, it's playing every day and every night on Ubu. And although you won't find any of Dalí's paintings on UbuWeb, you will find a recording of an advertisement he made for a bank in 1967. Not everything at the site is offbeat: there are, in all fairness, lots of artists' works that perfectly port to the web, such as Hollis Frampton's structuralist films, Kathy Acker's collaborations with punk bands, Samuel Beckett's radio plays, Mary Ellen Solt's concrete poems, Maurice Blanchot's mystery novels, and Aleister Crowley's magical wax-cylinder recordings.

Named for Alfred Jarry's mischievous, foul-mouthed, Dadaist protagonist Ubu Roi, UbuWeb began as a site focusing on visual and concrete poetry. With the advent of the graphical web browser in the mid-1990s, I began scanning old concrete poems and posting them on the web. I was astonished by how fresh those dusty old paperbound pieces looked when backlit by the computer screen. When I emailed the link to a few friends, they seemed to agree; they emailed the link to a few of their friends, and in a short time I found myself surrounded by a group of

concrete-poetry fans. Encouraged, I scanned a few more poems before setting out to convert whole important anthologies of the genre to the web. Shortly thereafter, when streaming audio became available, it made sense to extend Ubu's scope to sound poetry, a historical movement similar to concrete poetry, but instead of words and letters published on the page, words and letters are intoned or spoken. I began transferring old sound-poetry LPs to MP3s and posting them alongside the concrete poems.

Unbeknownst to me at the time, sound poetry—a broad and varied genre that often includes instruments and electronic treatments—posed some challenging questions. For instance, certain of John Cage's readings of his texts could be termed "sound poetry," so I included them. But just as often Cage accompanied those readings with an orchestral piece, which I included as well. I soon found myself unable to distinguish the difference between "sound poetry" and "music." I encountered this dilemma time and again, whether it was with the compositions of Maurico Kagel or of Joan La Barbara or of Henri Chopin, all of whom were as well known as "composers" as they were as "sound poets" or "audio artists." Finally, after a while I gave up trying to name things; I dropped the term *sound poetry* and began referring to the section under which they were filed simply as "Sound."

A similar thing happened with concrete poetry. For many years, I had been collecting outsider writings scrawled on scraps of paper affixed to New York City walls that expressed highly emotional narratives, conspiracy theories, and political sentiments. They often employed beautiful and innovative graphical letter forms that appeared to me to be a sort of handmade concrete poetry but with an entirely different history and agenda. I scanned and uploaded these scraps but began to question where they should be filed. Could they easily fit alongside the classical

modernist concrete poems, or should they be in a category of their own? I ultimately decided that although they resembled visual poems, they were something else, so I created a new section simply called "Outsiders"—named after the genre known as "outsider art"—which grew to become a large repository of audio and visual material created by street poets and visionaries.

One of the collections housed in the Outsiders section is *The 365 Days Project*, which had its inception as a blog where hundreds of people over the course of a year posted one song or album a day of outrageous novelty music, all of which was donated to Ubu when the blog went offline. The range is vast, including a panoply of weird stuff, such as celebrity crooners, offbeat children's records, amateur song-poems, hammy ventriloquism, and homemade tape recordings. The collection is studded with bizarre gems such as Louis Farrakhan singing calypso and a high school choir's rendition of the Sweet's AM radio hit "Fox on the Run." Buried deep within are rare recordings by the legendary avant-garde conductor-composer Nicolas Slonimsky, inexplicably yowling out copy from old newspaper ads for cod liver oil and toothpaste, accompanied by a detuned piano. Written in 1925, the compositions were a sort of predecessor to pop art, exploring the expressive possibilities of found text. While many listeners to *The 365 Days Project* might've written off these recordings as little more than "weird-old-man-who-can't-carry-a-tune" novelty records, when these recordings collided with UbuWeb, the backstory (which I recount later in this book) became complicated. For several years previously, we had been hosting a series of world-premiere recordings of modernist composers such as Charles Ives, Carl Ruggles, and Edgard Varèse that Slonimsky conducted during the 1930s. Zooming out and viewing Slonimsky's career in retrospective, we could connect the dots to the two different personas represented, but the initial shock that both of them live together under the same roof, so to

speak, was profound. Ultimately, the files were cross-referenced, once in the Outsiders section under *The 365 Days Project* and once in the Sound section under "Nicolas Slonimsky," the consummate inside outsider.

Jerome Rothenberg, a scholar, approached Ubu with an idea to build a wing on the site that would focus on sound, visual art, poetry, and essays related to his specialty, ethnopoetics. Rothenberg's ethnopoetics focused on how the avant-garde dovetailed with the world's ancient cultures, both those surviving in situ as well as those that had vanished except for transcriptions in books or recordings from earlier decades. It was a perfect match for Ubu. Rothenberg's sound offerings included everything from the jazz singer Slim Gaillard to Inuit throat singing, each making formal connections to modernist strains of Dada or sound poetry. Examples of ethnopoetic visual poetry ranged from Chippewa song pictures to Guillaume Apollinaire's graphical arrangements of letters in his *Calligrammes*. Rothenberg edited a subsection containing dozens of scholarly papers reflecting on ethnopoetics, such as Brent Hayes Edwards's "Louis Armstrong and the Syntax of Scat" and Kenneth Rexroth's writings on American Indian song. He also put together a selection of plain-text poetry, including Cecilia Vicuña's contemporary shamanistic poems, Vietnamese *ca dao* folk poems, and Henry Wadsworth Longfellow's proto–sound poem "Song of the Owl" (1856).

There is a precedent for such an eclectic approach to bringing together varied works of art and writing: *Aspen* magazine, which was published between 1965 and 1971. Though *Aspen* is long out of print, UbuWeb was fortunate to be given a digitized version of the entire run. Its ten issues attempted to bring together several disciplines under a single curator; any given issue contained poetry, music, film, art criticism, reproductions of paintings, and critical essays. Each issue came in a customized box filled with booklets, flexi-disc phonograph

recordings, posters, sketches for sculptures, and postcards; some issues even included spools of Super 8 movie film. The publisher, Phyllis Johnson, claimed that *Aspen* should be a "time capsule" of a certain period, point of view, or person; hence, whole issues were devoted to subjects such as pop art, conceptual art, swinging mod London, and the psychedelic scene. They were edited by the likes of Andy Warhol and Dan Graham and designed by people such as George Maciunas and Quentin Fiore. Contributors included a who's who of the period, Lou Reed with notes on rock 'n' roll; Tony Smith with a make-it-yourself cardboard sculpture kit; Susan Sontag with "The Aesthetics of Silence"; Eva Marie Saint with a statement about painting and film; Roland Barthes with "The Death of the Author"; and Yoko Ono with stark, unaccompanied vocal pieces—in total amounting to several hundred works of art. After absorbing *Aspen*, UbuWeb was flooded with the work of dozens of artists spanning various genres, timeframes, and practices; the jazzmen Yank Lawson and Peanuts Hucko playing "St. James Infirmary Blues" snuggled up against Richard Hulsenbeck intoning Dada poems. The eclecticism was thrilling and unpredictable. *Aspen* created an unorthodox environment, one in which a democratic art—an art that functioned outside of galleries and museums—was available to everyone at an affordable price. Its utopian purview was everything Ubu-Web strived to be.

The Super 8 films from *Aspen* formed the basis of UbuWeb's Film & Video section, where more than 5,000 avant-garde films are both streamable and downloadable, from the gritty black-and-white videos of Vito Acconci to the glittery filmic oeuvre of Jack Smith. There are countless filmed biographies and interviews with authors such as Jorge Luis Borges, J. G. Ballard, Allen Ginsberg, and Louis-Ferdinand Céline. The scope is international: there are dozens of obscure Yugoslav Black Wave Cinema

films (1962–1972), a four-decade survey of German video art (1964–2004), and a number of samizdat Soviet films from the 1980s. Experimental music films—both documentary and performance—are abundant. UbuWeb hosts Robert Ashley's epic fourteen-hour *Music with Roots in the Aether*, a series of composer portraits made in the mid-1970s and featuring artists such as Pauline Oliveros, Terry Riley, and Philip Glass. There's a lot of contemporary work as well, such as *Her Noise* (2007), a documentary about women and experimental music; Kara Walker's difficult-to-see video *Fall Frum Grace, Miss Pipi's Blue Tale* (2011); as well as the chaotic MTV-gone-wrong videos of Ryan Trecartin. There are also hours of vintage performance-art documentation by artists such as Marina Abramović and Ulay, a bootleg version of Robert Smithson's *Hotel Palenque* (1969), and an astonishing twenty-one-minute clip of Abbie Hoffman making gefilte fish on Christmas Eve of 1973.

● ● ●

UbuWeb's large, boundary-blurring archive of the avant-garde necessarily alters what is meant by *avant-garde*, a term saddled with the legacies of patriarchy, hegemony, imperialism, colonization, and militarization. Giving voice to these concerns, the poet and critic Dick Higgins wrote, "The very concept of an avant-garde, which relates to the military metaphor of advance troops coming before the main body, is masculine."[5] The avant-garde theater scholar Kimberly Jannarone concurs: "The term 'avant-garde'—coming to us from the military and first applied to the arts around World War I—is heavily weighted by historical and political critical baggage. . . . Indeed, the historical avant-garde often relied on sexist, racist, primitivist, and imperialist notions."[6] And it's true even today: witness how Italy's far-right-wing party Casa Pound named itself after Ezra Pound, emblazing images of him across their posters, or how one of

Vladimir Putin's main ideologists, Vladislav Surkov, reputedly took techniques from his days as an avant-garde theater director and used them to sow confusion, discord, and chaos—exactly what the avant-garde excelled at—into rightist political situations. When you assemble a collection of the avant-garde, you run the risk of replicating everything wrong that is associated with it. I deployed impurity as a way of muddying, *détourn*ing, and playfully reimagining the avant-garde, twisting and warping the rigorous, hard-baked grids of modernism into something more fluid, organic, incorrect, and unpredictable.

Think of the many artists who dissembled received notions of avant-garde as part and parcel of their avant-garde practices, such as Cornelius Cardew, Amiri Baraka, Musica Elettronica Viva, and Henry Flynt, or of others who took the idea of avant-garde in directions previously excluded from the canon. My mid-century avant-garde pantheon and inspiration comprise artists such as Moondog, Marie Menken, Harry Partch, Daphne Oram, Conlon Nancarrow, Alice B. Toklas, and Sun Ra. Driven by outsiders and visionaries, my avant-garde revels in eccentricity, impurity, and innovative formal experimentation. And at the same time I still love the denizens of the old-school canon, James Joyce, William Carlos Williams, and Pablo Picasso. But most of all I love it when they all get jumbled together on UbuWeb. Sparks fly when Henry Miller collides with Ana Mendieta, Karlheinz Stockhausen with Hito Steyerl, Fatboy Slim with the Situationist International, Weegee with Carrie Mae Weems, or F. T. Marinetti with Trinh T. Minh-ha, each nudging, reflecting, and shading their neighbors in unpredictable and destabilizing ways.

Sometimes the dead patriarch's works were the basis for new pieces by contemporary artists that critique older notions of the avant-garde. I'm thinking of one artist on UbuWeb who goes down into his Tokyo basement every Wednesday night

and screams out *Finnegans Wake* at the top of his lungs, accompanying himself on drums. He's taped hundreds of hours of it. Of a poet who took it upon himself to read aloud and record all nine-hundred-plus pages of Gertrude Stein's *The Making of Americans*, which is available on Ubu. He quickly became bored and started howling the book like an alley cat, page after page, until he completed his task. These gestures defuse some of the accusations hurled at the avant-garde, showing how it is playful and funny, fodder for deconstructing and remixing. And all of these things lived happily together on my book and record shelves. UbuWeb reflects this approach, and its avant-garde is vast and inclusive, moving away from the patriarchal, militaristic, racist, and imperialistic model. I liked the idea of taking a discredited or orphaned term such as *avant-garde* and using it against its own bad history in order to reimagine it, similar to the way AIDS activists in the 1980s *détourn*ed the Nazi's pink triangle into a symbol of liberation. I'm not entirely certain what the limits of the avant-garde are, but it's that uncertainty that makes it work for me. UbuWeb often lacks objectivity, expertise, theoretical justification, and historical accuracy. I could be wrong, but something tells me that those certainties were partially what led parts of the avant-garde astray in the first place.

Reflecting these ideas, UbuWeb is a purposely unstable library, a conflicted curation, an archive assembled by embracing the fragmented, the biased, the subjective, and the incomplete. We favor the casual mode of accumulation expressed by Andy Warhol's massive archival project *Time Capsules* (1974–1987), where the distinctions among collecting, curating, archiving, and hoarding collapsed into an artistic practice. The *Time Capsules* consisted of 610 cardboard boxes that Warhol filled with stuff, sealed, numbered, signed, and sent off to a storage facility. Beginning in 1974, he kept an open box next to his desk in his studio at 860 Broadway, into which he tossed whatever came

his way, from envelopes containing tens of thousands of dollars in cash to nude photos of Jacqueline Onassis to a mummified human foot belonging to an ancient Egyptian to a 45-rpm test-pressing of a Ramones single signed by Joey Ramone to a McDonalds Big Mac wrapper—and that's just a fraction of the trash and treasures contained within these capsules.

How exactly were they assembled? In his book *The Philosophy of Andy Warhol: From A to B and Back Again* (1975), Warhol gives us a hint:

> What you should do is get a box for a month, and drop everything in it and at the end of the month lock it up. Then date it and send it over to Jersey. You should try to keep track of it, but if you can't and you lose it, that's fine, because it's one less thing to think about, another load off your mind. Tennessee Williams saves everything up in a trunk and then sends it out to a storage place. I started off myself with trunks and the odd pieces of furniture, but then I went around shopping for something better and now I just drop everything into the same-size brown cardboard boxes that have a color patch on the side for the month of the year.[7]

Warhol's *Time Capsule*s are a kind of folk archiving that takes no real expertise or training to perform but that happens organically through a process of accumulation and desire. As I have previously written, this kind of archiving is a new folk art, something that is widely practiced and has unconsciously become integrated into a great many people's lives, potentially transforming a necessity into a work of art.[8] There's something about the *Time Capsules* that resonates with the digital age, when many of us, like Warhol, have become accidental archivists by accruing artifacts in a voracious yet almost unconscious way. Think of the way vast amount of digital artifacts—voice memos, MP3s,

airline tickets, tax certificates, pay stubs, photos, and so forth—accumulate daily in our downloads folders, similar to the way flotsam and jetsam accrued in the *Time Capsules*. If we so desired, we could easily posit our downloads folder as a work of archival folk art, as Warhol did with his boxes, which in true pop-art style made no distinction between valuable and worthless, high and low, art and trash. Similarly, we could envision our furious sharing of artifacts on the web as a type of collective folk archiving, be it the amassing of photos on Instagram, the aggregation of music on MP3 blogs, or the adding of videos to the already groaning archives of YouTube. Alternative or folk models of gathering things—jumble sales, boot sales, garage sales, flea markets, time capsules—seem a more relevant way to theorize the archive in the digital age because machines still are incapable of addressing artifacts in productively illogical and intuitive ways. In the future, everyone will be a world-famous archivist for fifteen minutes.

● ● ●

What follows is a Duchampian door, at once open and closed, logical and whimsical, focused and drifty, academic and anecdotal. Part explanation, part justification, part reification, and part provocation, it's a memoir of sorts, an attempt to answer a question I often ask myself regarding UbuWeb: "What have I done here?" Is it a serendipitous collection of artists and works I personally happen to be interested in, or is it a resource for the avant-garde, making available obscure works to anyone in the world with access to the web? Is it an outlaw activity, or has it over time evolved into a textbook example of how fair use can ideally work? Will the weightlessness and freedom of never touching money or asking permission continue indefinitely, or at some point will the proverbial other shoe drop, when finances become a concern? The answer to these questions is both "yes"

and "no." It's the sense of not knowing—the imbalance—that keeps this project alive for me. Once a project veers too strongly toward either one thing or the other, a deadness and predictability sets in, and it ceases to be dynamic.

Although there's a substantial user base around UbuWeb, it's hard to say exactly who these users are since we don't keep tabs on them. Once in a while when UbuWeb materializes in a physical space—if, for instance, there's an exhibition of the site in a gallery or when I give a talk about it—I get to meet some folks. Generally speaking, they don't skew toward any single demographic; rather, reflecting the site's eclectic offerings, a variety of musicians, poets, academics, artists, dancers, and theory heads show up. I've never done much to encourage an online community.[9] Instead, I preferred the quieter model of the public library, a large repository of cultural artifacts waiting to be browsed, borrowed, and shared. If there is a UbuWeb community, it's more at the level of our shadow-library peers, a like-minded circle of individuals and institutions across the globe who are dedicated to the free dissemination of cultural artifacts and intellectual materials. The people who use those resources (which I discuss in depth in chapter 4, "Shadow Libraries and Preserving the Memory of the World") overlap with the people who use UbuWeb.

This book is broken into three parts: "Polemics," "Pragmatics," and "Poetics." The "Polemics" section is just that—a short manifesto to explain UbuWeb. Even though it may be hard to swallow, it's important to how UbuWeb has evolved over the years. The section is called "Polemics" for a reason. UbuWeb is at its best when it's at its most assertive.

"Pragmatics" comprises a series of essays focusing on the legal, curatorial, distributive, economic, communitarian, and aesthetic issues that have defined the site and the free-culture movement from its inception and that continue to flavor it today. I discussed

these concerns with experts in several fields—legal, curatorial, distribution, artistic, and academic—in order to find out how my views hold up. While the answers often confirmed my instincts, they sometimes surprised me; I got some things right, but I also got some wrong. I invoke terms such as *folk archiving* and *folk law* to describe the amateur mantles UbuWeb adopted when assembling and protecting its collection. I discuss UbuWeb in relation to the status of the cultural artifact in the digital age and how our presence has nudged that discourse in terms of such artifacts' legal, economic, distributive, and artistic reception. I also survey the various shadow libraries that constitute Ubu-Web's peer group,

The next section, "Poetics," is a series of six essays focusing on specific genres and artworks that are foundational to the site. I examine various works—historically, philosophically, and aesthetically—through a series of close readings, focusing specifically on boundary-blurring, genre-crossing artists who define expanded notions of the avant-garde. I also delve into several historical publications and anthologies that have served as precedents for UbuWeb, discussing how their curatorial philosophies and distribution models influenced our thinking, ultimately giving us permission to do what we do.

After a brief coda, which critiques the nefarious role algorithms and surveillance capitalism play today in the distribution and reception of cultural artifacts, the book's appendix is an annotated list, "101 Things on UbuWeb That You Don't Know About but Should." It's a guide to some of the hidden treasures on Ubu. UbuWeb comprises hundreds of thousands of cultural artifacts, so this short selection is little more than a trail of breadcrumbs, encouraging you to hack your own path through the thickets contained therein.

● ● ●

UbuWeb can be construed as the Robin Hood of the avant-garde, but instead of taking from one and giving to another, we're giving to all. UbuWeb is as much about the legal and social ramifications of its self-created distribution and archiving system as it is about the content it hosts. In a sense, the content takes care of itself, but keeping it there at the site has proved to be a trickier proposition. The sociopolitical maintenance of free server space with unlimited bandwidth is a complicated dance, often involving the dodging of darts thrown by individuals who call foul play on copyright infringement.

Acquisition by a larger entity is impossible: nothing is for sale. You might remember the denouement of the film *24 Hour Party People* (2002), where a large record conglomerate swoops in to buy the stubbornly independent Factory Records for millions of pounds. When asked to show evidence of his contracts with his artists, Factory head Tony Wilson can only produce a funky, DIY document signed in blood stating that the bands own the rights to all their material—nothing can be sold. The record execs grin madly as they walk away with the lucrative Factory catalogue for free. Wilson muses in the coda that although Factory Records was financially worthless, it was a great success, a fantastic conceptual-art project, full of integrity, one that never had to make a single compromise. UbuWeb is similar, except what we host, unlike pop music, has never made money.

These days there's a lot of support for the way we go about things. Many think of UbuWeb as an institution. Artists both well established and lesser known write us asking to be on the site. But it wasn't always this way; for a long time many people despised UbuWeb, fearing that it was contributing to the erosion of long-standing hierarchies in the avant-garde world, fearing that it was leading to the decimation of certain art forms, fearing that it would tank entire art-based economies. Of course, none of that happened. We just happened to be there at the

beginning of the web and had to ride the choppy currents of change as each successive wave washed over. Whereas we once used to receive daily cease-and-desist letters, today we rarely get any. It's not that we're doing anything different; it's just that people's attitudes toward copyright and distribution have evolved as the web has evolved.

By the time you read this, UbuWeb may be gone. Never meant to be a permanent archive, Ubu could vanish for any number of reasons: our internet service provider (ISP) pulls the plug, we get sued, or I simply grow tired of it. Beggars can't be choosers, and we gladly take whatever is offered to us. We don't run on the most stable of servers or on the swiftest of machines; crashes eat into the archive on a periodic basis; sometimes the site as a whole goes down for days; more often than not, the already small group of volunteers dwindles to a team of one. But that's the beauty of it: UbuWeb is vociferously anti-institutional, eminently fluid, refusing to bow to demands other than what we happen to be moved by at a specific moment, allowing us flexibility and the ability to continually surprise even ourselves.

Pay no attention to the man behind the curtain. I designed UbuWeb to make it seem like an official, well-funded enterprise. With its clean design and its vast content, it feels, for lack of better words, "official" or "real." I figured that if UbuWeb appeared to be a legit entity, then people would be forced to acknowledge the importance of the difficult and obscure materials we championed. This approach seems to have worked; people have told me that they thought that there was a huge team of well-paid people toiling day and night behind screens, building the internet's largest archive of avant-garde art. Sounds good to me. If only it were true. Sometimes people come over to my apartment and ask to see UbuWeb. They're disappointed when I show them an old MacBook Pro hooked up to a wheezing four-terabyte

hard drive in a drab room overlooking a gray alleyway in midtown Manhattan. Many assume UbuWeb to be a fortress of bricks and mortar, when in reality it's just a pile of pixels held together by tissue paper and spit.

Throughout this book, the pronouns *I* and *we* are interchangeable—because UbuWeb is mostly just me. Over the years, although there have been editors and volunteers, for the past two decades I've pretty much been on my own, designing, coding, archiving, and assembling the site. I am completely unqualified for the job. I have a BFA in sculpture that I got from the Rhode Island School of Design in 1984. I took one art history class in college, and it was on baroque art. As a result, everything about UbuWeb is sort of skewed and idiosyncratic, if not entirely wrong: the taxonomies are vague, the collections are incomplete, and why certain things are there and others aren't is unclear. UbuWeb was assembled in the way artists create their works: by following hunches, trusting intuitions, and blindly following them wherever they may lead—even when they lead to dead ends. This approach is both Ubu's blessing and its tragic flaw; it's what makes the site so exciting and dynamic but what makes it a flop when it comes to rigorous academic research. Throughout this book, the examples I use tend to skew toward my own tastes. While UbuWeb is a vast and diverse enterprise, it is still riddled with my subjectivity. Had someone else written this book, it would've undoubtedly been a more objective endeavor. The fact that I not only built and curated the site but also am writing its history speaks to an obvious bias, one that is replicated time and again through this book and through the site as a whole. I have toiled for the past quarter of a century putting in, as Mike Kelley once said, "more love hours than can ever be repaid," building a utopia of avant-garde art, mixing the obscure and the canonical, and making the mix purposely

invisible to most web denizens. In the end, UbuWeb remains closest to the spirit of its namesake, an elaborate—and at times obnoxious—exhaustive and illogical endeavor, a pataphysical schoolboy prank illuminated and sanctioned by the bright green candle of Pere Ubu himself. Pshite!

PART I

POLEMICS

A few years ago for UbuWeb's twentieth anniversary, a group called Custodians Online, who are dedicated to the dissemination of free culture and knowledge, gave UbuWeb two gifts. First, they created multiple mirrors of the site so that even if UbuWeb should disappear, it never will disappear. Second, they wrote a six-point takeaway manifesto inspired by Ubu's ethos. Although I didn't write it, I might as well have since it succinctly sums up UbuWeb's philosophy:

1. Keep it simple and avoid constant technology updates. Ubu is plain HTML, written in a text-editor.
2. Even a website should function offline. One should be able to take the hard disk and run. Avoid the cloud—computers of people you don't know and who don't care about you.
3. Don't ask for permission. You would have to wait forever, turning yourself into an accountant and a lawyer.
4. Don't promise anything. Do it the way you like it.

5. You don't need search engines. Rely on word-of-mouth and direct linking to slowly build your public. You don't need complicated protocols, digital currencies, or other proxies. You need people who care.

6. Everything is temporary, even after twenty years. Servers crash, disks die, life changes and shit happens. Care and redundancy is [*sic*] the only path to longevity.[1]

The manifesto reads like a set of best practices of how to remain independent in the increasingly corporately controlled environment that the web has become. I'll begin by elaborating on each point, one by one, and then tack on additional ones of my own.

Keep It Simple

There's a commonly held idea that it's impossible to be independent on the web anymore. The internet is in many ways now dominated by corporate giants, and we have pretty much accepted that as true. But although much of the web has been colonized, the fact remains that most of it is as free and open as it always has been.[2] What we tend to forget is that the bedrock architecture of the web is the same as it was decades ago. Everything I did twenty years ago on UbuWeb I still do today in an identical way, using the identical programs, languages, and tools. What was possible for UbuWeb in the beginning is still possible today.

Another commonly held idea is that the web is one giant shopping mall, where everything is either monetized or monetizable. Although that's true for certain pockets of the web, it's far from true for all of the web; there are vast swaths where things still get done for little or no money. The gift economy works in parallel with the paid one. And, finally, there is the idea

that every move we make is tracked, sold to marketers, or swiped by nefarious foreign agents. Again, that's true for a lot of the web, but you have the choice not to implement such marketing devices or trackers on your site.

With each passing month, we hear about another attack on internet freedom, be it assaults on net neutrality, the enactment of link taxes, or automatic content-upload filters. These threats are real, but by staying independent you can sidestep those nefarious implementations; they need not apply to you. Walk away. Stay free.

It might sound obvious, but one of the best things about Ubu-Web is that it works. After more than two decades and a mind-boggling array of technical changes to the web, we have stuck with plain HTML, and it was the right decision. No matter what operating system or new code is written, every computer or device anywhere can read UbuWeb's basic code. We have always refused to use web-building packages, the kind that throw lots of unnecessary and ugly code into your documents. Those programs also don't allow you to see the code, so you never really know what's getting slipped into it. And over the years most of these programs have come and gone, leaving you with an unruly mess when you try to load your material into a competitor's program. Finally, if you sign up for a corporately owned blog or site-development kit that's marketed to make it "easier" to handle your site, you have no choice but to buy into the corporation's monetization scheme. If our approach sounds naive and overly simple, you're right: it's both—it's utopian, and it's realistic. Sometimes you just need to take back control of your digital environment.

Don't get me wrong. I'm no geek. I know the barest bones of HTML. I still write UbuWeb in a plain text editor, same as I always have since 1996. The code is clean, crisp, and legible. As a result, the site not only functions better but is also easier to

maintain. Last night, when I added a dozen movies and half-a-dozen LPs to the archive, I was working off the same templates that I wrote in the mid-1990s when I first learned to code; I've never needed to learn anything more than what I knew then, and what I knew then was super basic.

UbuWeb was born in the time of dial-up connections. Back then, you had to watch the size of pages so that they would load quickly on the slowest connections. It's an ethos that we still abide by; after all, the digital divide is real—many folks around the world still struggle with bandwidth issues or view the web on aging cellphones. As a result, our top-level pages are tiny; our front page today is still a mere four kilobytes. It's only when you get into rich media a few levels down that the pages get heavier. There's also no junk in the pages: no trackers or sniffers or ad servers or metrics. You will not be receiving one of those annoying General Data Protection Regulation terms of service and conditions notifications from UbuWeb because there are no terms of service or conditions. You don't have to click to accept our cookies policy because there are no cookies.

I can't tell you how many times over the years people have offered to put the site into a database such as Oracle or MySQL. They are horrified that I have to update each page by hand and use primitive batch-file search-and-replace strings. They promise that with a database I can update thousands of pages with a click of a button. It sounds so great. But what they never tell me is how they—the sysadmin—would always be in control of my site. Each and every backend change would have to go through them. And while often utopian and generous, sysadmins are just as often moody and cranky. And sometimes they get pissed off and walk away with the keys. I remember getting a call from staff at a prominent arts institution in New York City who were panicked because their sysadmin simply vanished and refused to return their calls. He was never seen again, and all their

incredible content—including digitized video and audio documentation stretching back to the 1960s—was inaccessible. They had to scrap the site and start from scratch. I guarantee you that they didn't go down that road again.

Elaborate, privatized technologies are an ever-escalating treadmill. With each version comes a new update, and with each update comes a new cost, and with each new cost comes a host of new problems and incompatibilities. HTML is free and always works regardless of the technological changes. Stay backwardly compatible. Stay simple. Stay free.

Even a Website Should Function Offline

Boy, am I glad that I didn't build UbuWeb on the cloud. There were times when I actually considered it. I mean, it sounded so good: unlimited server space, large bandwidth, global access, all for free. There were times over the past few years when I felt that MP3 and film blogs, which are based on the cloud, were doing as good or better a job of archiving the avant-garde than Ubu-Web; our site felt out of date, even verging on obsolete. But stick around long enough, and you'll find that because many of these cloud-based storage platforms are profit based, they often go out of business. Easily decimated by copyright-infringement lawsuits, federal investigations, and bankruptcies, they almost always get their plug pulled, leaving a site's content scrambling for a new home. As I write this, Flickr, one of the earliest photo-sharing sites, founded in 2004, is discontinuing its unlimited free photo storage. Allowing each user only 1,000 images, the new owners of the Flickr photo-sharing website will begin deleting millions and millions of photos unless you upgrade to a premium account.[3] My hunch is that the site won't be around for long. It's always a losing game.

I used cloud lockers—remote servers that allow you to upload, store, and share files—as much as you did. In fact, much of the content on UbuWeb was culled from them and reposted on Ubu. I had paid memberships to cloud lockers such as Megaupload, Rapidshare, and a few others so I could have fast-lane access to their treasures. Even today I still do, with the understanding that they come and go, so I use them cautiously. And, frankly, the price to me—as a ravenous collector, consumer, and distributor of cultural artifacts such as MP3s, MP4s, PDFs, and EPUBs (e-book file format)—was small, much cheaper than buying these artifacts from shops around town (often at inflated collector's prices) and then having to digitize them and upload them to Ubu.

I love the idea of the cloud, but I hate the reality of it. The reality of it is nothing like what's been promised to us. Trusting the cloud is a mistake: it's too centralized, too easily blocked, too easily controlled. And it's privatized, owned, and administrated by someone other than you. The cloud is presumed to be all around us, advertised as "your data when you want it." But that's a lie: when I travel, finding unlocked Wi-Fi connections anywhere on the globe (grimly, with the exception of Starbucks) is impossible.

And free isn't always free: I often encounter a highly censored, "family friendly" cloud on public transportation, boasting of hotspot connections as a way of filling seats. Aside from content restrictions, these clouds work sporadically and slowly, if they work at all. Streaming media are censored and tightly controlled on the cloud. YouTube and SoundCloud are not benevolent or free: they are massive entities seeking equally massive profits and are out to control, police, remove, and censor content. (YouTube actually has an algorithm that sniffs out anything in the shape of a sexual organ and removes it, whether it

is anatomical or not; it has recently made downloading any video with music in it impossible.) Their free is not free; it's a hook, a means to their end, making money by selling your data and inundating you with ads. We're all dazzled by free, but in commercial culture there is no free.

Then there's the issue of politics. There are many places in the world where your particular cloud is blocked, and when you try to access your files in those places, you come up empty-handed. I've been in countries where my cloud-based Gmail was unavailable, as were the cloud lockers upon which I relied and my social media accounts. In certain parts of the planet, relying on the cloud blasted me back twenty years in time because I was unable to access much of today's technology because of politics (for starters, there's no Google, Twitter, Reddit, Netflix, or Facebook in China if you don't have a virtual private network [VPN]). But our own domestic policies can have consequences for cloud-based computing that are equally precarious. Just think back to 2009, when the U.S. Department of Justice cracked down on the most prominent cloud-based service, Megaupload, for copyright infringement. The shutdown caused file-sharing lockers to shutter both in the United States and throughout the world. One by one, the cloud-based hosting services dissipated; MP3, film, and literature blogs that relied on the cloud quickly followed. I feel terrible for folks who put their trust in the cloud, building beautiful libraries of cultural materials to share with others, only to have them collapse overnight. While much copyrighted material was hosted on these servers, out-of-print and orphaned works were also posted and shared. The tragedy of seeing such libraries decimated is absolutely heartbreaking.

Don't trust the cloud. Use it, enjoy it, exploit it, but don't believe in it. Or even the web for that matter. Many people assume that the web—and its riches—will always be there

waiting for them. It won't. Don't bookmark. Download. Hard drives are cheap. Fill them up with everything you think you might need to consult, watch, read, listen to, or cite in the future. Your local library should be as vast as anything up for offer on the web. Understand that the web and its offerings are temporary and ephemeral; that PDF you bookmarked yesterday may not be there tomorrow.

I am fortunate that UbuWeb's servers have always been run by people who care and are committed to the project. By hosting a vast trove of files without, in many cases, the necessary permissions, they are assuming a great risk—but they are still willing to take it because of their belief in the free and open sharing of cultural artifacts. With a push by sympathetic academics or sysadmins, over the years several universities have hosted UbuWeb. Things proceed smoothly for a while, but sooner or later someone always catches on to the fact that there's a ton of "illegal" files being hosted on the university server, whereupon we are promptly kicked off (happily no one's ever lost a job by taking the risk of hosting Ubu). We somehow always land on our feet and move on to the next server. Although the interface and delivery of our content appear so simple and smooth, there's nothing like a team of trusted allies behind the scenes to keep up that appearance.

But this is not just about UbuWeb. You should be able to send an email to a human who cares. Sure it's cheaper to sign on with some massive web-hosting corporation,[4] but we feel it's worth the extra change to have a sysadmin you know, one who is on your side. Every time we outsource our money to entities who don't care, we lessen the possibility of supporting those that do. Seek out smaller and independent ISPs and platforms with philosophies that are in line with keeping the internet democratic and open. There are many out there, and they're not that hard to find. They deserve our support.[5]

Don't Ask for Permission

When you want to independently host cultural artifacts on your website (rather than embedding things from YouTube or Sound-Cloud), the common protocol is to reach out to the copyright holders to obtain their permission. But it's rarely quick or easy; most of the time—particularly if you appear to have money—you enter into protracted negotiations with the copyright holders involving mountains of correspondence. If they ask for money, contracts involving royalty schemes and residuals need to be hashed out. If music is involved, you often need to get in touch with rights agencies to clear those permissions, too. Enter the lawyers. What starts out as a simple idea to host, say, a single MP3 or an artist's video can become a process that takes years and costs several thousands of dollars. It's little wonder why there isn't much primary-source artists' film and video on most museum websites; for official institutions with substantial budgets, everything needs to done to the letter of the law.[6]

For UbuWeb, it's a different story. If we had to ask for permission, we wouldn't exist. In fact, we have never asked for permission. We post things because we want to, choosing instead to deal with the consequences later. (Spoiler: there are almost no consequences. I discuss why in the following chapter.) When you ask for permission, you ask for trouble. What was fun quickly becomes a burden, reeking of official culture. When you ask for permission, you become a business. These days we walk a fine line between the permissioned and the unpermissioned, the legal and the illegal. But it wasn't always this way; when we first started, the site was completely unpermissioned. Although we still don't ask permission, at a certain point things began to change when artists started offering us their works, putting us in a permissions gray zone. For instance, for many years we had been hosting the audio works, writings, and films of the

important Canadian artist Michael Snow without having asked his permission. At one point, we had up nearly a dozen of his films. One day out of the blue we received an email from Michael simply asking us to remove two of his films from the site—he didn't explain why—but said that it was okay to keep the rest up. We saw this as a victory. Having ten Michael Snow films with his permission—without having to launch into torturous negotiations with him—beats having a dozen without or having none, and our having permissioned works by Snow encouraged others to grant us permission.

Sometimes when galleries enter the picture, it gets more complicated. Several years ago an elder statesman of conceptual art, John Baldessari, got in touch with us, pointing out that an unpermissioned audio piece of his that we had been hosting was an excerpt of a much longer work. He was pleased to see it there and offered to give us the full-length piece, which we gladly accepted. Then a few years later his commercial gallery sent us a cease-and-desist order on all of his works at UbuWeb—including that audio piece. In light of our warm history with the artist, something didn't feel right. So we wrote to John telling him of the situation and within a day received a note from a gallery representative stating, "I am writing to confirm that you have permission to share the John Baldessari videos on Ubu-Web."[7] That little audio piece took a torturous journey: it started out unpermissioned; after John's intervention, it became permissioned; after the gallery complained, it became unpermissioned; and today it's been permissioned once again. All of those flips took a lot of time and correspondence, not to mention a certain emotional toll on me. Now, multiply these gymnastics by hundreds of thousands of cultural artifacts, and you can see why we don't ask for permission. The downside is that since we play so fast and loose, artifacts don't last forever on UbuWeb. But, then again, as I said in the introduction, the site was never meant to

last forever. Believe me, I'd rather be doing this whole thing above board. But I just don't have the money, the time, or quite frankly the interest to clear permissions for everything on UbuWeb.

Don't Promise Anything

It's often said that writers write the books that they wish were in the world. I do UbuWeb because it's the web that I want to exist. If others benefit from it, that makes me happy. But I do it mostly for myself as an artist, as a curator, as a critic, as a fan, and as an educator. Although UbuWeb is publicly accessible, the public has no say about what goes or doesn't go on the site. We don't take unsolicited submissions; we post work erratically and sporadically, never according to a schedule. And the works that we choose are there because we want them to be there, not because they fulfill any curriculums, quotas, or canons. While we want to expose people to wonderful and underappreciated works of art (and, of course, provide new perspectives on tired notions of the avant-garde), everything on the site is there primarily because it's meaningful to us, for reasons we don't feel the need to explain. And since we don't take any money, we don't have to answer to anybody regarding the content we host on the site. Is that approach biased? Yes. Is it incomplete? Yes. Is it imperfect? Yes. Is it the way we want to do it? Yes. All the way.

Even though UbuWeb has the feel of an official institution—and in some ways has evolved into an institution—it really isn't. Institutions are answerable to boards, funders, staff, and the paying public. Institutions must be representative of their constituents; institutions need to keep an eye on several bottom lines. We say, stay independent. You don't need institutions to support you. Every time someone offers you a handout or a grant, it comes

with strings attached. We say no. You can get by without institutional support. Everything on UbuWeb is donated or given or volunteered; it's a massive gift economy, a potlatch that works.

Several of my friends in Europe received grants from the European Union to make a European UbuWeb. They got a ton of money to sit around the table and argue; and when the money ran out, they walked away from the table, and the project ended. It was a very expensive conversation. Needless to say, there never has been a European UbuWeb. We have no secret sources of income (in addition to my work at the university, I am constantly lecturing, giving workshops, and writing books), nor do we have any stealth funders. I made the decision long ago to do this without any grant money or support in order to have maximal freedom. It seemed like a pipedream at the time, a long shot, but a quarter of a century later it's actually worked beyond my wildest hopes.

You Don't Need Search Engines

A little line of code is one of the most important on UbuWeb. Nestled in the header of every page is the tag <meta name="robots" content="noindex">, which means when search-engine spiders come knocking, they'll be turned away at the front door. Many people write books about how to get your Google ranking higher; we want ours to be lower. In fact, we want to get completely off the ranking list to protect ourselves from copyright trolls, entities seeking to claim ownership of artifacts that are either in the public domain or out of copyright.

What many people don't know is that if you own a domain, you can remove it from Google. Once we did that, for all intents and purposes we vanished from public view. Although doing

this might seem to go against UbuWeb's more democratic impulses—even seeming somewhat elitist in the sense that you have to be "in the know" to find it—for us it's a means of survival. I like to think about finding UbuWeb the way you used to learn about bands before the internet—by word of mouth from friends, by publications, and by trusted sources such as college or independent radio. It's the way underground culture has always traveled, and being firmly rooted in the underground, we see no reason to break with that tradition. There are a million links to UbuWeb from other pages, posted by people simply because they're interested in what we do. Bots, algorithms, artificial intelligence, and other technologies can't replace people who care about content and the way it is distributed. Never underestimate the power of word of mouth even in our social media world. We've never had a mailing list, nor have we ever done a scrap of publicity. I advocate for the site via our Twitter feed, but that's just a way of sharing a tiny fraction of the treasures contained within the site, a way of letting people know that we're still alive. With the exception of search-engine spiders, UbuWeb is open to all. We're hiding in plain sight, right out in the open. You just have to know how to find us.

Everything Is Temporary

Over the past two decades, UbuWeb has weathered a constant series of crises—technological, legal, mental, and physical. We have been hacked, had our servers pulled out from under us, served with a parade of cease-and-desist orders, to name only a few threats to our existence. There have been countless reasons not to continue to run the site. Over the past two decades, my employment has often been demanding or shaky; I've had a couple of kids to boot. But each time I consider shuttering the site

because of the work involved or some hassle from an artist or rights holder, I decide to continue. As Samuel Beckett says, "I can't go on. I'll go on."

Just when I'm about to end it, I meet someone who tells me how much UbuWeb has meant to him, how when he was a graduate student a decade ago, he did much his research there. Or there will be that tug on my sleeve, urging me to want to contribute to making an increasingly commercial, cruel, and banal online world less so. Running the site is also a giving back that I liken to community service; after uploading dozens of smart, hard-to-find avant-garde films, I walk away from the computer feeling as if in some small way I've helped make the web a better or more interesting place by sharing something hard to find but beautiful or compelling or thought provoking. That feeling alone is enough to keep me doing this.

A few years ago, on one of those occasions when I wanted to throw in the towel, I mentioned to my friend Marcell Mars that perhaps it had come time to wave the white flag. I was becoming burned out and couldn't see why I should keep on doing this. Mars, one of the Custodians Online, decided that he wouldn't let this happen. He quickly marshaled his forces of shadow librarians, who made multiple mirrors and backups of the site. He then offered to host the whole thing at no cost. A few months later, when everything was transferred, Marcell smiled, and said, "See? Now you'll never be able to get rid of UbuWeb even if you wanted to."

Marcell cares. And the Custodians care. And all the shadow librarians scattered about the web care. There are vast numbers of people who care. Care and redundancy are the path to longevity. Left to my own devices, I would have quit doing UbuWeb long ago. And there were many times when I came close. But when you build something for the right reasons, you find yourself stuck with it, surrounded by people who care. And that's the

greatest thing in the world. Just when you can't go on, you go on.

A Little Bit Every Day

Tonight after I put my kids to bed, I'll pour myself a glass of whisky and do what I do most evenings from 10:00 p.m. to 1:00 a.m.—update UbuWeb. I'll put on some music, crack open my text editor, and start coding the site manually. I've been doing it for so long that I can update the site with my eyes closed. I'm really fast; I can add dozens of films or hundreds of MP3s in a few hours. All it takes is lots of copying and pasting. As a ritual, the process is relaxing. I liken it to gardening. Each night I plant some new seeds, pull up some dead roots, clear some underbrush, trim the shrubs, and water the garden. Some nights yield huge harvests; other nights, the fruits of the labor are invisible, as when I'm tinkering with code or fixing broken links. As an academic, I am fortunate to have summers off, and that's when the garden really grows. It's then that I have the time to do major plantings that aren't possible during the semesters.

I never planned for this archive to be so substantial. I'm still not sure exactly how many artifacts are hosted on Ubu—I estimate hundreds of thousands—but if you work on something a little bit every day, you end up with something massive. Particularly over the course of decades, it really adds up. Years ago I began ripping books, LPs, and VHS tapes from my shelves. But I rarely need to do that anymore. There's a rich glut of cultural artifacts waiting to be scooped from various file-sharing sites, MP3 blogs, and invitation-only private groups that truck in these sorts of materials. Each night when I crack my RSS feed, it's brimming with treasures to download and repost; social media are awash in links to material that are perfectly tailored to Ubu;

and every so often a hard drive will arrive in my postal box from a collector halfway across the world, packed with incredible films and music she wishes to share with Ubu. There seems to be no end in sight. I have hundreds of films waiting to be posted and thousands of MP3s waiting in the wings. But there's no rush. There's no pressure to publish. Our timeframe is very long. With time, energy, and inspiration, the site grows. And during the fallow periods, there are more films to watch and MP3s to listen to than can be watched and listed to in the next ten lifetimes.

Money Is Overrated

Operating within an economy of no economy, UbuWeb runs on practically no money. For the past twenty-two years, I've forked out $50 a month to my ISP, a few bucks a year for a paid search engine, and some pocket change for video-streaming services. Believe me, it's not a lot. The bulk of our servers and bandwidth is either donated or given to us for obscenely low rates by sympathetic parties, which, of course, we greatly appreciate. Sometimes these parties have been universities, and other times radio stations. Today UbuWeb is hosted by our shadow-library pals somewhere between Zagreb and Iceland. To be honest, I'm not really sure where UbuWeb lives.

I realized long ago that if we took money, we'd have to pay money. It would be only fair. If I am getting rich on this endeavor, then the artists on the site should be getting rich also. If neither of us is, then almost everyone feels better. Though some avant-garde artists have become fantastically wealthy, it bears repeating that the business of the avant-garde, generally speaking, is no business. In 2012, Jonas Mekas said that he hadn't been paid for a screening in more than sixteen years. That year, when he

showed a film at a Brooklyn gallery, he netted $20 in cash, which he framed and hung on his studio wall.[8]

That said, there are small presses and little record labels that do make gorgeous editions of this stuff. UbuWeb hosts works that are either out of print or hard to find or obscenely expensive. If a little record label reissues something that's on UbuWeb, and it comes to our attention, we'll remove that material from the site. These presses and labels deserve our support. They're not in it for the money. But we've been around so long that when those reissues fall out of print—and economics dictate they almost always do—we pounce and put them back up.

In this way, UbuWeb is tidal: things flow in, and things flow out. Sometimes a corporation will catch wind that we're hosting something that it deems valuable and will send us a threatening letter. We comply with the order to cease and desist. Temporarily. Such corporations always move on, and a few months or years later we put the item in question back up. They never seem to catch on a second time. After all, there's no sense suing an entity that loudly professes to have no money; no corporation in its right mind would throw good money after bad. That's just not what they do.

All Material Is Usable by Everyone

Guy Debord wrote: "All the material published by the situationist international is, in principle, usable by everyone, even without acknowledgement, without the preoccupations of literary property. You can make all the *détournements* that appear useful to you."[9] We couldn't agree more. UbuWeb is open source. Please use it any way you like, especially the wrong way. Although UbuWeb is used to teach the history of the avant-garde in properly academic ways, we are delighted when people find other uses for

it. A few years ago we got word that some music from the site had become popular with dance DJs, who plundered it for new and weird sounds. It's been reported that samples from Bruce Nauman's mantric chant "Get Out of My Mind, Get Out of This Room" from his *Raw Materials* compilation on Ubu have been mixed with beats and are somewhat the rage among unwitting partiers on dance floors in São Paulo.

Independent projects using Ubu spring up constantly. One group built an interface called "Ubu Roulette," which selected and played random films; other people have created radio stations using our MP3 archive; and there seems to be a parade of exhibitions and film festivals around the globe drawn from Ubu's collection. We love and encourage all of these efforts. Please don't ask us for permission to use the site in whatever way you want because the answer is always yes.

People ask us all the time whether we can grant them permission to use a certain film or music in an exhibition (as I said earlier, museums and film-production studios often tend to stick to the letter of the law when it comes to rights and permissions), and we always emphatically answer, "No, we can't give you permission for our pilfered materials." If we can—and in certain cases where artists have actually given us stuff—we steer those seeking permission to the artists. In other cases, we refer them to proper distributors so that the artists can get paid. But usually we have no clue who the actual owner is.

A long time ago Creative Commons got in touch with us, asking us to put all our materials under its open license. Although we love the idea of Creative Commons, we responded that we couldn't possibly license materials to which we didn't own the rights. And while Creative Commons does protect artists, we're no fans of licenses of any kind. We'd prefer the materials be used without any restrictions whatsoever.

University libraries are full of great things that the general public can't use. If you were lucky enough to go to a university, that library privilege was often pulled the minute you graduated. UbuWeb is dedicated to building an alternative system—a shadow library that provides access to its materials to anyone regardless of affiliation and free of charge. We also feel that cultural artifacts should be accessed with no strings attached. We don't track what you have downloaded, how much time you spend on the site, or where you have clicked. Who you are and what you do are no business of ours.

The Problem Is Obscurity

It has been said that being well-enough known to be pirated is a crowning achievement.[10] If your work is well regarded enough to be pirated, that means you have achieved some level of success that most artists will never have. When we decide to pirate an artists' work, it means that we think that work is worth knowing about and worth preserving. The next time someone pirates your work, you should thank that person. Piracy is preservation. Unpopular culture is preserved by people who love and cherish obscure artifacts. Left to market forces, the kinds of things on UbuWeb would essentially vanish and be lost forever. Thank goodness there are custodians and librarians dedicated to collecting and caring for obscure and unloved cultural artifacts.

Every so often someone asks us why we don't bundle everything on UbuWeb into one big BitTorrent—a peer-to-peer file-sharing protocol—instead of insisting on serving files one at a time via HTTP (hypertext transfer protocol). The answer is simple. Torrents reward the popular and punish the unpopular. If we were to put all our strange avant-garde films, sound poetry,

and concrete poetry into a torrent, they would die a quick and lonely death waiting for seeders. We prefer the model of the public library, where works of all degrees of difficulty sit on the shelves, always available to those who wish to access them.

UbuWeb believes in artists. But artists who are not visible are forgotten. The worst thing an artist or an artist's estate can do is to eradicate him or her from the internet. The shortsightedness of doing so is incredible. There are many examples of avant-garde artists getting rediscovered in their old age after starving and struggling for decades. They're so thrilled to have love and patronage and glamour and sales that they clamp down on their work in open distribution, hoping to squeeze the market for every last dime they can. This late-life bump often goes against everything they previously stood for in their work and ideology when there was no money involved. They seem to have forgotten that once upon a time they were in favor of radical open distribution, sharing, nonremunerative economies, and open source.

But time has shown again and again that those who pulled their work from open distribution paid for it dearly by not being written about or talked about or taught and subsequently being forgotten by all except for the marketplace. And the marketplace is the loneliest place on earth, filled with people, as Oscar Wilde famously quipped, who know the price of everything and the value of nothing. But what we've discovered is that one thing has nothing to do with the other. People who can afford to buy works of art should not be worried about what's circulating on the internet. As the artist Seth Price says, "If you have a real Chanel bag, you don't give a shit that there's Chanel bootlegs out there."[11]

If someone requests that her work be removed from the Ubu-Web archive, we try to explain the consequences of her action. We try to convince her that we believe in her work and that for

no money whatsoever we are happy to promote and publicize it because we feel that the work is important and that making it known as widely as possible is the right thing to do. If, despite our arguments, the artist threatens and insists, we remove the work and are deeply saddened. If only that person could see the bigger picture.

Sometimes UbuWeb feels like a backup for the commercial internet. How many times have you gone looking for that video on YouTube, only to find it removed because of copyright violations or because that "content is not available in your area"? Corporately programmed bots sniff out all sorts of presumed copyright violations and remove them. If you had to rely on YouTube for video alone, you'd often be out of luck. On Ubu-Web, things mostly don't get taken down; instead, they get temporarily darkened—if you wait, they will usually reappear.

Not Coming Soon to a Theater Near You

In May 2000, I received the following email at UbuWeb: "i really enjoyed your site. it made me think about different cultures other than the ones i experience daily living in a small texas town.—meredith." I can't imagine that much of UbuWeb's materials are available in Meredith's local library. Chances are that it doesn't have a very good a collection of, if any, sound poetry or concrete poetry. Odds are that the local bookstore isn't chock full of this stuff, either. If Meredith were ambitious, she might try searching the web and buying these items online. But then she'd have to fork out $125 to buy a used copy of Emmett Williams's *An Anthology of Concrete Poetry* or $90 to purchase the *OU Revue* box set, which compiles the entire run of the legendary French sound-poetry magazine from the 1960s. Those two items are only the extreme tip of the iceberg, a miniscule amount of what's

available to Meredith for free on UbuWeb, which she can access right in the comfort of her own living room.

Most town or city's theaters don't show Stan Brakhage's films, nor would the multiscreen cineplex at the nearby mall. Even in New York, they are shown only every so often at places such as the Anthology Film Archives. Admittedly, the quality of some of the films on UbuWeb is not as good as you would want it to be. However, most of us have learned to live with the blocky pixilation; access has trumped resolution; the postcard has become the painting.

Meredith's note nicely and succinctly sums up everything that I wished to achieve with UbuWeb: the creation of a distribution point for out-of-print, hard-to-find, small-run, obscure materials, where they are available at no cost from any point on the globe. Although the technologies of the web are continually developing in terms of sophistication, UbuWeb embraces the distributive possibilities inherent in the web's original technologies—the ability to radically distribute artifacts.

But it's always been this way, even before the internet, where floating embers have sparked fires, causing great cultural explosions. A few summers ago I went to see Pietro Sparta, a very successful art dealer living in the tiny French town of Chagny. He had a beautiful industrial space and a stable of internationally known conceptual artists. After seeing his shows, we went to a café for drinks, and he told us how he ended up in this unique situation. His father, a Communist sympathizer, was thrown out of Sicily for his leftist politics and found factory work in Chagny. While the family was there, one of his sons died and was buried in the town. According to Sicilian tradition, a family can never leave the place where a son is buried; hence, Chagny became the Spartas' new home. Pietro got interested in contemporary art in the early 1970s by reading glossy art magazines he procured from the newsstand in Chagny. He became obsessed and

started corresponding with the artists. Before long, when in France the artists came to see him. He soon won their trust and began holding modest exhibitions. The artists were so impressed by his sincerity and devotion to art that they began showing their best work with him. Little by little his reputation grew until he was able to buy the factory that his father worked in when he first came to town and convert it into a spacious and gorgeous gallery. Today, Pietro still lives in Chagny, and his father, still alive and now retired, happily maintains the numerous and luscious plantings on the former factory grounds as his hobby.

The World Is Full of Citations

When you are doing research, one of the most heartbreaking moments is when, as you are searching for a rare or obscure book or film on the web, you get a bibliographic entry instead of the actual, complete digital artifact of what you're looking for. With that item locked away in some library halfway around the world, chances are that the listing is as much as you're going to experience of it, unless you are very well funded. If the digital artifact can be called the "ghost" or bad version of the physical artifact, then the bibliographic entry is the skeleton or residue of the digital artifact. On UbuWeb, we want to give access to primary sources. Everything we host is a link to an actual artwork, not a citation of it. Even if that link provides a crummy copy of the artwork, that copy still beats just a citation. Anything beats just a citation.

Completely untrained in library science, we assume custodianship of these artifacts—collecting, maintaining, cleaning, organizing, and protecting them so that you can access them. The ever-shifting economies of the web make it certain that

many of the things you love will eventually either disappear or cost dearly to be accessed. To ward off starvation, we're like squirrels preparing for the winter, gathering nuts that are falling from the trees (or from trees that are about to fall) and hoarding them so that all can continue to partake in the feast far into the cold season. Because the work is harried, our primitive grain silos are sometimes scattershot and sloppy. And because we grab what we can to avoid famine, the quality can be less than desirable. But it's better to have a few slightly stale nuts than no nuts at all.

Love Art, Hate the Art World

A few years ago, an artist pal of ours was on the cover of *Artforum*. He's a great artist, and we host a lot of his work on UbuWeb. I was really proud of him, so I tweeted as much on Ubu's feed. Tweets are a great way to tell how engaged your audience is with your content—but when I tweeted my friend's success, it was crickets. While the art world here in New York was abuzz with excitement, the larger world—UbuWeb's audience—couldn't give a fig.

I often give talks about UbuWeb around the globe, and judging by the folks who show up, much of UbuWeb's audience loves art but couldn't care less about the art world. At the bar after the talk, over drinks, I hear time and again how alienated people feel by the art world—how cliquish and exclusive and intimidating and pretentious and cold and expensive and impenetrable it is. Back in New York, I'm invited to art-world parties and fund-raisers, where I'm seated next to strangers. When I get to talking to them, I discover that they are curators or critics or collectors or directors of museums or galleries—and to a person, not one has ever heard of UbuWeb.

Nam June Paik once said that the internet is for everyone who doesn't live in New York City. Paik's comment can be read two ways. On one hand, in New York every night there's another opening or screening or concert or dinner or reading or party. Life here is rich with glorious artifacts situated in meatspace that by Paik's estimation makes the internet pales by comparison. On the other hand, he might be celebrating the fact that the internet offers even more kinds of cultural choices than New York City does. Typical of Paik's Zen-based practice—which often turned on koanlike contradictions—it's probably both at the same time. But Paik died in 2006, when less people in New York were paying attention to the internet than they are now. Today, when you walk into a subway car, almost every person is glued to a device. So, in a way, I think Paik's statement—although clever, puzzling, and proactive—might be a bit out of date, which makes me think that the art world itself might be a bit out of date. Sometimes the gallery and museum world feels too slow, too out of touch with the rest of culture, like an antiques market: featuring highly priced, unique objects at a time when value is in the multiple, the many, the distributed, the democratic. In this way, the art world is quickly making itself irrelevant. Soon, no one will care.

Regrets, I've Had a Few . . .

As you can tell, we're full of ourselves. We actually believe in these polemics. And sometimes, to be honest, we get a bit carried away. About a decade ago, we got up on our high horse and foolishly decided to publicly call out all those people who demanded their work be removed from Ubu by inventing something we called the "Wall of Shame." What a bad idea. People got angry, and rightfully so. If someone wants his work off

UbuWeb, it's his work, and that should be that, even though we might try to convince him otherwise. But we couldn't leave well enough alone. Like the fanatics we are, we took it too far. When we should have been trying to build bridges with artistic communities, we were making a lot of enemies. When we realized how wrong we got it, we broke down the Wall of Shame. Since then, many have come around, able to sympathize with our vision, but for others it was too late.

Also, we've been too slow in diversifying the site. We inherited a legacy of dead, white, straight, European, male artists, and for too long we didn't question that history hard enough. And although we love that stuff, there's also a ton of work outside of it that fits equally into UbuWeb. So for the past decade we've been adding works that broaden definitions of the avant-garde, consequently enriching the site in ways that delight us. We're still too slow, though, and more of these works need to go up on UbuWeb in order to expand and explode received notions of the avant-garde in radical ways.

Finally, if anything, we've been a bit too bold, a bit too brash, a bit too obnoxious (Exhibit A: this text). It's been a turnoff for many folks. But, in hindsight, it's been a necessary stance to take. What we've pulled off is so perverse, so weird, and so impossible that if we didn't cop a bigger attitude than necessary, we wouldn't have made it past the first year. You need a thick skin to play this game; and although in real life we are as thin-skinned as any artist, on the internet—as they used to say—nobody knows you're a dog.

PART II

PRAGMATICS

1

FOLK LAW

t might surprise you to know that Mick Jagger takes a sympathetic view toward file sharing. In an interview with the BBC in 2010, he said that music and technology have been together since the beginning of recording and that file sharing is just another aspect of that:

> But, you know, it is a massive change and it does alter the fact that people don't make as much money out of records. But I have a take on that—people only made money out of records for a very, very small time. When The Rolling Stones started out, we didn't make any money out of records because record companies wouldn't pay you! They didn't pay anyone! Then, there was a small period from 1970 to 1997, where people did get paid, and they got paid very handsomely and everyone made money. But now that period has gone. So if you look at the history of recorded music from 1900 to now, there was a 25 year period where artists did very well, but the rest of the time they didn't.[1]

Ignoring the fact that Mick walked off with a fortune in that "small period" of time, he still seems to have unusually progressive ideas about file sharing, which has clearly eaten into his

royalties as much as it has into anyone else's. If only everyone's attitudes were as open and evolved as Mick's. One evening in 2003 my friend Tim Davis, a poet and photographer, was sitting at his Avenue A apartment downloading a few songs from LimeWire, a peer-to-peer file-sharing client. He was trying to reassemble an out-of-print R&B LP that his father loved called *Hollywood Rock 'n' Roll* song by song. Since the LP had never made it to CD, Davis thought that he'd be able to conjure up fond memories from his childhood over the then new digital technology with a few clicks. The next day he got a phone call from an Associated Press reporter informing him that he had been named in a lawsuit by the Recording Industry Association of America (RIAA) for copyright infringement. Tim said, "You got the wrong guy. I'm not some kid who is downloading songs. I'm a professor at Yale," and hung up, which was when he realized that by giving them his status as an elite Ivy League prof, he'd made a terrible mistake. The next day he got a call from his dean at Yale telling him that hundreds of reporters were calling them from all over the world begging to know how a renowned professor could be such a scofflaw.

Davis was one of 261 people accused of illegally sharing files in suits brought by the RIAA in late 2003. His codefendants included a seventy-one-year-old grandfather from Texas named Durwood Pickle—who blamed his woes on his grandkids—and a twelve-year-old Manhattan schoolgirl. While the RIAA settled with the girl's family for $2,000, Davis was hit with an astronomical $10,000 fine. "They've pegged me as someone who should pay more," Davis said. "They thought I should know better." To help defray the fine, he threw a party in his Tribeca studio and sold T-shirts emblazoned with the words "Free Timmy" for $25. "It didn't go as well as it should have," Tim recalled. "I should have been taking money at the door instead of harassing people all night to buy t-shirts." In the end, he

cleared only about $1,000 for the night. The rest he paid out of pocket.[2]

The RIAA ended up settling only a handful of lawsuits, but stories like Davis's sent fear ricocheting across file-sharing communities, causing people to flee in droves, which was exactly the RIAA's intention. It was basically a bluff, as RIAA president Cary Sherman stated: "The music community's efforts have triggered a national conversation—especially between parents and kids—about what's legal and illegal when it comes to music on the Internet. *In the end it will be decided not in the courtrooms*, but at kitchen tables across the country."[3] This lawsuit was not about adjudicating justice—it was about scaring people. In Tim's case, it worked. To this day, he claims that he has never downloaded a file illegally; in fact, he went back to buying vinyl, which today is filling up his small house in rural upstate New York. The settlement had a chilling effect on his teaching: even if a digital file is permissioned and on a university intranet, Tim won't touch it, afraid to trigger a repeat of the nightmare he lived through.

The RIAA's action gave way to a torrent of Digital Millennium Copyright Act (DMCA, 1998) takedown notices in its wake. Seeing the success that the RIAA had in instilling fear into file-sharing users, issuers of DMCA takedowns hoped to achieve a similar end. A DMCA takedown notice is what Jason Schultz, professor of clinical law and director of New York University's Technology Law and Policy Clinic, terms a "performance." Schultz says that a DMCA takedown is not so much a legal notice as it is a protocol or, as he puts it, a "hello," an invitation to a dialogue, one that rarely leads to a lawsuit. Schultz told me that "the number of websites that actually get sued for noncommercial works are so small that you could count them on two hands." And beyond that, Schultz says, it all as usual comes down to economics. "If they don't see you as a big payout, they're not going to bother you. People would be a lot more

bold if they knew their chances of being sued are very small. But they only hear about the big ones. You never hear about the stories of the thousands of people who never got sued."[4]

Even if I weren't armed with legal knowledge, I always intuited that this was true, particularly when dealing with artifacts whose economic stakes are miniscule. Over the years, I've asked myself why there aren't thousands of UbuWebs, and the answer is fear of copyright. Funded institutions are compelled to follow copyright to the letter of the law, but for us unaffiliated folks there's more leeway. In spite of the fact that we don't clear copyrights, several legal experts have told me that UbuWeb makes an excellent argument as a case for fair use. In our approach to copyright, we've managed to build a massive archive, one that would, if done properly, take tens of millions of dollars to legitimize. Because we've observed that the law works differently in practice than what's written or what's threatened, we've been able to build something large and substantial. Call it a "folk law" approach.

Peter Jaszi, a professor at American University's Washington College of Law, says that the fear of copyright looms so large that most people can't distinguish between a nasty letter and a lawsuit. "A nasty letter is an almost reflexive act," he says. "Lawyers see writing them as a duty rather than as a choice." Part and parcel of zealous advocacy, such letters constitute an essential element of Schultz's theory of legal performativity. A certain amount of threatening behavior comes with the turf. But handling it is not easy. Jaszi warns, "If you're going to be someone who exercises fair-use rights, you need to have nerves of steel." Threatening letters from lawyers need to be either dealt with or ignored, he says, but they shouldn't be mistaken for actual legal threats. It feels counterintuitive, but if you stand up and push back, chances are that they're going to back off. Jaszi claims that many rights holders are cautious about asserting

rights against fair use because the last thing that they want is for the situation to be clarified; they thrive on fear, uncertainty, and chaos, and they don't want you to know your rights. The pervasive myth is that you have no rights. But it is a myth—and once that misinformation has taken root, it is accepted as fact. "People have been conditioned to be timid because the notion that fair use is a right has been strongly resisted in the rhetoric of copyright owners," Jaszi told me. "Copyright isn't a right; it's a privilege, it's an affirmative defense. Even in the copyright statute itself, it [fair use] is referred to as a right. Fair use is a right."[5]

●　●　●

I don't know if you've ever received a DMCA takedown notice, but it's designed to scare the shit out of you. You get an email with the subject line "Notice of Copyright Infringement," which alone is enough to make you tremble. When you open the mail, you're confronted with what seems like miles of impenetrable legalese beginning with

> Pursuant to 17 USC 512(c)(3)(A), this communication serves as a statement that:
>
> 1. I write to you from the _____ agency as the duly authorized representative of the exclusive rights holder for The Estate of _____.
>
> 2. Several works to which The Estate of _____ holds exclusive rights are being violated by material available on _____ at the following:

Then you are served with a list of the works that you're accused of infringing upon, all stuff you've posted on the web. Most file sharers post things on the web out of enthusiasm and passion; now that posting is being framed as a criminal act. By this time,

you're in such a frenzy that all logical thinking has gone out the window. Finally, you get three more threats:

3. Please note that these works are protected by copyright.

4. I work with the copyright holder and confirm that the use of this material in such a fashion is not authorized by the copyright holder, the _____ Agency as the copyright holder's agent, or the law;

5. Under penalty of perjury in a United States court of law, I state that the information contained in this notification is accurate, and that I am authorized to act on the behalf of the exclusive rights holder for the material in question.

It's terrifying. For most of us, it feels like something straight out of Kafka. Our life savings, our real estate, our future, our children's futures, and our grandchildren's futures—all flash before our eyes. Our heart palpitating and our eyeballs exploding, without a second thought we take down the offending content and scribble a desperate note of apology, begging for mercy. We frantically check our inbox every two minutes hoping to never hear from the sender again. And usually we don't. The copyright holders have achieved what they wanted without spending a dime. Most DMCA takedowns are not even sent by lawyers—they're written by people claiming to represent copyright holders. Anyone can copy and paste a standard DMCA takedown notice, plunk in a few details, and so make it have the same effect as a lawyer's letter. That's why it's worth carefully parsing these letters to check the validity of the claims, which are often bogus. Sometimes a takedown notice is sent by someone who is declaring to be a copyright holder but actually isn't. This is known as "copyright trolling"; a whole shady industry is based on claiming copyrights and collecting fees for the use of artifacts that it doesn't own. Other times, bots trawl the

web for keywords and automatically send you a robot takedown notice, also issued without substantiation but merely in search of a fee.

In 2004, the Tape-beatles, a group of sample-based musicians, asked UbuWeb to host their discography as well as a series of cassette compilations they had curated. We happily said yes and put the files on the PennSound servers, our partner site, which is housed at the University of Pennsylvania and hosts works that we have permissions for. The Tape-beatles files peacefully resided on Penn's servers for fourteen years, until 2018, when I received a frantic email from Penn's computing center notifying me of a copyright infringement on the Tape-beatles material. They were in a panic and wanted me to take action immediately.

The notice came from a legitimate royalty-collection agency from the United Kingdom that had sent out an infringement bot to trawl the web for keywords. It was programmed to seize upon *beatles* and *help*. When I discovered this, it quickly became obvious to me what they were after. I pushed back, politely informing the agency in an email that "the files which you reference are by a band called The Tape-beatles, which have nothing to do with the pop group The Beatles. Furthermore, you claim that The Beatles' song 'Help!' is the cause of infringement, when it is not even sampled or cited on any of the tracks for which you requested a cease and desist. Finally, we have full permission from Lloyd Dunn, one of The Tape-beatles to host these files."[6] Shortly afterward, we received a brief response: "After reviewing the information presented and the copyright notification we have decided to retract this claim for copyright infringement."[7] The original letter—as all cease and desists are—was scary and threatening; had I not had years of dealing with these sorts of things, I would've taken the files down without question, decimating the Tape-beatles archive. When I asked Dunn to back up our claims, he sent the following statement to the agency:

"UbuWeb has the right to host the files in question. The Tape-beatles have declared all their work to be in the public domain. Everyone in the world has the right to host them."[8]

Unlike my correspondence with the royalty-collection agency for the Beatles, there are times that even if you want to, you can't engage in a dialogue because there is literally no one there. Ken Freedman, the station manager at Ubu's partner WFMU radio has a lot to say about this subject. For the past thirty-odd years, Freedman has helmed the longest-running listener-sponsored, freeform radio station in America, specializing in eclectic, off-beat, and oddball music. When a DJ is given a show there—as I had from 1995 to 2010—he or she is given complete freedom regarding what to play during that slot. The result is some of the strangest radio you've ever heard. During one show, for instance, I played a recording of two men snoring for an hour; for my three-hour slot, I looped the piece three times (the piece, a work of performance art, is mirrored on UbuWeb). Did I get phone calls begging me to take it off? You bet I did. But that's part of the freeform package, the price listeners are willing to pay to support the unique idea of DJ autonomy. These attitudes helped shape UbuWeb's ethos—philosophically and artistically—to the point where our two endeavors became symbiotic; the station has lent Ubu technical support and shared its trove of cultural artifacts with us (see chapter 4).

Freedman believes in testing the limits of copyright law. He once told me that when a WFMU blog post featured a series of weird remixes of Prince's hits right after singer's death, the station was hit by a blizzard of cease-and-desist notices issued by an automated bot. One remix consisted of "Little Red Corvette" played backward, accompanied by text that made it clear that the recording was backward. Immediately after the MP3 went up, Freedman's inbox was flooded with numerous identical copies of a cease-and-desist letter requesting he take down

the backward track. He politely responded, telling them that song was not, in fact, what they thought it was. Then, just to make sure he had all his bases covered, he removed the file. But the identical cease-and-desist letters kept arriving day after day. What Freedman finally figured out was that in spite of his efforts to explain, the automated trolling service was still responding to the *title* of the blog post, which contained the name of the song, thereby triggering the letters. To this day, Freedman still receives those same notifications, which are now filtered into his trash. And, needless to say, he has restored the file, title and all.

Then there are people who claim to own material that is not theirs. Freedman once received a takedown notice from a U.K. record label requesting that he remove a series of recordings made during World War II by Charlie and His Orchestra, a Nazi-invented propaganda swing band. Freedman smelled a rat. Nobody owns the copyright to music produced by a government that no longer exists. He threw out the letter, left the files up, and never heard from the label again.

Freedman is what I might call a "folklawist," using common sense to take a reasonably relaxed attitude about the law. He'll often push back against laws on the books to see whether they're actually enforced or not. If not, he'll go on doing what he was doing. The result is a great deal of freedom, which makes other, more conventional radio stations ask him how he manages to get away with what he does. For instance, Federal Communications Commission (FCC) law states that whereas radio stations are allowed to play more than three songs by the same artist in a hour, webcasters technically are not. (Ironically, these days all FCC-governed terrestrial radio stations are also webcasters.) It also says that webcasters are prohibited from playing more than three songs from a box set in an hour. These laws, which have been on the books since 1996, have never been enforced, yet most

stations are terrified to break them. Freedman asks, "When Prince died, are you telling me that we couldn't webcast the same Prince special that we were simultaneously playing over the airwaves? When Prince died, everybody did a Prince special, and nobody got in trouble."[9] But most not-for-profit radio stations are captive to overly cautious institutions and their boards, which make them follow the letter of the law, even when that law is not enforced. Even though you might think that college radio is freer, few have the courage to push against legal boundaries, even when those rules are clearly absurd.

Sometimes legal threats can unintentionally have good results. In 2009, WFMU launched the Free Music Archive, which contains more than 200,000 royalty-free songs that anyone can use for no cost. The seeds of the archive began in response to a Library of Congress query in 2004 to decide how much to charge radio stations for streaming content over the web. The initial proposal was so outrageously expensive and far more than a noncommercial station such as WFMU could afford that Freedman decided to create an archive of copyright-free music that the station could fall back on should the fees go into effect. He put out the call to a bunch of the record labels and bands that the station had supported over the years and asked them to give WFMU the rights to their music for the Free Music Archive. The outpouring of support for the station was enormous, and MP3s came pouring in. In a short time, the station had amassed a giant copyright-free and royalty-free library. As it turns out, the dreaded fees never went into effect, and noncommercial stations had to pay only $500 annually, a price they could easily afford. Freedman says, "We had so much success with that, that it was an inspiration to set up the Free Music Archive. The 200,000 songs that have come to comprise the Archive were submitted by artists and labels directly to the Free Music Archive," which keeps growing to this day.[10]

Because UbuWeb traffics in decidedly less-than-remunerative fare, it's not usually the commercial collecting agencies that come knocking, but the estates of artists or their representatives, many of whom have set Google keyword alerts for relevant names and works. Like the bots, they usually don't look into the context but instead blindly issue takedown notices in threatening legal language. For years—before we removed ourselves from Google— I'd wake up and check my inbox stuffed with angry letters from, say, a deceased sound poet's siblings who inherited their brother's archive and were determined on monetizing it. In the email, they would be furious with us for hosting their brother's works on UbuWeb without their permission, outraged that we were "profiting" from them. Although it always stings to get these kinds of letters, I felt compelled to explain our policies and the mission of UbuWeb, entering into a lengthy correspondence with them, telling them how important their brother's works were and how they should be more broadly shared with the world. But I also had to break the news to them that no matter how hard they tried, their brother's sound poetry was never going to be monetized in ways they had imagined. I would tell them that it was better to have their brother's works freely available to scholars and a general audience who were interested in those works rather than have them languishing in the garage. In the end, more often than not they agreed that UbuWeb was promoting their brother's work and was not asking for anything in return from its users. What's to lose? It's a happy ending and a good story; most important, their brother's work continued to circulate and find a new audience.

In other cases, an artist's estate has reached out to UbuWeb. The sister of Jack Goldstein, a Pictures Generation artist who died young, found UbuWeb and offered us her brother's audio recordings, which had been released only on vinyl in limited editions, essentially as artworks. She reasoned that having MP3s

of them on Ubu would not affect the sale of the physical objects, nor would giving them away affect the market sales for his exquisite oil paintings, which continue to increase in value with each passing year. If anything, having Goldstein's audio works freely available expands the historical context of his paintings (for which he is predominately known), providing a fuller picture of the wide spectrum of his artistic practice.

One would not usually compare big corporations to sound poets' siblings, but in some cases they are similar. UbuWeb once received a takedown from the Canadian Broadcasting Company (CBC) for a series of really difficult and obscure noncommercial Glenn Gould radio plays. It was clear that the CBC was trolling for the name "Glenn Gould" with little regard to which works were being hosted. After all, UbuWeb would never host Gould playing "The Goldberg Variations," as much as we love it. It's really not our thing, and, besides, we know where the Gould estate makes its money, and it's not from his weird and difficult *hörspiele* such as *The Search for Pet Clark*, *The Scene*, and *Three-Cornered World*. In its correspondence, the CBC demanded that "all copies of our Glenn Gould materials be destroyed." We, ahem, "destroyed" all of them. Like most copyright trolls, the CBC assumed that the threatening email was enough to accomplish the "destruction" of its property. They screamed at us, then they went away. As usual, they never returned. A few months later we put the Gould plays back up, where they remain to this day.

Recently, a powerful commercial gallery angrily demanded to know *exactly* where we got our copies of videos by an artist they represent. In part, we responded, "As to your question where did the files come from? The answer is simple: they came from the internet, where hundreds of thousands of those identical artist's videos are circulating right now as we write and you read

this. And while you might be able to suppress a single site, you will never be able to squelch the possibly infinite lovers of his works who are digesting and swapping these videos, all day, every day, year after year."[11] We never heard from that gallery again.

Another time we got a cease and desist from WNET asking us to take down *An American Family* (1973), a twelve-hour documentary chronicling seven months in the day-to-day lives of the Loud family in Santa Barbara, California. Influenced in part by Warhol's static cinema and in part by cinéma vérité, it was perfect for Ubu. The takedown was sent by WNET's director of program rights and clearances and was copied to the vice president and general counsel. I wrote back telling them that because the films couldn't be seen anywhere, we assumed that they were out of print. I let them know that we don't touch money and that our intentions are pure. It's funny what a little human discourse can do. The lawyer wrote back to me, very informally and friendly, and began the email, "Understood. I read about your site's methodology before finding the DMCA page and figured your intentions were honorable." He then went on to tell me that the reason *An American Family* has been "out of print" on public television for upward of twenty years and never made available on the web or on video was simply prohibitive music clearance costs. There's so much high-profile copyrighted music used in the series (including the Beatles, the Stones, the Who, etc.) that anyone who streams it online runs a serious financial risk, even if they do it for free and for purely educational, noncommercial purposes. He told me that as a public-TV station, WNET simply couldn't afford those clearance costs, nor could it afford to take the risk of streaming the entire series without clearing the music. He turned out to be a sweet guy, and through my engagement with him I got a glimpse

of the complicated reasons behind what at first seemed like another cold, nasty takedown. In the end, we removed the episodes for a few years but ended up reposting them; we haven't heard from WNET since.

Folk law works best through reason, politeness, and common sense. I've found that if someone is the actual owner of the material and is asking you to take it down, it's best to correspond with that person to see if you can't persuade him or her to give you permission. If you are kind and reasonable, this approach often works. But once in a while you have to push back. Several years ago a prominent literary agency sent a boilerplate cease-and-desist letter regarding the numerous William S. Burroughs materials we host. The agency had obviously just plunked Burroughs's name into UbuWeb's search engine and cut and pasted everything it found into a DMCA takedown notice, claiming that it owned the rights to each and every instance where his name appeared on our site. But these instances included academic papers that cited Burroughs, song lyrics that had the name "Burroughs," and even poems that invoked his name. And, beyond that, many of the Burroughs MP3s that the agency claimed ownership of weren't its property; the copyrights lay elsewhere. But, most absurdly, its boilerplate order included the following statement: "Under penalty of perjury in a United States court of law, I state that the information contained in this notification is accurate, and that I am authorized to act on the behalf of the exclusive rights holder for the material in question." By claiming that the agency owned the copyrights to things that it didn't, its representative had already perjured himself!

I responded, countering the claims that those works were protected by copyright: "We believe that they are protected by copyright as well, but many of the copyrights are not yours and therefore you have no claim on them." The cease-and-desist

letter had also advised me that by being posted on UbuWeb, Burroughs's material was being used in a fashion that the agency had not authorized. For instance, the letter flagged an academic paper on plundergraphia published by a Canadian scholar in 2005, where a *footnote* cited Burroughs' name: "William Burroughs and Bryon Gysin's work with cut-up is also closely related to plundergraphia because they maintain the integrity of the original source in its entirety while putting words into startlingly new and charged relationships."[12] Proper names can't be copyrighted. Nor can footnotes. Clearly the agency had no rights to this citation. It also flagged UbuWeb's posting of the avant-pop musician Momus's LP *The Poison Boyfriend* as violating the Burroughs copyright. Momus had given UbuWeb permission to host his album, so I was puzzled by this accusation. When I investigated the "infringement" further, I found that the agency was claiming a copyright violation for Momus's liner notes, where he describes his compositional methods as being inspired by Burroughs's cut-up techniques.

I responded to this charge: "Under penalty of law, then, this information is not at all accurate. While UbuWeb is happy to correct the violations that are actually yours, the cutting and pasting of an internet search based on the name of 'William S. Burroughs' and claiming that anything on the site with that name is your property is not helpful in achieving your goal."

The facade crumbled. I received a sheepish reply stating that the agency had received the links to UbuWeb by "a concerned party" and apologizing, affirming that "the said items were not held within the agency's copyright." I asked the representatives to please resend a new set of links for materials that the agency could legally claim ownership of. A few days later a whole new list arrived, but most of the copyrights still did not belong to that agency.

Finally, I composed a note to the executor of the Burroughs's estate, James Grauerholz, which I asked the agency to forward:

Dear Mr. Grauerholz,

William wrote, "Tristan Tzara said: 'Poetry is for everyone.' And André Breton called him a cop and expelled him from the movement. Say it again: 'Poetry is for everyone.'"[13]

At UbuWeb, we take his words as inspiration in, I think, the spirit in which he meant it. Ubu has no interest other than educating people about William's (and many others') work. We don't touch money; nothing has or will ever be sold on the site. All of the works you wish us to take down are long out of print and unavailable (from old Giorno Poetry Systems LPs, etc.). As such, we assumed that by hosting them, we weren't hurting anyone. And if we have upset you, we sincerely apologize; no harm is meant.

Ubu is the largest educational site for the avant-garde on the web. It's been around for 15 years and is mostly used by students and scholars. We try to take great care to place works in their historical context in a commercial-free environment. To remove William's work from the site would create a great hole and be a tremendous loss for a worldwide community dying to get their hands on these materials which is otherwise nearly impossible to get a hold of. . . . It is in this spirit that I ask your permission to let us keep the materials up to ensure that poetry still can be for everyone.

Sincerely,

Kenneth Goldsmith / UbuWeb

I never heard from the agency again. And to this day, all of the William S. Burroughs material on UbuWeb is still there.

Other times, specious takedown requests come regarding the quality of images. I recently received one for videos from a

powerful New York City gallery, which complained, "The installation of these films is central to their integrity, and to encounter them in this context [i.e., UbuWeb] gives the viewer an incomplete understanding of the work. Because of this, we kindly ask you to remove them from your site."[14] What the gallery failed to note was that infinitely reproducible media such as film and video have no stable presentation. Even if you were to prescribe an optimal viewing situation, it would be unenforceable because there are no "moral rights" in U.S. copyright law, and the issue of "integrity" is beside the point. What UbuWeb provides isn't a substitute for the original, but the documentation of it—to say nothing of the commentary and critique that such a gesture generates—making it a candidate for fair use.[15] By this logic, every single artifact that UbuWeb hosts could be framed as a candidate for fair use.

Sometimes people accuse UbuWeb of cutting into their potential market, a concept that Amy Adler, the Emily Kempin Professor of Law at New York University School of Law, finds fraught when applied to contemporary art in general: "An artist who copies another's work, even without evidence of transformative message, meaning, or purpose, even without any changes whatsoever, will not substitute in the art market for the artist she has copied." She cites the case of Sherrie Levine, who famously rephotographed a Walker Evans photograph and claimed it as an original appropriative artwork—in terms of market substitution, Levine's sold for $30,000, while Evans sold for $142,000.[16] If anything, such homages reify the value of the original gesture rather than detract from it. Although much of the work on UbuWeb is being hosted without permission, it is work that is mostly otherwise not being commercially exploited. For much of the material on Ubu sadly there is no market (remember the sound poet's siblings). UbuWeb can't be a "market substitute"—one of the pillars of fair use—when there is no

market. Copying can increase the value of an original, but when that artifact has little economic value (a cassette tape or concrete poem, for instance), its value is in its accessibility, resulting in yet another argument for fair use.

● ● ●

Peter Decherney, a professor of cinema and media studies at the University of Pennsylvania and author of *Hollywood's Copyright Wars*, argues that in the case of the avant-garde it's the stories and myths rather than litigation that govern fair use of materials. In fact, from the mid-1960s to the mid-1990s avant-garde film and video encountered "no direct relevant case law and few fair use disputes between filmmakers and copyright holders."[17] Decherney feels instead that the vast majority of fair-use conflicts and questions are resolved not by judges but by gatekeepers, including publishers, film producers, librarians, website managers, and teachers. They determine whether one copyrighted object can be incorporated into another. Decherney also says that there are the gatekeepers in our heads. Uncertainty about fair use has had a chilling effect, causing many inventors, authors, and artists to avoid projects and to discard new ideas for fear of a copyright lawsuit.

Decherney cites certain myths surrounding the avant-garde and fair use, the most well known of them about Kenneth Anger's use of pop music in *Scorpio Rising* (1964). In reality, Anger hired a lawyer and spent $8,000 to clear the music rights so he could freely show the film at film festivals. But, according to the myth, Anger was a romantic avant-garde outlaw who flaunted copyright, invoked his right to fair use, and went ahead and used all the music without permission. This myth was taken up by later generations of filmmakers as a green light to use uncleared music in their films and thus "stick it to the man." One of them was then New York University film student Martin

Scorsese, who, against his professor's advice, used unlicensed pop music in his student films. Scorsese, who of course later became famous for his use of music in his films (all permissioned), was encouraged not by Anger's action but by the *myth* about it. Anger claimed that "Martin Scorsese learned about soundtracks from me."[18] But what Anger didn't acknowledge was that as much as Scorsese learned from him aesthetically, he learned equally from disinformation in the myths surrounding him. Scorsese acknowledged Anger when he wrote in his introductory notes to an Anger DVD box set, skirting the elephant in the room: "I was entranced by *Scorpio Rising* when I saw it for the first time, and it's had a powerful effect on me and my own films over the years. The way Anger used music in that film, in such perfectly magical harmony with the images, opened my thinking about the role music could play in movies. It could become as important to the characters and the world of the film as it was to all of us at the time."[19] As Decherney says, "In such a system, misinformation can be as powerful as accurate information."[20]

Decherney tells of how in 1987 Todd Haynes, then a grad student at Bard, made *Superstar: The Karen Carpenter Story* using only Barbie dolls. Haynes drifted back to the Anger outlaw myth and decided that he, like Scorsese, would use the music without permission. Haynes later told an interviewer, "It was still in the era when there was a kind of underground cinema that famously ignored issues of rights and stuff like that. I think Kenneth Anger was still working out the rights issues on many of his films—*Scorpio Rising*—for years after he made it."[21] Even in this statement, the Anger myth was perpetuated; Anger wasn't "still working out the rights issues" for *Scorpio Rising*—they had been worked out at the film's inception.

Although Mattel, the doll manufacturer, didn't bother Haynes, Richard Carpenter did. When Haynes's film was shown at underground venues, Carpenter was fine with his music being

used, but as the film began to grow in cult status, he sent a cease and desist, which backfired when it made the film even more desirable as a bootleg, with copies being spread far and wide. Although Haynes was never sued, Decherney claims that a new set of myths kicked in after *Superstar*—a cautionary tale that you might get busted if you attempted fair use. Decherney writes that "critics often blame Mattel for the suppression of the film rather than Richard Carpenter and the record label, A&M. In *No Logo* . . . journalist Naomi Klein cites Mattel's legal action against *Superstar* as a classic example of growing corporate censorship."[22]

In a conversation with me, Decherney concluded:

> Avant-garde filmmakers . . . told stories. Their stories mirrored the aesthetic and ideological tensions they encountered, and at times they may have reflected widespread attitudes toward fair use as well. But this was regulation from below, as indeed is most fair use regulation. . . . For avant-garde media artists, fair use norms did not evolve systematically or linearly. They were not the product of negotiations with rights holders or responses to the shifts in fair use law. Norms were spread orally through stories, and that should cause us to rethink the methodologies we use for researching and understanding fair use. Perhaps the best methods are not legal or economic. Fair use is largely a narrative system, closer to folklore than to jurisprudence.[23]

I love how he uses the word *folklore*. Exactly. When I brought up the idea of folk law, Decherney agreed: "Folk law is the law. It's outside the law but is more efficient than anything the law could create." Folk law is often determined by community norms. "In general, if you put up an entire work and for the most part people don't complain, then maybe the community norm is that it's okay to circulate it in that way," he told me. "Then it becomes an instance of community-based folk law. There's a lot

of academic work showing that the courts cared about what's fair use in a particular community."[24] By Decherney's reasoning, UbuWeb works as well as it does because of those same community norms.

He cites the Grateful Dead concert tapers, whom the band allowed to tape and to sell the tapes in a folk economy as long as it didn't interfere with the band's own commercial recordings. The Dead saw the bootleg not as a copy but as a document that would bolster their own ecosystem of fandom and artifacts. But even when the question moves into "official" culture, the conclusion is the same. In the case *Bill Graham Archives v. Dorling Kindersley, Ltd.* (448 F.3d 605 [2d Cir. 2006]), DK Books, a big mainstream press, published a book on the Grateful Dead that used seven images of event posters for a collagelike visual history of the band without asking Bill Graham for permission, citing fair use. Graham sued and lost on the grounds that in a new form—the book—the posters were no longer being used for their original function, which was to sell tickets. They had instead become historical artifacts, divorced from any functionality of selling tickets to concerts, thus falling within fair use. In terms of their relevance to UbuWeb, both Dead examples propose expanded notions of copyright. What if a bootleg isn't a copy but instead a new artifact? What if the identical artifact that once functioned in one context now functions differently in another contest? Is this not the definition of transformative use, the conventional standard for fair use?

● ● ●

Most of the material in UbuWeb's film and video archive is in the public domain, whether the relevant artists, estates, or institutions would want to admit it or not. There is more stuff in the public domain than anybody probably realizes. In the United States before 1976, if you didn't include the copyright notice on

the film at its first public appearance—something most avant-garde filmmakers didn't bother to do—you forfeited copyright.[25] Decherney confirmed this: "Copyright used to be opt in. Now it's automatic. After the Copyright Act of 1976, everything becomes copyrighted automatically. Before that, you had to register copyright, give two copies to the Library of Congress, pay a fee, and fill out a form. Then you had to put a notice of copyright on the document or film, etc. If they didn't send two copies or didn't fill out the form properly, it wasn't copyrighted. For instance, *It's a Wonderful Life* wasn't copyrighted—that's why it's shown on TV all the time."[26] Similarly, *Night of the Living Dead* entered the public domain because the filmmaker, George Romero, neglected to include a copyright notification. As a result, today it is the most downloaded film from the Internet Archive.

Andrew Lampert, a former archivist at Anthology Film Archives, builds on Decherney's ideas:

> One of the misunderstandings about copyright—even including works that the artists themselves claim rights to—is because of slippages which often involve messy paperwork, that their works are not copyrighted and are therefore conceivably free to use at will. Of course, there are some exceptions, such as Kenneth Anger and Tony Conrad, whose 16 mm films from the mid-60s all included a copyright card. But for other important filmmakers such as Ken Jacobs, Jack Smith, Joseph Cornell, Harry Smith, there is no legitimate copyright to many of those films. In the case of Jack Smith's most famous film, *Flaming Creatures* (1963), first shown the same year, even though it has a title card, it is not registered. Like every Jack Smith film that he made and showed before 1976 it is in the public domain.[27]

But certain myths about copyright are perpetuated regardless of what a film's actual legal status might be. Lampert cites the

complicated copyright history behind Joseph Cornell's film *Rose Hobart*, which was first screened in 1936 at New York's Julien Levy Gallery with no copyright card. Salvador Dalí was in the audience and was so jealous of the film that he knocked over the projector in a fit of rage. Shortly after the incident, Dalí said, "My idea for a film is exactly that. I never wrote it down or told anyone . . . but it is as if he had stolen it."[28] Cornell was so freaked out by Dalí's accusation that he showed the film only a few times during the 1940s and 1950s. In the 1960s, he gave it to Anthology Film Archives, where Jonas Mekas and P. Adams Sitney preserved it. Some years after Cornell died, his estate turned over the management of his legacy to MoMA, whereupon MoMA and Anthology Film Archives entered into a protracted legal dispute because the estate wanted all of Cornell's film masters moved from Anthology, where Cornell had placed them, to MoMA. A deal was struck that allowed Anthology a window of time to make sure that all the preservation work it wanted to do was done and that it would be able to screen the works in perpetuity in its Essential Cinema series.

According to Lampert, MoMA has long claimed ownership and copyright to all Cornell's films. Anthology preserved the large majority of them and has prints of most to fulfill loan requests from other institutions. MoMA had done limited preservation of the materials and for many years had not preserved *Rose Hobart*. So for years when people wanted to borrow *Rose Hobart* from Anthology (because it was not in distribution via Film-Makers' Coop, Canyon Cinema, or MoMA's Circulating Film and Video Library), MoMA would have to approve the loan as the third-party rights holder.

But it turns out that these baroque arguments were pointless because, according to Lampert, "that film has *zero* copyright. The film itself is made entirely of another film, *East of Borneo*, which, of course, Cornell didn't get permission to use. MoMA

has no legal right whatsoever to make any cease and desist claim, or ownership claim over it. While they might own physical property, they don't own intellectual copyright because the film was never copyrighted."[29] So the film has sat on UbuWeb's servers for decades, undisputed by either Anthology or MoMA or the Cornell estate.

● ● ●

Fair use is famously hard to define. Slippery and subjective, it goes into overdrive when confronted with the vagaries and contradictions that are part and parcel of contemporary art. Speculating on those difficulties, Amy Adler writes:

> The transformative inquiry [of fair use] asks precisely the wrong questions about contemporary art. It requires courts to search for meaning and message when one goal of so much current art is to throw the idea of stable meaning into play. It requires courts to ask if that message is new when so much contemporary art rejects the goal of newness, using copying as a primary building block of creativity. . . . While some courts search for the artists' intent, contemporary art revels in the erasure of the artist; while other courts look for meaning in aesthetics, contemporary art rejects the assumption that art is even visual; while other courts look for the viewpoint of the "the reasonable observer," contemporary art pictures the notion of a stable or reasonable viewer as fiction. . . . To the extent an artwork has any message or meaning at all, that message may be its defiance of a singular message or meaning, it's uncertainty, it's multiplicity.[30]

When litigating digital copyright-infringement cases, Jason Schultz uses a line of questioning that forces a defendant to admit to the fact that community norms around copying are evolving: "Are you telling me that you never in your entire life

downloaded something without permission or posted something on Instagram that you didn't have permission for, ever?"[31] Of course, everyone posts things on the web without getting proper licenses; otherwise, social media—and the internet as we know it—wouldn't exist.[32] Adler notes a similar shift among her students, recalling that years ago they referred to Jeff Koons and Richard Prince as amoral thieves. Today they have softened due to the way images flow freely on the internet: "They understand that copying is a part of their everyday lives, even if they won't admit it."[33]

These arguments resound when I asked most legal scholars whether what UbuWeb does could be considered fair use. "The decision to assemble related material in a way that it makes possible kinds of inquiry and comparison and consumption and appreciation that were not formerly possible is itself a kind of repurposing," argues Jaszi. "It's one thing to present an avantgarde film in theatrical isolation as a polished gem of modernism and another to present it in the context of a whole set of similar and related works and follow-on works[, which] is in itself an act of transformation."[34] Decherney agrees, citing the gathering and archiving of materials as transformative in and of themselves: "Maybe the transformative use is preservation, putting it into dialogue with other work, making it available to a community that it wouldn't normally be available to."[35] Adler frames the project through a legal lens: "Yes, I infringed your copyright. Yes I stole, but I did so in a way that ultimately furthers the purpose of copyright itself, which is to advance the progress of culture. It's for the public."[36] Every assertion of fair use helps fair use. Every time an academic publisher doesn't clear the rights to images, that act furthers the cause of fair use; every website that posts things without permission furthers the cause of fair use—all of which leads to an evolution of community norms.[37]

More than a century ago, Marcel Duchamp legitimized recontextualization by taking a urinal and putting it on a pedestal. The act of moving something from one context to another was an act of transformative use. In 2018, the fashion designer Virgil Abloh, who uses extensive quotation and appropriation in his work without acknowledging sources, said, "I often tell people that Duchamp is my lawyer. He's the legal premise to validate what I'm doing."[38] When these once-arcane art world defenses—perverse and complicated, as Adler explained—move into the mainstream, you know that norms are changing; shortly after Abloh said that, he was hired to be the artistic director for Louis Vuitton.

Following Abloh's lead, UbuWeb can be considered one enormous appropriative artwork, a giant collage, which appropriates not a single object but rather the entire history of the avant-garde. "In the case of Duchamp, the creative act is not performed by the artist alone; the spectator . . . adds his contribution to the creative act," Adler writes. "The observer in this sense becomes a co-author of the work."[39] In other words, every visitor to UbuWeb contributes to it, affirming it as one gigantic single fair-use artwork.

I've long maintained that for a certain set of cultural artifacts—specifically the type UbuWeb deals with—copyright doesn't exist. But Peter Jaszi begs to differ. "For a certain set of cultural artifacts, it is not that copyright doesn't exist, it's that copyright actually works. That there are enough features that are designed to protect the user of institutional and individual users—including fair use—that as a practical matter, copyright may exist, but it doesn't impede. I want to make all sorts of uses possible within the scheme of copyright."[40]

2

FROM PANORAMA
TO POSTAGE STAMP

Avant-Garde Cinema and the Internet

On a crisp autumn afternoon in 2018, I met Andrew Lampert for a few beers at McSorley's in New York's East Village. It was one of those magical times at the bar when the pale-yellow sunlight filters though the paned windows on East Seventh Street, splashing onto the sawdust-covered floor. A few older patrons sat silently around us, reading newspapers, eating cheese-and-onion plates, and sipping dark beers. Over the course of the few hours we spent together, clumps of tourists stopped in, took photos, and left; on occasion, a tour bus emptied out, flooded the bar, and just as quickly departed. For many years, Lampert has been on the front lines of the experimental-film world. From 1998 to 2015, he was the main archivist, curator, and programmer at Anthology Film Archives, a New York–based center for the preservation, study, and exhibition of avant-garde and experimental film and video. And for two decades, Lampert has run interference between UbuWeb and the experimental-film community, which for the most part has been—putting it mildly—suspicious of what we do.

Andy has always had a soft spot for UbuWeb. "At the bottom of it all, I'm still a kid from St. Louis who wanted to see the stuff I read about in books and magazines, and for me that's

UbuWeb's ideal user. It's not the imagined New York audience that is craving to come to events; instead, it's people scattered around the world who love this work but lack access."[1] Lampert moved to New York in 1995 to attend New York University. He first went to Anthology just after arriving in town and was hired in 1998, after having already been the director of programming for the New York Underground Film Festival, which was being held there. He began working at Anthology as its theater manager after dropping out of NYU, helping out around the office, and contributing shows to the calendar. At some point, it dawned on him that this job was not leading him any closer to a career in film. Soon after, he learned of a film-preservation program at the George Eastman House in Rochester, New York. Anthology had been without an archivist for more than a decade and desperately needed one. He struck a deal with Jonas Mekas that if he made it into the program, Mekas would raise funds to bring him back as an archivist. He was accepted and spent a year being thoroughly trained in all things celluloid. Mekas held up his end of the bargain and convinced Louise Bourgeois to pay Lampert's salary.

Lampert served as archivist from 2003 to 2011 and curator from 2011 to 2015, overseeing the daily management of Anthology's media collections, which contain more than 25,000 films, 7,000 videotapes, and 2,500 audio recordings. His duties included fund-raising, selecting titles for preservation, overseeing restoration and digitization projects, acting as a liaison with artists and estates, making acquisitions, loaning works to institutions, overseeing licensing and sales, managing the archival staff, and negotiating contracts. During his tenure, he restored more than 350 films by artists such as Vito Acconci, Stan Brakhage, Carolee Schneemann, Harry Smith, and Robert Wilson. He also managed Anthology's digitization program, which transferred hundreds of audio recordings and antiquated tapes of early video

art onto contemporary formats. Beyond that, he was responsible for coprogramming Anthology's bulging calendar of more than nine hundred annual public screenings. To say that he knows this world is an understatement—he is this world.

When he started at Anthology, the web wasn't capable of streaming video; by the time he left, Ubu, YouTube, and Vimeo were running full steam, leading him to question the cultural relevance of the work he was doing at Anthology. "I can find a very obscure film and preserve it. I have to get funding to do it. I have to convince a government agency or the Warhol Foundation that this person who you've never heard of is important and this is a cultural landmark work. I would spend a year restoring it and premiere the film on a Thursday night at Anthology to an audience of twenty-five people. Did I make this work more culturally relevant? No. You have to be in New York, you have to be free on a Thursday night, you have to be able to come down there and see it. You put the same film up online, it automatically has an audience."

Lampert led the experimental-film world through the changes in technology from analog to digital. He talked its denizens off the edge when they panicked, fearing that the web was snuffing out their art form. He tried to make them see that celluloid and the digital were two very different mediums, with very different métiers and ecosystems and that, if looked at from a certain perspective, one wouldn't cancel out the other. He turned out to be correct. The digital would eventually strengthen and bolster celluloid, but Lampert recalls that it's been an uphill battle:

Back in 2005, YouTube and Ubu were seen as a threat to film. But what's happened over time is that we've learned to distinguish between experiences. Seeing a film in a theater is not the same as seeing it on Ubu, but at the time it felt like all or nothing. To see a film that's all about sprocket holes, like a Sharits

film, online is a diminished experience. But access is another thing—now somebody in Kansas or Korea can have access to something that was a primarily urban and entitled experience. But in 2005 there was a lot of discussion about legacy, about keeping the institutions that supported this work going and not damaging their bottom line. The prevalence of YouTube and Ubu has actually increased the value of the cinematic experience. People who were young, who were interested, instantly recognized the necessity and the gift that Ubu really is, but the commercial agents and representatives of the work saw it as damaging in part because they weren't involved. That was very ego bruising.

In terms of quality, UbuWeb's films are truly a disaster, but Lampert says that it's these inaccuracies that prevent UbuWeb from ever being mistaken for a proper film-distribution service: "If you want to see the real thing, go to Anthology or MoMA or the Pompidou, but don't expect truth from online versions—expect approximations or remixes." As an example, he brought up Ubu's copy of Alfred Leslie's *The Last Clean Shirt* (1964), which for a long time contained only one-third of the film. No distributor would ever release a film with two-thirds missing. We did because it was all we had; that one-third stayed up for a few decades until Lampert called it to our attention. Today, the complete film is on the site. But even though the complete film is now available, its quality is far below what any distributor would allow. With no other online version available—the DVD is out of print, and no streaming services offer it—having a sub-par copy beats having no copy at all. And, at best, this "thumbnail" might make you want to see the "real" thing when it plays in a cinema.

As another example, Lampert cites two of his own films that he gave to UbuWeb in 2007, short, silent, black-and-white

portraits of the cellist Okkyung Lee. When he gave us the files, he didn't realize that they were completely wrong until he saw them on the site. Somewhere along the line—he can't pinpoint whether he gave us bad files or if they got corrupted by our servers—things got jumbled. One file begins at a random point. The other splices two films together into one. And beyond that, the compression for both films is awful. "When I saw that, instead of writing you to complain, I thought to myself, well how great, Ubu made a new version of my piece! Over the years, I've come to look at almost everything I watch online as either authorless or reauthored versions of works that I should be seeing elsewhere." When I offered to host the correct version of his works, he laughed and said, "I actually don't mind it. I feel like it was a permutation I didn't even expect."

Andy Warhol used to say that the action of his static movies, such as *Empire* (1964) and *Sleep* (1963), was not to be found on the screen but in the theater. He claimed that because so little was happening on the screen that the real action was in the audience—the comings and goings, talking, falling asleep, fighting, drug use, and sometimes sex. For him, the cinema was a performative space, with the images on-screen as a prompt or backdrop against which these performances could unfold, transforming the normally passive space of cinema into a relational one. Lampert feels similarly that

> cinema is not a medium. It's an experience, a collective experience, with people. By hearing them breathe next to me, I'm sharing that experience, I'm experiencing cinema. The cinematic experience is defined by a projector behind you projecting above your heads, onto a surface in front of you. Usually the room is dark, the walls are black, and the screen is white. But the room itself is comprised of viewers, and we're experiencing things simultaneously. I think it's that simultaneous

viewing that defines cinema because we could all watch the exact same content on our phones, at home, anywhere else, talk about it the next day at the water cooler, but cinema is about the experience of all of us watching at the same time in the same space. That's especially true if there's a mistake. For me cinema is alive when there's a focus problem, when the sound drops out, when a splice breaks, and we have to wait five minutes together in the dark while they get the projector running again. I don't want a fluid experience. This is cinema.

Following Lampert's logic, the web can never function as a substitute for cinema, which is distinctly a meatspace experience. It's an important point. Over the years, one of the film community's biggest criticisms of UbuWeb is that it's an inferior version of cinema. After listening to Lampert, I realize that although UbuWeb can give access to a cinema-based experience, UbuWeb is not cinema at all.

● ● ●

UbuWeb hosts digital copies of 16mm films by an avant-garde filmmaker named Dominic Angerame. They're meditations on richly textured urban landscapes constructed by superimposing images on top of each another. On occasion, bodies are overlaid with cityscapes, suggesting the city as body or the body as geography. Angerame's films are homages to earlier movies, such as Willard Maas's *Geography of the Body* (1943), in which body parts are photographed in such minute detail that they appear to be landscapes, and Hilary Harris's *Organism* (1975), which compares New York City's complex systems to those of a single biological organism. Angerame updates these movies by adding pop soundtracks from bands such as the Eurythmics, making them feel like off-kilter, avant-garde MTV videos. Sexy and opaque, they're new wave in both the Godardian and the post-punk-rock

sense. And even though they've been transferred to video and compressed, they still retain their cinematic qualities. In May 2016, Angerame emailed UbuWeb with a simple request: "I would like to have Ubu present some of my films. How do I proceed? Thanks."[2] Within a month, we had six films up. Angerame was so pleased that he quickly sent us another half dozen.

But our relationship with him wasn't always this way. In the mid-2000s, UbuWeb had no greater enemy than Angerame, who was then director of Canyon Cinema, one of the most iconic experimental-film distributors in the world. For years, we received a stream of angry emails from him threatening legal action if we didn't remove all Canyon Cinema films from our archive. The whole thing came to a head in 2010 when the experimental-film listserv Frameworks criticized UbuWeb. After several heated conversations on the list and a response from me, the resistance from that particular part of the film world evaporated, for reasons I never understood. To my surprise, after the controversy died down, several of my most vehement critics on the list—including Angerame—approached Ubu requesting us to host their films.

In 2018, I telephoned Angerame, a soft-spoken man approaching seventy with a thick New York accent, to find out what had changed.[3] Angerame was director of Canyon Cinema from 1980 to 2012. He was essentially running the business by himself, doing everything from overseeing the finances to inspecting films upon their rental and return. He was responsible for producing the lavish catalogues that propelled the company to become the leading distributor of avant-garde film. In the early 1980s, Angerame told me, there were just a few experimental-film distributors, notably Filmmakers Co-op on the East Coast and Canyon Cinema on the West. When he arrived at Canyon, the business was failing. It had only two employees, one of whom

was Angerame. Both worked part-time for the then hourly minimum wage, $3.85.

In the early 1980s, the bulk of the rental market was university film studies programs, which would be the source of many digital rips that ended up first on file sharing and then on Ubu-Web. In 1981, to rent a film from Canyon cost a hefty $2 a minute, which the filmmaker split with Canyon 65/35 percent. Even then, things were tough for both the distributor and the artists. "Nobody made a living off of what we gave them," Angerame recalled. Even the bigger-name artists were having trouble getting paid. "Stan Brakhage was owed thousands of dollars from Filmmakers Co-op. They couldn't pay because they were in debt. We were the only organization that was paying people." As a result, filmmakers started fleeing Co-op and joining Canyon, so much so that by the late 1980s Canyon Cinema had 3,000 films to Co-op's 1,200. Subsisting on grants from the California Arts Council, Angerame remained part-time throughout that decade, still working only thirty hours a week.

Even though underground video stores such as Kim's in New York were full of sloppy VHS rips of underground films (many of which ended up on Ubu), Canyon's academic market remained strong thanks to university professors who insisted on original formats to show students. But even that source of revenue was beginning to disappear. Many of the films we host on UbuWeb originate from university film and video programs, which in the 1980s, with their budgets being slashed, found it cheaper to rent each 16mm film one time from places such as Canyon and then make copies of it for their libraries. In a sense, university libraries were some of the first pirates, making unauthorized copies long before the internet. Over time, they amassed gigantic media libraries of pirated materials. These rips—first on VHS, then on DVD, and finally as Audio Video Interleaved files (AVIs) and MP4s—were, in turn, copied by students and faculty members,

who first circulated them among themselves and then released them on file-sharing networks.

Many of these files can be traced back to one "small liberal arts college in upstate New York" (everyone I interviewed requested that the school not be named). "God knows how," says Lampert, "but I know that a lot of your stuff on Ubu can be traced back to their AV closet." In 1988, the school acquired a television-recorder-model ELMO machine that transferred 16mm films to VHS. The college allegedly bootlegged every film that came in from every distributor and kept it as a VHS reference. "All you needed was a time-based corrector to get rid of any copy protection that was on it, but most people didn't bother to copy protect stuff and they charged enough in rentals to cover it," filmmaker and media scholar Keith Sanborn told me. "Most places that you rented from charged steep prices. A rental VHS would be run through a time-based corrector and burned to a DVD."[4] From there, it was a short step to the digital files that began flooding the internet.

Not everybody had the time to screen a full film in class, never mind repeatedly; downloadable MP4s allowed students to write better papers and pay close attention to the films. By charging such high prices, Canyon was unknowingly shooting itself in the foot, hobbling its own business interests. Since rental costs were so high and projection equipment was unavailable, teachers would often rip and burn their own collection—often consisting of thousands of DVDs—and bring them into the classroom to teach from, many of which could not be found elsewhere. These rips, too, were placed on university intranets, ultimately finding their way to file sharing. Over the years, many filmmakers, unaware of these goings on, complained to Lampert that they were shocked to find their films all over the web.

Although things began to go awry in the late 1980s, Canyon's upward swing extended into the early 2000s—2002 was its

biggest year—until the appearance of commercial DVDs of underground films visibly began to eat into its business. Angerame told me that once the Stan Brakhage DVD collection *By Brakhage: An Anthology, Volumes One and Two*, containing fifty-six of his films in high-quality digital transfers, came out in 2003, Canyon Cinema saw its rentals drop in half. It was all downhill from there—once DVDs came in, even Canyon's academic film rentals started drying up.

While the Brakhage discs could have been a wakeup call, Canyon chose to ignore it. Lampert recalls having lunch with Angerame in San Francisco, where he tried to convince him to offer video-distribution copies alongside film reels. Andy told him, "They don't make projectors anymore. Teachers aren't teaching on film. It's a death industry, and you're permanently tied to it. You could still distribute films, and you could also offer the same works on video in high-quality versions that the artists could approve, made at a lab that you trust, ensuring that it would not be the bootleg experience." "It really would've been a very controlled, smart way to increase access and distribution," he commented to me, "but the only thing Angerame and a lot of other institutions foresaw was more overhead: 'Who's going to do it? I have enough to do every day.' And that's the reality of all of these places—they've got too much going on." Lampert pressed, but he could feel he wasn't getting anywhere. "Dominic totally rejected this idea as being crackpot, that you would do something that might actually enable the work to be seen in the contemporary mediums of distribution. He told me it was a bad idea, and I couldn't understand why he wasn't listening to me. It seemed to me to be a win–win situation for everybody." When I asked Angerame about this conversation, he sighed and said, "We understood film. We had no idea about the digital. We were completely blindsided by it."

● ● ●

Of all the arts, film has taken the biggest hit in the digital age. Although MP3s and EPUBs are fair approximations of physical media, they shrink the filmmakers' art from engulfing panoramas to the size of a postage stamp. The digital age ripped asunder strong film communities with established hierarchies that stretched back decades; the "elders" (as they're referred to time and again in interviews) were in firm control of knowledge and were evidently rather stingy about sharing it. Over the many interviews I did with people in the experimental-film community, almost everyone had something to say about the elders' cryptic elitism. As Rick Prelinger, founder of the Prelinger Archives, told me,

> In the film community, knowledge of the avant-garde is passed down. It's largely an oral tradition. People who have spent a lot of time with elder members of the community know stuff that other people don't know. There's often a litmus test—"Do you know enough to really talk to me?"—type of thing. It's an imperfect system for transmitting knowledge about the avant-garde because there's these people who know everything—the people who know the anecdotes, the people who know the people—which locks out everyone else. The reason I started putting films online had nothing to do with the critique of copyright. It was ready, fire, aim. It was a critique of hierarchy and enclosure. What always killed me was that there was no access, that access was reserved for people with money or people with clout.[5]

Andy Lampert echoes Prelinger, turning his critique on the avant-garde as a field:

> The avant-garde vilifies what's new. The avant-garde is an avant-garde that recognizes itself, and when it sees the next

avant-garde coming, it typically hates it. A lot of people are so entrenched in their status within the experimental-film community, within this medium, that they see whatever next new wave or new technology on the horizon as a threat to them rather than a promotional tool that could help bring their work if not to the masses, at least to the unknown. The avant-garde audience is also the most conservative because the thing they care about most is the designation of being avant-garde—it doesn't have to always be cutting edge as long as it is nonnormative, however conformist that might sometimes be. Being avant-garde is essentially the only status you have because you don't reap any financial gains by making incredibly difficult work. Furthermore, if somebody does anything that leans in other directions or has a populist tone, there's an instant rebuttal from that community.

Lampert speculates that this is because the experimental-film world has long had an inferiority complex to the art world:

There's an inherent bias to the medium itself which is time-based—you're required to sit through the entire duration of a film—as opposed to gallery artists whose works you can walk in and out of at any point. Experimental filmmakers are stuck in theaters making short films that play in group programs, where they have virtually no control over how the works are curated or juxtaposed. Experimental filmmakers made work that was not able to be commoditized, as opposed to visual artists like Robert Morris or Richard Serra, who began treating film as a sculptural material. Even the museum hierarchies reinforce these narratives. If you go to MoMA, you'll find film and video by artists in the main galleries upstairs, whereas experimental film is still shown in the basement theaters. And it's not just MoMA; it's the same across the entire film ecosystem.[6]

● ● ●

Although devoted to Canyon Cinema, Angerame considered it a day job. His real passion was making films, which he continued to do while working there. And in spite of his senior position at Canyon Cinema, like everyone else he was making very little money: "Running Canyon, I realized nobody was really making a living. The most Brakhage ever made in royalties from us was a few thousand dollars a year—impressive, yes, but you can't live off of that." In 2012, unable to respond to the digital onslaught, he was fired by the board. After leaving Canyon, he pulled his own films from Canyon's distribution and began to ponder the next move. "I'm making all this stuff, but I'm not making any money on it. Why not just have people look at the work? I have nothing to lose." His first impulse was to go with commercial streaming services, but the most his Fandor royalty check ever amounted to was $6.95.

"At some point, everybody realized that the work is going to end up on YouTube, so it's better to be on Ubu," Angerame admitted. "Anything is better than YouTube." When I asked him what made Ubu better than YouTube, he replied that it was about caring and context. He was impressed by the fact that Ubu positioned itself as a resource, providing abundant information about the films and filmmakers, which was absent from YouTube. The other thing that impressed him about Ubu was the roster of filmmakers, which in many ways was close to Canyon's. But finally the decision was economic. From his decades at Canyon Cinema, he was forced to admit the dismal financial circumstances of the experimental-film world. Echoing UbuWeb, he confessed that "when you take the money equation out, things become a lot freer."

Angerame uses Ubu as a way to promote his films. "UbuWeb is a service to me. I might as well have people know my work rather than hiding them in a closet." He sends curators to Ubu

to preview his films before they show them in a gallery or theater. In this way, he's seen an uptick in screenings and invitations. And the digital turns out to have worked in his favor: "I get more people coming to my movies in theaters than I ever have before because of the reaction against the digital." And over the years, Angerame has repositioned himself: "I've changed my attitude about UbuWeb. I used to hate Ubu because it was competition. We weren't quite sure if filmmakers were approving the work that was put up on Ubu. We weren't sure if it was pirated or if the filmmakers gave permission. We felt it was like YouTube. We felt that a lot of filmmakers didn't want to have their work presented that way."

It turns out he wasn't the only one.

● ● ●

In 2010, UbuWeb was hacked. I never found out who did it or what happened. One day a bunch of files were gone, and I had to darken the site for a while to rebuild. When the word went out, although many were concerned and saddened, others were relieved. At least that's the message I got from some of the members of Frameworks, the prominent experimental-film listserv. "Ah, this is such good news," crowed one member.[7] Angerame (at the time still hating Ubu) chimed in: "YES YES YES. posting of films on UBU, youtube, and the rest HAS HAS, yes HAS decreased rentals and demands for people to see these works in other ways. it has impacted the entire field. in a negative way. and if it continues the field will not be able to be plowed. I cannot be more clear."[8]

Others felt differently. The video artist Peter Rose, who had approached UbuWeb early on to host his videos, wrote:

I must come to Ubu's defense. Having been rejected by every major video art distributor in the U.S, having at last let go of

the apparently frivolous desire to make any money off of my work, having concluded that the web offered at least some method of broadcasting the work to a larger audience, and having appreciated the opportunities afforded by Ubu to showcase important work to my students, I happily flung 13 titles up onto Ubu and never regretted it. I realize there are copyright and permission issues of substantial importance that have arisen in this context, but I'm not one to be counted amongst those who celebrate their demise.[9]

The film critic Fred Camper chimed in his support for Ubu, elaborating on some of the arguments that Peter Jaszi, Peter Decherney, and Amy Adler make:

Once a cultural product has been put out in the world, and has influenced others, it should not solely be considered the "property" of its maker at least in moral terms, even if, legally, it is, because it has become part of the discourse . . . I was invited to present six programs of Brakhage films in Rio de Janeiro. Nobody could remember the last time Brakhage in prints were in that great city. I carried most of them; some were shipped. The shows went splendidly. And many of the people there told me that their interest in Brakhage had been stimulated by the horrible (and, presumably, illegal) copies they had seen on the "Net." They knew these were bad versions, but were at the least intrigued, and really wanted to see the real thing.[10]

The hacking of Ubu spurred a vigorous conversation about the viability of the extant ecologies of film in the digital age—its financial systems, quality, distribution, accessibility, and privileges or lack thereof. In the end, most people ended up siding with UbuWeb, while noting its obvious faults: my lack of knowledge of the subject featured (true), Ubu's poor quality (true),

and the infamous Wall of Shame (true). I read the thread carefully at the time. It's still worth reading today to grasp the extraordinary challenges the field was facing.

At some point in the early 2000s, I got a 501(c)(3) tax designation for UbuWeb as a nonprofit, thinking that I might apply for some grants. While that never happened, I had to form a board, with Lampert a member. Andy took a lot of heat for joining Ubu's board. Some in the experimental-film world accused him of feeding UbuWeb films from Anthology's vaults. "People would assume that because of the scarcity and type of films you were putting up that places like Anthology were feeding Ubu," he told me. "Absolutely not. I never gave a single film." He's right—they all came from file sharing. But his affiliation with Ubu caused him to absorb every complaint directed at anything digital. "Whether it was Tony Conrad, Dominic Angerame, or Bruce Conner, everyone would come to me and complain."

The irony, Lampert says, is that there are several films on UbuWeb that can't be found or rented from distributors or seen in cinemas. Henri Michaux's *Images du monde visionnaire* (1964), for example, can't be rented or screened, but it can be found on Ubu. Michaux's film, which was intended for the medical profession to demonstrate the visual effects of mescaline, was commissioned by Sandoz, the Swiss pharmaceutical company. Michaux disowned it, claiming that it in no way was representative of what it felt like to take drugs. In an essay describing his experiences with mescaline, he wrote:

> When it was proposed to make a film about mescaline hallucinations, I have declared, I have repeated and I repeat it again, that that is to attempt the impossible. Even in a superior film, made with substantial means, with all one needs for an exceptional production, I must state beforehand the images will be insufficient. The images would have to be more dazzling,

more instable, more subtle, more changeable, more ungrasp-
able, more trembling, more tormenting, more writhing, infi-
nitely more charged, more intensely beautiful, more fright-
eningly colored, more aggressive, more idiotic, more strange.
With regard to the film's speed, it should be so high that all
scenes would have to fit in fifty seconds.[11]

Dissatisfied with the resultant film, he prohibited the film from
ever being screened in public, something the Michaux estate vig-
orously enforces to this day. But the more you try to suppress
something, the more people want to get their hands on it. In
2012, we were slipped a copy of the film and posted it even while
knowing it was highly illegal. The Michaux estate was quickly
alerted to the fact that *Images du monde visionnaire* was on Ubu,
but it never complained, thereby giving us tacit permission. So
while you'll never see this film in the theaters, you'll always be
able to see it on Ubu. The copy we have is good except for one
full minute when an update window from some Mac operating-
system program pops up out of nowhere, completely obscuring
the film. It's a lovely error, a bootleg watermark, and a reminder
that you're not actually seeing the "real" thing (although in this
case the "real" thing is unavailable, somehow making our lousy
copy the "real" thing).

Piracy also can be a form of preservation. The copy that we
have of René Viénet's *Chinois, encore un effort pour etre revolution-
naires* (*Peking Duck Soup*, 1977) is a dub of the only copy that
exists. The film, a collage of archival footage of leaders from the
People's Republic of China, applies the method of situationist
détournement to the genre of the political documentary. Only one
print of the film was ever made, and it was sent to Australia to
be shown and, for reasons unknown, never returned. Viénet tried
to have another print of it made, but he owed the film lab so
much money that it destroyed his negative. Keith Sanborn was

passed a PAL VHS from a friend in Australia—already a very degraded copy—which he transcoded to the analog television standard NTSC (losing yet even more quality), translated it, and slapped English subtitles on it. The copy we host on UbuWeb is an umpteenth-generation copy that Sanborn gave us. It's not great, but at least for the time being it's as good as it's going to get.

Most of the situationist films on UbuWeb are courtesy of Sanborn, who has taken up the task of translating and subtitling the situationists' oeuvre—for no money. It's safe to say that most letterist and situationist films wouldn't be in English if not for his efforts. When I asked him why he would put in hundreds of hours of his time and thousands of dollars in studio editing time to transfer the tapes, he answered, "It was done as potlatch: a conspicuous destruction of time, energy and money. But more importantly, I thought these films had revolutionary potential, that they could change the way we see things."[12] He gave the films to UbuWeb because he wanted them to be distributed without anyone profiting monetarily from them.

Sanborn used his skills as a translator as a way of escaping the confines of his rural upbringing in Kansas. As a teen, he would attend translation seminars in foreign countries each summer and in this way learned half-a-dozen languages. He studied film and media at several U.S. universities, working closely with filmmakers such as Hollis Frampton and Tony Conrad. In 1989, he attended a situationist retrospective at the Institute of Contemporary Art in Boston at a time when the movement was little known in the United States. There, he saw René Viénet's *La dialectique peut-elle casser des briques?* (*Can Dialectics Break Bricks?*, 1973), which overdubs a cheesy kung-fu flick with Marxist jargon, turning the fighting scenes into metaphors for class struggle. Intrigued, Sanborn set out to find a copy to translate into English. He found a bootleg VHS floating around that had

been transferred so many times that the color had washed away, virtually turning it black-and-white. It's a complicated film to translate, so rife with arcane cultural allusions and complicated wordplay that it left him perplexed. He and another situationist scholar spent hours poring over the tape, which required an enormous amount of research, a feat even more remarkable considering there was little or no internet at the time. The subtitles were burned in by hand using analog technology. When the subtitled film was complete, he showed it to small audiences in San Francisco, taking suggestions from them (who often included a number of French people) as a way to help correct errors. Satisfied that he'd done the best job he could, he set out to become the English situationist translator of record. He began hunting down copies of other situationist and letterist films as well as the films of Guy Debord, many of which he obtained in VHS copies that had been copied off of French television.

Because of the situationists' political ethos, he never sought permission to translate and distribute the films. He knew that Debord had never sued anyone for making bootlegs of his work, and, besides, the Situationist International had always published its works with an effusive anticopyright rhetoric. When someone would approach him about showing the films, Sanborn always made it clear that he had no rights to them, that the inquirer would be legally on her own if she showed the films. He really wasn't after money, offering this person the option of showing the film with no rental fee if she would agree not to charge admission to the screening. Ironically, in all the years during which he circulated the tapes—they showed in a fair number of venues in the United States and abroad—no venue ever took him up on the option of *not* charging admission. Potlatch. Anticopyright. Open distribution. The situationists predicted the way that media would flow on the networks. Andy Lampert muses, "When I think back on the filmmakers who

complained to me, the real complaints came about quality. My main argument was, 'Don't let Ubu do it better than you. Take this as an incentive.'"

"Take this as an incentive" was my exact response when I penned an open letter to the Frameworks community in response to their discussion:

> I think that, in the end, Ubu is a provocation to your community to go ahead and do it right, do it better, to render Ubu obsolete. Why should there only be one UbuWeb? You have the tools, the resources, the artwork and the knowledge base to do it so much better than I'm doing it. I fell into this as Ubu has grown organically (we do it because we can) and am clearly not the best person to be representing experimental cinema. Ubu would love you to step in and help make it better. Or, better yet, put us out of business by doing it correctly, the way it should have been done in the first place.[13]

So what happened? Nothing. Nobody bothered to build a site the way it was supposed to be built. The grumbling subsided, and now, as I write this book nearly a decade later, UbuWeb—warts and all—is still the only resource of its kind.

3

THE WORK OF VIDEO ART IN THE AGE OF DIGITAL REPRODUCTION

There's a middle-aged, semiretired rare-gem and minerals dealer who lives in a small town in central Arkansas. When he was involved in business, he used to travel for work but never too far—just to do some trade shows around the South and Midwest—but since his husband and business partner died a few years back, he rarely travels. That's fine with him: he's a bit of a homebody and didn't much like traveling anyway. These days he spends most of his time doing dark, smoky graphite drawings of tornadoes, like the kind that haunted him throughout his childhood in the Midwest. He also makes expressionistic self-portraits that communicate the horror he felt when experiencing those storms and maybe even providing insights into his current state of mind. He tends toward periods of depression since the death of his husband, which, coupled with the loneliness, makes it hard to get much done. He doesn't spend too much time on the internet anymore; his machines are outdated, and his semirural connection is slow. It's quite a change from how much time he used to spend there, for, as far as I can tell, most of pirated artists' videos on the web today, including most of what's on UbuWeb, originated entirely from him.

We first met on a private cinema torrent tracker, where I got to know him by his online handle, "videoartcollector," where he was posting mostly rare artists' videos, which I scooped up en masse and reposted to Ubu. One day I backchanneled him to say hello. We struck up a correspondence, and at some point he suggested that I mail him a two-terabyte hard drive so that he could fill it with videos and mail it back to me and thus save me from the arduous process of downloading torrents. A few weeks later, a small package arrived in the mail bearing a return address in Arkansas. When I plugged in the hard drive, I was astonished. It contained only two directories—"Artists" and "Compilations"—both of which were packed with thousands of films and videos. It was hard to believe that this box in my hand contained virtually the entire history of artists' videos, including virtually the entire catalogues of both Electronic Arts Intermix (EAI) and Video Data Bank (VDB), the main video distributors in the United States.

The more I dug into the drive, the more I became curious about this guy. The breadth and depth of his collection were so impressive that I started to wonder how and why he obtained such an encyclopedic knowledge—not to mention a nearly complete set of artifacts—of such an arcane field. After all, the viewing of artists' videos is generally a rare and inaccessible experience for many. In order to see them, you have to be in an urban center; or if you're teaching, you need to have a sizable budget to rent them. It was clear from our correspondence that he was not in either of these situations. I sensed quite the opposite. He struck me as "one of those guys you meet on the internet," an outsider, a fan, an autodidact. So one day I phoned him to find out what his story was.

My assumptions turned out to be correct. videoartcollector (who wished to remain anonymous for this book) speaks with a light southern accent and is a man on a very specific mission.

He's hell-bent on getting video art to everybody who doesn't have access to it free of charge. Unlike for independent cinema, there is no Hulu or Netflix for artists' video. When speaking about the subject, he becomes very passionate. The more he speaks, the more the layers of his southern gentility begin to peel away. With great zeal, he is convinced that his open sourcing of videos has not only enriched the parched intellectual deserts of the internet but in some respects made the world a better place. And he may be right. By my estimation, he alone has ripped, dubbed, and seeded torrents of tens of thousands of artists' videos for the web. He at once feels he is performing a public service and, like many pirates, exudes an infectious glee about getting away with it—another guy sticking it to the establishment, sticking it to the galleries, sticking it to capitalism, sticking it to the elitist art world—all from his living room in "the middle of bumfuck Arkansas," as he calls it.

Born into a large family in a chaotic home under extremely "difficult circumstances," as he describes it, he decided early on that he wanted to be an artist. His first exposure to contemporary art came in high school in the mid-1980s when he came across the book *What the Songs Look Like: Contemporary Artists Interpret Talking Heads' Songs* (1987), in which artists were commissioned to make artworks to accompany the lyrics of the songs. Around the same time, he began taping episodes of *Alive from Off Center*, an American arts television series aired by PBS between 1984 and 1996 that featured a lot of the same downtown New York artists he knew from the Talking Heads book. From his location in the middle of America, with TV as his only conduit, he began to observe the trickledown effect that artists such as Nam June Paik were having on, say, Super Bowl commercials, network news, and MTV.

As a result, he became an obsessive home taper, recording anything having to do with art. If PBS was broadcasting artists'

videos late at night, as it sometimes did, he taped them. When traveling for work, he'd scour local museums, buying all the tapes he could. He'd scan lists of big exhibitions; if a video artist was in a Whitney Biennial, he'd collect that person's works. "I was desperate for any artist working with video. I'd comb the web, magazines, festivals. If they made it to a certain level of visibility, then they must be worth collecting."[1]

He took to Usenet bulletin boards and began posting lists of the mountains of VHS's that were piling up around him. Before long, he was involved in swapping artists' tapes with other collectors. "I had a room upstairs in the house with a bunch of VCRs and stacks and stacks and stacks of blank VHS cassettes that I would babysit for days on end, doing boxes of VHSs that I would send out at my own expense," he told me. "It got so expensive that I eventually had to declare bankruptcy." You could say he was the Johnny Appleseed of pirated internet video art, all done by VHS through the U.S. mail. "I was the clearinghouse for most of the artists' videos that were in circulation on the web," he confessed to me. "I digitized them and spread them throughout the internet. I would send them to anybody who wanted them. I would look for people looking for the works." There was an evangelical aspect to his mission: "If you could get to this stuff, it would open up your mind in ways that would change the way you see the world. I needed to get that to people at any cost. I wonder what it would be like if everybody had access to art. . . ." His voice trailed off. Sighing, he continued, "How different things might've turned for me if I had access to video art—and the internet—when I was younger," hinting at his own failed attempt to be an artist.

His reputation as a bootlegger grew. Soon he began getting requests from universities to supply them with video libraries. A national public university in Mexico, Centro Nacional de Alto Rendimiento, wrote and asked if he would supply it with a

teaching collection that it could in turn dub and distribute to all the satellite campuses around the country. He responded by getting a set of what he considered to be his very best tapes and sent it out to the university, free of charge. He even paid the postage. At some point in the late 1990s or early 2000s, much of what a typical Mexican art student knew about video art was determined by those tapes that videoartcollector sent.

Major artists affiliated with blue-chip galleries soon began sending him VHS copies of their work that they wanted released on the web but were afraid to do so themselves, fearing reprisals from their galleries. By this time, with the internet in full swing, videoartcollector filled the web with those works, posting them to YouTube and seeding torrents of them on every sharing site he could. Sometimes he'd meet famous artists on the web, as when in the mid-1990s he saw a comment that Tony Conrad left on Pipilotti Rist's website asking how he could locate copies of her works. Rist never responded, but videoartcollector did. At the time, he had no idea who Conrad was and assumed that he was just a fellow collector. He emailed Conrad and let him know he had copies of Rist's works, which he would happily rip for him. In return, Conrad sent him a bunch of tapes of his own works—which then, unbeknownst to the artist, were widely shared without Conrad's permission. "What did he expect? Since he knew what I was doing, I have to assume he was okay with me sending people copies of those specific works." Over the years, videoartcollector became a main source of Conrad's pedagogical materials for his legendary video seminars at the State University of New York at Buffalo, mailing Conrad box after box of tapes.

In 2003, the *New York Times* ran a story about video art and file sharing, where videoartcollector is extensively quoted. He is referred to as a "self-taught video art expert" with a collection of 1,500 works that "rivals those of many museums."[2] The article

centers around the format battle between the infinitely repro-ducible medium of video and galleries' attempts to sell artists' videos for astronomical sums as limited editions—a struggle that continues to this day, in particular with Matthew Barney's *The Cremaster Cycle* (1994–2002). videoartcollector's obsession with Matthew Barney began in the late 1990s when he came across a stack of *Art in America* magazines in a thrift shop and read an article written about Barney's *Cremaster 2*, which had just come out. His mind was blown; he had never heard of any-thing remotely like it. He had to have that tape. He jumped on the internet and blanketed Usenet groups, begging for some-one to send him a Barney VHS, which was nearly impossible because Barney adamantly refused to release his tapes commer-cially. But as time went on, they began to leak; the earliest tapes were copies that Barney passed along to friends and artists for "private use," which quickly found their way onto the VHS underground. Before long, collectors who had bought the vid-eos at full price were getting into the act, making copies and passing them along to friends and other collectors, and so crummy dubs of the *Cremaster Cycle* were soon flooding the internet. From that time to this very day, obtaining DVD-quality copies of Barney's *Cremaster Cycle* remains the holy grail of the video-file-sharing community, a feat that not even video-artcollector has managed to pull off (he has DVD-quality files for four out of the five films, but his copy of *Cremaster 5* is still a VHS rip). Barney's series was originally released in an edition of twenty and sold to collectors for $100,000 each. In 2007, Sotheby's sold a single copy of *Cremaster 2* for $571,000. But Barney refuses to yield, informing an interviewer in 2018 that "it's not right for them to be available to be owned in an unlim-ited way after they've been sold in a limited way."[3]

Barney is at odds with many artists these days, who view file sharing as one component of a complex and overlapping

distributive ecosystem. Generally conceived of as tripartite system—file sharing, cinema/museum distribution, and commercial galleries—the newer approach reflects the botched realities of trying to bottle an infinitely reproducible medium. Back in the mid-1990s, my wife, the artist Cheryl Donegan, when pressured by galleries to shoehorn her video works into one-of-a-kind artifacts, demurred and instead put her videos into open distribution, feeling it was more honest to the medium.

She recalled when one day in the early 1990s she was walking down the street in Soho, and a woman came up to her and said she'd seen one of her videos in a bar in Berlin. This woman was thrilled to see Donegan's work in this casual context. But Donegan's stomach dropped: "I thought: How did that happen? Who got the tape? How did they show it? Who did I give it to? Who did they give it to? Was it a copy of a copy of a copy?" It was then that she had the sinking feeling that she couldn't keep track of things. Yet this woman seemed so excited and enthusiastic that Donegan began to question her own assumptions: "Maybe a lot of people saw it, or some young artist was remixing it. And I thought, well, maybe this isn't so bad. Maybe it was a good thing to be part of instead of being afraid of it and seeing it as a loss. And I just sort of relaxed into it."[4]

At the time, Donegan was working with commercial galleries and using the services of EAI, which distributed tapes to institutions in addition to offering duplication and preservation services. The Berlin story made her realize the value of a third system—a grassroots fandom that eventually found its full form on the internet. She came to feel that these various distributive systems didn't have to conflict with one another, but that each served a unique purpose and audience. The more she thought about it, the more she felt that video has been mislabeled a "medium." She began to see it instead as a storage facility or a container: "I've always compared it to water because it takes the

shape that it's poured into. If you pour it into a phone, it's going to take the shape of the phone; if you pour it into the screen, it's going to take the shape of the screen; if you pour it into a projection, it's going to take the shape of the projection. So, like water, it just kind of seeks its level. Video's true level is to distribute and to flow."[5] She saw the distributive possibilities as being equally liquid: if your video is flowing into a museum, then you use EAI; if it's flowing into a gallery, you work commercially; and if it's flowing through the web, you use internet channels.

The artist Pierre Huyghe feels the same way. He says, "For videos, editions are fake. When Rodin could only cast three sculptures of a nude before the mold lost its sharpness, it made sense. But all my works are on my hard drive, in ones and zeros." Yet his dealer, Marian Goodman, sees things differently, selling "signed" and "certified" copies of Huyghe's videos for prices that as early as the 2000s were in the high five figures. When confronted with Huyghe's statement, the gallery responded that limited editions represent a "logical, established tradition which makes that possible."[6] But Donegan questions if that tradition was either established or logical with respect to video: "The way video is positioned in the gallery system is problematic. It isn't a unique object, which becomes more precious over time. But it isn't a sculpture either, from which a limited edition of copies could be made. Video was meant to be copied endlessly, especially when it went digital. And the digital, with its water-like qualities, is riddled with gaps, which the galleries and collectors paper over. Ever-escalating prices for a single-channel video struck me as absurd." She continues, "I've always had this patchwork of systems which don't, in fact, line up. I think there's no uniformity to it. Video is an incoherent medium, which is one of its beauties." Commenting on Marian Goodman's response to Huyghe, she says, "So how can you get upset with an artist

who is 'using it wrong' when there's no 'right' way to do it? How can you have a completely un-thought-out position which you then proceed to enforce vigorously, one which is based on received ideas and [a] status quo that the nature of video itself defies?"[7]

● ● ●

About a decade ago I was asked to curate an evening of film and video from UbuWeb by the Walter Reade Theater in Lincoln Center. Naturally, I was flattered and agreed, but I had only one stipulation: that they show AVIs or MP4s downloaded from the site. They hemmed and hawed about how the quality of such small files might not hold up on such a large screen but ultimately concurred. The other thing I insisted upon, following Ubu's ethos, was that no money be charged for the screening, nor was I to be paid a fee. The big night came, and the theater was packed. I stood up in front of the audience and told them exactly what was going to happen: they were about to see a series of great films in the worst quality imaginable. There was some grumbling in the audience. I continued, saying that the reason I was doing this was to demonstrate the value of high resolution and good distribution. I wanted to say, in essence, that UbuWeb or the internet had no chance of killing the cinematic experience, which at the time was still a big fear. I told them this is proof that we need distributors such as EAI and big-screen theaters like the one we were sitting in that night. After my talk, there was scattered faint applause—and then the show began.

Although I was warned how bad the screening of the films would be, I had no idea that it was going to be this bad. Each pixel was the size of a piece of plywood; even if you squinted your eyes, you still couldn't make out an image. It was as if the screen at the mighty Walter Reade Theater had turned into a giant moving JPEG, reminiscent of the oversize pixelated

photographs that Thomas Ruff prints out from tiny JPEGs he grabs from the web. The sound was no better: muffled and garbled, it was barely audible. It wasn't long before people began trickling out, which soon turned into a stream, ending in a torrent of exiles. Within the first thirty minutes, the theater was empty. We stopped the program then and there, a full ninety minutes before it was scheduled to end. People were eager to see these films, so they left perhaps frustrated and disappointed. Fair enough. No one paid, so no one asked for their money back. But, for me, this experimental screening was an exercise in how once again UbuWeb is not a substitute for either meatspace-based cinema or video.

A few weeks later I got a call from Lori Zippay, then director of EAI. Lori and I are old friends (Cheryl's videos have been represented by EAI for decades), and she was concerned about how much EAI stuff was ending up on UbuWeb without its permission. She requested a face-to-face meeting to iron out these issues. When I arrived at EAI's Chelsea offices, Abina Manning, the director of VDB, was also there. They began by telling me that I was eating into their businesses. Humiliated, I listened silently, my head bowed, staring at my shuffling feet. Then there was a long uneasy silence that seemed to go on forever; when the conversation resumed, their tone had changed. In a 180-degree turnaround, they told me that as much as UbuWeb was harming them, it was also helping them. They explained that although Ubu was causing them to lose business, an equal amount of traffic was also coming to them because institutions could preview their works on UbuWeb, which ultimately converted into sales and rentals for them. They went on to explain that they were besieged, taking flak from all sides. The galleries were upset with them because they were distributing in open editions what the galleries were trying to pass off to collectors as unique. The educators were upset with them because they were

charging what they felt to be exorbitant rental fees for stuff that was going to be used in the classroom. And the free-culture people were upset with them for being, well, profitable nonprofits. By aligning with UbuWeb, they were able to deflect the heat they were getting from free-culture proponents by saying that a large percentage of their material was in fact offered for free on Ubu. But no matter what they did, the galleries, still wedded to the notion of the singular masterpiece, remained both hostile and perplexed. After some discussion, we made a deal. They would survey their artists and ask them if it was okay to have their stuff up on UbuWeb, and I would remove the works of those who were not comfortable being there. A week later I received a small list from each distributor with artists whose works were to be removed, which I did immediately. A decade on, this arrangement has been working well. In all, about fifteen artists' works were removed from our site. Like Anthology Film Archives, neither EAI nor VDB gave UbuWeb any videos, and they haven't to this day. Everything on the site came from file sharing or was material that artists gave directly to me. Unconventional, yes, but this arrangement was a first crucial step in the ways that legal and semilegal/gray zones could work in tandem to benefit all.

In the beginning, like the experimental-film world, EAI and VDB had assumed that UbuWeb was cutting into their bottom-line rentals. Then they went to a library conference and discovered that the problem wasn't Ubu at all. Rather, the way libraries had been purchasing videos had changed. EAI and VDB's revenue stream—attained by charging hundreds of dollars for each disc, one DVD at a time—had begun to dry up. When the libraries stopped buying the DVDs, EAI assumed that it was because much of that same material was available online in places such as Ubu. However, what they discovered was that libraries were gravitating toward streaming subscriptions and in the late

2000s began paying organizations such as Kanopy a flat fee to have access to a huge database of titles. In response, EAI subsequently built its own subscription model and began offering bulk screening services for educational institutions, which could be as small as a fee per course or access to its entire catalogue for a year. Unlike with Ubu, in this way the students get full-length, high-resolution videos of verifiable provenance, along with the assurance that they are seeing the best, most authentic versions available.

Echoing Donegan, Zippay told me that the field of moving-image distribution has now splintered into a Venn diagram of overlapping but distinct economies. What initially seemed like one big knot gradually became untangled, resulting in several distributive threads, each with its own history, philosophy, and economy. Whereas at the beginning there were accusation and recrimination, today we have acceptance and reconciliation. As Zippay puts it, "None of us are going to cease existing. We're always evolving. We can't afford to be stagnant because conditions—the art world, technology, and artists—are changing constantly. Each of the parallel ecosystems have their own demands—different contexts, different audiences, different venues, and different display modes—which are all part of the current reality of our moving image ecosystem."[8]

In order to distinguish itself from, say, UbuWeb or the commercial galleries, over the past decade EAI has begun pitching itself as artisanal boutique shop catering specifically to the needs of institutions. It's a booming business: in the face of lousy bootleg online video (UbuWeb being a prime example), institutions have distinguished themselves by showing or making available high-resolution, top-quality video. So when MoMA does historical re-creations of video installations that attempt to replicate the conditions and technologies as close as possible to those extant when the videos were first made, they go to EAI to get

the tapes. Today it's a given that most of the artists on EAI's roster place their works in all three ecosystems, the way Ryan Trecartin—an EAI-affiliated artist—did more than a decade ago when he emailed UbuWeb asking if we would host his works. At the time, YouTube limited videos to ten minutes, and his works were much longer. Naturally, we said yes, which began a long relationship in which each time Ryan would make a new video—be it for a gallery installation or for open distribution via EAI—he would also toss us a copy of it to host. He was born in 1981, so, as for many artists of his generation, his aesthetic was informed by the web; it would be weird to him to show a video for sale in a gallery and not have it available online for free at the same time.

● ● ●

When I first met Seth Price in the early 1990s, he was working at EAI dubbing and editing tapes. He had just gotten out of Brown and was doing what every artist does when he or she first comes to New York: working a day job. But it was a good day job. He met all sorts of amazing video artists. Price listened carefully to the conversations going on in the editing booths at the time, and when he embarked on his career as a visual artist, content and its relationship to various forms of distribution became a focus of his work. In a way, his artworks demonstrate and embody the sort of flexibility emblematic of the digital age. Price was inspired by the fluidity of Robert Smithson's *Spiral Jetty* (1970), which takes several material forms: a film, a sculpture, and an essay. Price saw it as the prototype for a flexible artwork, one that was always in flux, appearing in various versions— like water, as Donegan says, flowing through various distributive channels. Price says: "You can read the essay, you can go to the sculpture, and you can also see a film. And they're all called *Spiral Jetty*."[9]

Price enacted Smithson's ideas when he published his essay "Dispersion" (2002) in various forms—as a free PDF, as a self-published chapbook cum artwork that he sold for $10 a copy at museum shops, and as an artwork shown in a commercial gallery. Like a DJ, Price opened up his text to various remixes. The title of the webpage where those remixes are hosted, "This Version," is a riff on the essay's title, "Dispersion."[10] The webpage for the project boasts seven translations of the text—some of which have their own cover and layouts—as well as a series of chapbooks that Price made, each illustrated with handmade, spray-painted colors and each a unique object that sells for many times the price of the trade edition. There's also a link to a funky "Ukrainian Art Student Bootleg" as well as images of his fine-art version, where the identical cheap chapbook is blown-up large, divided into eight spreads, and printed on Price's signature vacuformed plastic sheets, with embossed ropes snaking through the texts.

In contrast to Barney's rigid hierarchical notions of property, value, and singularity, the various forms of "Dispersion"/*Dispersion* propose a different scenario: "Suppose an artist were to release the work directly into a system that depends on reproduction and distribution for its sustenance, a model that encourages contamination, borrowing, stealing, and horizontal blur." Price is not a free-culture freak; he's happily invested in both culture and capital, with one foot in the lucrative art world and the other in file sharing and remixing. He proposes a twenty-first-century response to Marian Goodman's ideas of singularity: "New strategies are needed to keep up with commercial distribution, decentralization, and dispersion." And he calls into question the effectiveness of uniqueness: "A popular album could be regarded as a more successful instance of public art than a monument tucked away in an urban plaza. The album is available everywhere, since it employs the mechanics of free market

capitalism, history's most sophisticated distribution system to date." His is a digital solution: "With more and more media readily available through this unruly archive [the internet], the task becomes one of packaging, producing, reframing, and distributing; a mode of production analogous not to the creation of material goods, but to the production of social contexts, using existing material." Yet his brand of democracy doesn't work for all. Speaking of why his distributed ideals work, Price checks his privilege as a highly successful gallery artist, something afforded to a few: "Anyone can decide to sell an essay for thousands of dollars but you need to have a presence in all three of those economies in order to be able to demonstrate that they work together."[11]

Price is interested in diversifying and cannibalizing his own videos to highlight his ideas of distribution, which manifest themselves as self-referential, self-reflexive, hall-of-mirrors artworks. For his work *Digital Video Effects: "Editions"* (2006), he took eight videos that had previously been sold as individual artworks to collectors and used them as raw material. He cut them up and made an abstract video out of them, which he then transferred to a singular 16mm film and showed it in a gallery. Then he made a video version of the film that was simultaneously given to EAI to distribute widely. The irony was that Price's film was purchased by collectors who don't own a 16mm projector, so they asked for the video version in order to be able to experience the work immediately. Price's piece is a demonstration of Donegan's idea that video is not a medium but a container, shapeshifting and conforming to whatever it encounters, even film.

But it gets more complicated. Price is also a musician, who, like many musicians, has made music videos that he posts on YouTube. He wasn't really thinking of them as art, but when an opportunity for a show came up in a gallery, and he didn't have any work ready, he offered them his music videos. Because they

were already available on YouTube, he insisted that they be an unlimited open edition and that if a collector wanted to buy them, he or she had to purchase them as a set. He set up individual viewing booths as sculptural elements and let the videos run. They went unsold. The earlier YouTube postings prevented the collectors from seeing this body of work as having any real future investment value (If everyone can have it, why should I buy it?). When the videos were shown a few years later in his film and video retrospective at the Institute of Contemporary Arts in London, a reviewer wrote that the videos were appropriated—which they weren't; Price lovingly crafted them, with original music and original footage, as sincere music videos. But the framing of works in a common format confounded the critics as well as the collectors, all of which Price had planned as a critique of format and distribution models in the digital age.

Like Zippay, Price doesn't see these overlapping economies as conflicting with one another. If an institution is aware of video art and its history, and it wants to show Price's work, it would contact EAI. If a museum is doing a group show that involves installation, sculpture, and painting and wants a video by him, it might not even know about EAI and go straight to the gallery that represents him. Other times people will randomly contact his studio, which will burn or rip whatever is appropriate for the venue. Pirate venues will often grab bootlegs of his work off the web and show them without seeking permission.

In *Dispersion*, Price writes that "an entire artistic program could be centered on the re-release of obsolete cultural artifacts, with or without modifications, regardless of intellectual property laws."[12] It's here that distribution and archiving collapse into one practice. Price enacted this stance in his ongoing audio project *Title Variable* (2001–). Five editions have been released so far as CDs, LPs, cassettes, and MP3s. By rescuing obsolete music

made by obsolete technologies, Price turns archiving into an artistic practice. For one CD compilation, for instance, he snagged MIDI (Musical Instrument Digital Interface) files of video-game soundtracks from old internet bulletin-board systems, where they were shared by video-game fanatics as pieces of fan-boy culture. Price thought it was odd that no commercial CD compilation of these soundtracks was ever made, so he decided to make one. By merely moving the identical material from one format into another (the "transformative turn" enshrined both in copyright law and by Duchamp), the soundtracks, which at the time weren't thought of as "music" or "art" became both when Price reformatted and reclaimed them.

For other versions of *Title Variable*, he researched genres that had been overtaken by new technologies and thus rendered obsolete. He then reassembled these once-beloved but now defunct genres into CD compilations. They were so out of date that nobody would ever buy them if you tried to sell them in a record store but not out of date long enough to come back into fashion again. They were in an odd cultural limbo, which is exactly the point that Price wished to make. For example, in 2003 he downloaded all examples of New Jack Swing—a genre that hip-hop had blasted into obscurity—that he could find and compiled them as a CD/artwork, resulting in an unloved and unwanted compilation of artists already relegated to the trash bin of musical history. Although the compilation has no commercial value, as a gesture it hits Price's sweet spot—transforming the unloved and forgotten into an artwork. Although it might not look like "art," as we conventionally think of it, through it Price invokes a long history of recontextualization that stretches back to Duchamp's urinal, where the simple act of moving an object from one context to another and calling it art is a valid artistic gesture. But instead of with objects, Price is doing this with

preexisting cultural artifacts. After making several other compilations as artworks, he called his final project in this series *8–4 9–5 10–6 11–7*, an eight-hour mix of cheesy, goodtime, light disco and chill music. Again, this compilation wasn't so much about the music as it was about the fact that at that time an eight-hour mix was impossible to make with conventional audio equipment (in 2005, Price had to use video-editing software to create it), and even if you could, a CD then could hold only an hour or so of music at most. Price highlights the simple idea of duration as artistic practice. His mixtapes as artworks extend McLuhan's idea of medium as message, this time with the emphasis on container as message.

With Price, the problem is quantity—there's too much to consume. When the digital can contain anything, the notion of format is an obsolete one. Price points to the fact that today everything is apparatus, a sea of citation—tweets, retweets, shares, and likes. The web archive is completely formatless and formless—infinitely expansive, predictably stable, and staggeringly boring. In the midst of it all is Price, moving content from one place to another, questioning the work of art's status in the age of digital reproduction, pondering whether the death of the format might be the death of art.

Price's efforts resonate with Ubu. We, too, obsessively collect and archive materials in commercial or artistic limbo (too obscure to sell, too important to let vanish). Living somewhere between art histories and ephemeral media, we're not really sure exactly who the audience for our collections is, but we certainly sense that such an audience is out there. And beyond audience, there is a kind of completist drive that compels us year in year out to keep accumulating, with the hope of completeness (impossible) or at least the illusion that there is so much of it that it feels complete. Like Price, we're interested in the deep crevices or

ruptures of culture, salvaging artifacts from the shadows to prevent them from disappearing in the darkness of noncommerciality. Inspired by Price, gathering and collecting for an unknown but certain future, we'd rather have these artifacts be included in the "memory of the world" rather than be forgotten forever.

4

SHADOW LIBRARIES AND PRESERVING THE MEMORY OF THE WORLD

In the fall of 2018, the University of Louisiana at Lafayette listed an electronic textbook for a class called "Accounting 202" for $999. When there was a public outcry, the university tweeted: "We're sorry that the price for the Acct 202 online text has caused so much strife & are working with the publisher to lower it to match the hard copy cost. The $999 price was set w/ good intentions, though we realize now that we needed to explain the rationale behind it better." Their rationale? "Acct202 requires students to have a hard copy of book pages in class to work with—so they would have to print large sections of the online copy. Our intention was to encourage students to get the hard copy so they would avoid having to print so much. We will do better next time."[1] With a ream of paper costing around $5, the $999 price tag would be the equivalent to printing 200 reams of paper, in other words 10,000 sheets. The price of the paperbound textbook that the college was trying to persuade students to buy was $313, approximately double the cost than the national per class average for textbooks, which is around $154.[2] Is it any wonder that students prefer to pirate their textbooks?

Over the past few years, the term *shadow library* has emerged to describe vast digital repositories of publically accessible

intellectual materials. A mixture of legitimate and pirate venues, they have grown out of necessity, providing access to electronic copies of millions of copyrighted and uncopyrighted works to anyone around the globe free of charge. As library budgets have been slashed and materials have been deaccessioned, finding what you need in a public library isn't as easy as it once was. Combined with the rise of Amazon and the fact that there are few physical bookstores anymore, people hungry for certain types of texts have been shut out. To make matters worse, commercial academic-publishing giants have gobbled up knowledge, selling it at a high price; by restricting access only to people with institutional affiliations, they leave many others out in the cold. Writing about academic publishing, the library scholar Jonathan Basile says,

> While individuals have always been priced out of this market, libraries are increasingly unable to afford these texts as well. The culprits in this story are not the university presses, but rather scientific journal aggregators like Elsevier, which owns thousands of academic journals and sells subscriptions to university libraries at prices that keep their profit margin close to 40 percent. Meanwhile, the budgets of these libraries have stagnated due to government spending cuts and questionable priorities at some universities.[3]

Enter the shadow librarians. A whole bunch of people are worried about the erasure of certain sectors of knowledge, and, like the book memorizers in *Fahrenheit 451*, they are rushing to preserve what one shadow-library group calls "the memory of the world." Although many shadow libraries have been threatened by legal suits from both individuals and the publishing industry, they keep popping up in different forms, sometimes with different URLs, other times with multiple mirrored sites.

It's hard to eradicate what's grown out of need. "As long as there is a substantial difference between what is legally available and what is in demand," the media theorist Balázs Bodó writes, "cultural black markets will be here to compete with and outcompete the established and recognized cultural intermediaries."[4]

Although UbuWeb isn't exactly a shadow library, it shares many ideals with the shadow libraries. In fact, several shadow libraries are UbuWeb's partners, which lend us technical, infrastructure, and moral support, and for the past five summers we and the shadow librarians have met in Zagreb for intellectual activities and conferences. The group is usually made up of assorted members of Memory of the World / Public Library, Monoskop, the Artists, Architects, and Activists Reading Group (AAARG), Pirate Cinema, oxDB, textz.com, Custodians Online, Constant, MayDay Rooms, and UbuWeb as well as of an ever-changing cast of sympathetic academics, artists, architects, and writers. All of us share server space, artifacts, and philosophies throughout the year, but it's during those summer meetings that we get to catch up and hash out issues in person, face-to-face in ways that are nearly impossible over the academic calendar year. Every summer I am reminded of the Custodians Online truth that you don't need complicated protocols, digital currencies, or other proxies. You need people who care. These are the people who care.

Part 1: The Pirates

Memory of the World / Public Library

Marcell Mars looks like a pirate. Tall and thin, he walks with a swagger and dresses in blue-striped Russian sailor shirts, baggy pants, and sandals. His impish face is engulfed by a cascade of

dark hair that when swept to the side reveals ears studded with multiple rings and piercings. He's got a great big black beard that would overwhelm his face if it weren't counterbalanced by a pair of equally thick, arched, dark eyebrows. He pens manifestos in secondhand English, peppering them with slogans such as "Private property can and should be permanently questioned, challenged, and negotiated" and rambling utopianisms such as "There is a dream. Dream of universal access to knowledge for every member of society. Dreams rarely come true but this particular one: universal access to knowledge for every member of society got embodied into: public library! [*sic*]."⁵ He was raised in the former Yugoslavia, so the Communist ideals of shared culture come naturally to him, and he's on a mission to bring them into the digital age.⁶

Along with Tomislav Medak, Dubravka Sekulic, and dozens of other amateur librarians, Mars runs a Zagreb-based organization called Memory of the World / Public Library. Reacting to funding cuts for public libraries, the group—consisting of hackers, architects, artists, and critical theorists—builds free, globally accessible shadow libraries. Patterning themselves on the thinking of hacktivist Aaron Swartz (1986–2013), they focus on academic publishing, in particular academic journals and repositories. Swartz's "Guerilla Open Access Manifesto" (2008) provides the foundation for many of their activities: "Those with access to these resources—students, librarians, scientists you have been given a privilege. You get to feed at this banquet of knowledge while the rest of the world is locked out. But you need not—indeed, morally, you cannot—keep this privilege for yourselves. You have a duty to share it with the world. And you have: trading passwords with colleagues, filling download requests for friends." The Public Librarians take Swartz's manifesto as a challenge—if you have access, you have a responsibility to share with those who do not: "With enough of us, around the world,

we'll not just send a strong message opposing the privatization of knowledge—we'll make it a thing of the past. Will you join us?"[7]

Memory of the World / Public Library emerged from the rubble of the former Yugoslavia in the 1990s. Mars, a self-taught hacker who along with a few other people opened Zagreb's first cybercafé in 1996, was part of an effort in 1999 to build a cultural center called Multimedia Institute/MaMa in a tumbledown former leather shop in a Zagreb alley. The center quickly became a meeting spot for minorities and dissenting political groups (ecological, LBGTQ, ethnic, feminist) that were being pushed to the fringes of society by the right-wing government. A vibrant place where political activists collided with cyber activists, MaMa was one of the only three independent cultural spaces in Zagreb, a city of more than a million, that provided a physical site for political resistance in the wake of the Yugoslavian civil war. As the tide of nationalism subsided in the 2000s, MaMa shifted its focus to address issues of capitalist globalization by creating independent media channels and staging public programs and workshops. MaMa continues to this day, presenting a vast array of cultural programs, including film festivals, lectures, hackathons, reading groups, concerts, exhibitions, literary salons, and digitizing workshops—all free of charge and open to the general public.

The Public Library's online wing is Memory of the World, a website founded in 2016 and dedicated to the dissemination of free books. It is a "public library" in the truest sense of the word. Its manifesto states:

> A public library is:
> - free access to books for every member of society
> - library catalog
> - librarian

With books ready to be shared, meticulously cataloged, everyone is a librarian. When everyone is librarian, library is everywhere [*sic*].[8]

As of this writing, the Public Library hosts more than 150,000 EPUBs and PDFs, both in print and out. Each "librarian" acts as a curator and specializes in a specific field—art, critical theory, political science, history, feminism, and so forth. Mars claims that human filtering creates the best signal-to-noise ratio in ways that algorithms aren't capable of: "It's easy to build an archive of millions of books by scraping the web, but it's the human intervention that creates value." He fondly refers to the Memory of the World team of librarians as "amateurs," who volunteer their time—no money exchanges hands—and work to enrich the digital ecosystem for the public good. "In our view, amateur librarians are complementary to professional librarians, and there is so much to learn and share between each other. Amateur librarians care about books which are not [yet] digitally curated with curiosity, passion and love; they dare to disobey in pursuit for the emancipatory vision of the world which is now under threat."[9]

The Public Library began shortly after the Gigapedia (2007–2010) shadow e-book library was shut down, a painful reminder of the fragility of such archives. Inheriting a collection of thousands of digital books from a volunteer "librarian," the Public Library was conceived of as a memory bank for cultural artifacts that without some sort of intervention might simply vanish into thin air. The library's mission states:

Libraries frequently don't have the right to purchase E-books for lending and preservation. If they do, they are limited by how many times—26 in the case of one publisher—and under what conditions they can lend them before not only the license

but the "object" itself is revoked. In the case of academic journals, it is even worse: as they move to predominantly digital models of distribution, libraries can provide access to and "preserve" them only for as long as they pay extortionate prices for ongoing subscriptions. By building tools for organizing and sharing electronic libraries, creating digitization work flows, and making books available online, the Public Library project is aimed at helping to fill the space that remains denied to real-world public libraries. It is obviously not alone in this effort. There are many other platforms, some more public, some more secretive, working to help people share books. And the practice of sharing is massive.[10]

Massive is right. Memory of the World's underground network of rabid free-culture hackers collectively have access to nearly every physical and virtual library in the world. One of their "librarians," who goes by the name "Slowrotation," specializes in art and has contributed more than 50,000 books to the site. Living "somewhere in rural America"—it's hard to get specifics for the shadowy underground—he works twelve hours a day, every day, procuring books exclusively for Memory of the World's archive. Sometimes he gets his materials by trolling Instagram for students who haphazardly post their university IDs online. He then goes to their university libraries, makes fake library accounts under their names, and downloads everything that he deems worthwhile. He then removes the items' copyright protection and posts them to Memory of the World. Positioned at the center of a vast array of shadow-library hackers, Slowrotation swaps materials with his pirate peers and uploads them to Memory; since everyone is working anonymously, nobody gets either rich or famous.

Although Memory of the World uploads a lot of EPUBs, it also makes a huge effort to digitize books that haven't been

digitized yet. Sekulic is also a "librarian," specializing in books on feminism, space, architecture, race, urban riots, and social justice. She digitizes most of the books she uploads by taking rare books out of the library or off her shelves and scanning them using a homemade scanner. Taking anywhere from two to four hours to make a neat and searchable digital file, she tries to digitize and upload at least one book a week. When she's not doing that, she's enriching the archive by uploading pirated digital editions that relate to her interests.

Sekulic's scanner is one of eight handmade book scanners built by MaMa that anyone can use. Beginning in 2013, Memory of the World embarked on a project called Katalog oslobođenih knjiga (Catalogue of Liberated Books), centered around digitizing books that were thrown away from Croatian public libraries during the ideological cleansing of the 1990s. The books were focused mostly on subjects such as socialism, communism, and antifascist literature that the newly formed government wanted eradicated. To date, more than 1,000 titles have been preserved. Without Memory's intervention, most would likely have vanished. For Memory of the World, pirating, scanning, sharing, and archiving are defiantly political acts. Every so often the group brings these ideas into museums and galleries. In 2012, its members did a show at an art space in Ljubljana where they made more than a million electronic books available to everyone who walked in the door. The bulk of the files were grabbed from Library Genesis, which allows anyone to download its holdings en masse with a single click.[11] Although nobody could take all of what Memory had to offer at the show—the files amounted to more than eleven terabytes—the exhibition was both a potlatch and a reminder of also how easy it is to mirror or build a shadow library.

In 2014, Memory of the World staged a Public Library event in Stuttgart called "Herman's Library," a collection of books

selected by the incarcerated Black Panther Herman Wallace as being influential to his political education. In 2003, Wallace was serving a life sentence in solitary confinement in the Louisiana State Penitentiary in Angola, accused of murdering a prison guard, when an art student named Jackie Summell struck up a correspondence with him. Acting on a prompt from a professor to ask an imaginary prospective architectural client to describe his or her dream house, Summell wrote Wallace out of the blue: "What kind of house do you dream about after all these years in a cell?" This initial query kicked off an eleven-year collaboration, consisting of more than three hundred letters and culminating in a coauthored book. Through their correspondence, they dreamed up his fantasy house, imagining what its layout would be, how it would be furnished, what the grounds would look like, and so forth. Later, as they got into the nitty-gritty details, Summell asked Wallace what books would be on his bookshelves, to which he responded with a list of 111 books that were responsible for his political awakening. He was released from jail in 2013, after his conviction was overturned, and died three days later. The next year Memory of the World digitized Wallace's entire dream library in full-text versions, ranging from *Roget's Thesaurus* to Albert Speer's *Inside the Third Reich* to *The Collected Works of Lenin*, all of which anyone can download.

Whereas MaMa is funded through a combination of international and Croatian grants, Memory of the World, a pirate site, is trickier. Financed with a few Bitcoins that Mars picked up cheaply in the early days, the project is supplemented by lectures, exhibitions, and workshops across Europe focusing on radical library practices. Takedown notices don't bother Mars. He just ignores them or uses them to highlight the schizophrenia in the publishing industry—as when a few years ago he and Medak were asked to contribute a pro-piracy essay to a university press anthology about tactical media. They signed a contract

and, as is often the case, were not paid for their contribution. A couple of weeks later Memory of the World got a takedown notice from the same press for another book Memory was hosting on that exact subject. It was an example of how, in Mars's view, academic publishers use sharp swords to cut twice—the denial of wage and the denial of access—in order to enact a chilling effect on the free movement of ideas, which only further enrages Mars: "It's worth the risk [to pirate copyrighted printed works] because of what I stand for," he says. "If you want me in jail because I'm sharing books, then fuck this world. I want to be outside of that and challenge it with the best articulation. There are very few areas in which an individual can intervene in such a powerful way. And this is one of them."[12]

Monoskop

Dušan Barok is an accidental custodian. He stumbled into building Monoskop—which, along with UbuWeb, is one of the largest shadow libraries of free avant-garde materials on the web—as a way of keeping track of his reading and browsing as a student. If he was studying a topic such as Dada, he'd go around the web, collect everything he could about it—academic papers, films, MP3s, and so forth—and upload it all to a wiki for his reference, which he also kept open for the public. Over time, that wiki became Monoskop.

Barok is one of those eternal students. At forty years old, he's getting yet another degree—his fourth—for the simple reason that in Europe they keep giving him academic grants to build Monoskop. It's a great deal: year after year he's paid to update his site and accumulates degrees while doing it. As part of his research, he uses Monoskop as an intellectual diary of sorts, a by-product of his interests, obsessions, and digressions. Working without an agenda and going on intuition and whims, Barok

isn't trained as an art historian, nor does he profess that Mono-skop is in any way comprehensive or "correct." Like UbuWeb, it is full of omissions and personal biases, at once an idiosyncratic record of one person's intellectual drifts—a subjective personal library—and a publically accessible warehouse for specific types of knowledge.

Originally focused on central and eastern European media art and culture, Monoskop was founded in Slovakia in 2004 as a listings site for art and academic events across eastern Europe. In 2009, a friend showed Barok Gigapedia, which contained a number of books on media art and network culture, so he used it when doing research for a book on eastern European art. He downloaded everything he could from Gigapedia, sharing these materials on Monoskop in the event that Giga-pedia should go down, which it did a year later. He began post-ing all his research for his book—notes, bibliographic entries, chapters, even full books—on Monoskop. He eventually gave up on the book, feeling as if the subject were too big to fit between two covers, swapping it instead for Monoskop, which could expand in all directions. From 2010 to 2012, he got his second master's degree at the Piet Zwart Institute in Rotterdam in the networked-media program. One of his tutors encour-aged him to develop Monoskop—then still a hobby—into his thesis project. After he graduated, with his tuition paid by the Dutch government, Barok did nothing but work on Monoskop every day, from the moment he woke up until the moment he went to bed.

There's no real logic to the site; everything there is there because for whatever reason Barok found it interesting. If he gets curious about something and he wants to learn about it, he builds a page about it. For instance, a few years ago he got interested in neoism, an underground art movement influenced by futur-ism, situationism, Fluxus, and punk rock that began in the late

1970s. When researching on the web, he found bits and pieces about neoism strewn across different sites, but no comprehensive resource devoted to it, so he decided to build one by collecting as many statements, interviews, photographs, and documents from around the web as he could find and centralizing them on Monoskop. Instead of just providing links to them, he placed on Monoskop's servers actual copies of the primary-source materials he grabbed, safely backing them up in case they should happen to vanish.

When building a page on a certain subject, he turns the subjective histories that he finds into objective ones, almost building his own little *Wikipedia*. For Monoskop's page on neoism, for instance, he took an essay off the site of one of neoism's founders that was riddled with subjective bias and retuned it, cooling it down to make it sound more like an encyclopedia entry instead of a manifesto. By comparison to *Wikipedia*'s entry, Monoskop's neoism page is richer—not to mention much better written, which is even more remarkable in light of the fact that English is not Barok's first language. And unlike the *Wikipedia* entry, Barok's has right on the page a ton of primary-source materials related to the movement—magazines, newsletters, books, anthologies, source books, statements, and literature—all in proper bibliographic format.

Barok goes for stuff that falls between the cracks: movements either so obscure or so new that they're unknown outside of a small coterie. Monoskop is full of pages on subjects such as sound art, which is neither concert-hall music nor visual art nor performance art; software art, which lives more in the margins of computer history than it does in the center of art history; conceptual literature, which falls somewhere in between mainstream modernism and conceptual art; and neural aesthetics, teetering on the cusp of art, design, neural networks, and machine learning but not recognized by any of these fields. As these

movements gain credibility and recognition, Monoskop eventually will become the go-to place for information about them.

Drawing his materials from many places across the internet, Barok often stitches together bits and pieces into single files. He haunts sites such as the University of Iowa's Digital Dada Library, which contains complete runs of obscure avant-garde periodicals as well as books, pamphlets, and leaflets. It's an incredible archive. The problem is that every page of every book is posted as an individual JPEG. In order to look at anything, you have to laboriously click through a series of heavy images, one by one. Barok, who is trained as a programmer, wrote a program that goes in, grabs each image, and assembles all the grabbed images into a single PDF, which he houses on Monoskop. Like a hound sniffing out truffles, Barok has a nose for great things buried in vast archives. He plunders stuff from unruly messes such as archive.org and the Open Library, fishing out gems, removing their digital-rights-management protections, and sharing clean, easy-to-read PDFs on his site. When I ask him how he curates his material, he shrugs and says that one thing leads to another. When he runs into dead ends, as he often does, he leaves a page as a stub, which awaits to be populated by future files when he stumbles across them or decides to hunt them down.

Takedowns are rare. Once when the John Cage estate was blanketing the internet with cease-and-desist notices (it predictably got a whack of internet hate for ordering takedowns for his silent piece "4'33""), Barok got a boilerplate notice requesting that he remove a copy of Cage's "Songbooks" that Monoskop was hosting. He responded, "Dear Sir, these books were published a good half century ago and are long out of print. How shall we explain to the community that they cannot even be consulted online? I supposed that providing scanned copies is doing a fair service to the legacy of John Cage."[13] He never heard from the estate again.

AAARG

There's not a day when I don't visit the Artists, Architects, and Activists Reading Group, AAARG, a vast repository of critical theory. Hosting more than 70,000 books and periodicals, it's better stocked than any bookstore, and in terms of its specific content it offers more than my university library does. The range is vast: uploads include Wittgenstein's *Cambridge Lectures*, which he gave between 1930 and 1933; an Australian journal article called "The Vanishing Argument from Queerness" (2008); Koritha Mitchell's piece "Black-Authored Lynching: Drama's Challenge to Theater History" (2014); Kathy Acker's experimental novel *Blood and Guts in High School* (1984); and a full PDF of Govind Chandra Pande's *Studies in the Origins of Buddhism* (2006). And that's just the tiniest tip of the iceberg. Every day there is more and more.

Mind you, these works are not best sellers and are more noted for their historical or academic importance than for their market value. The texts are uploaded by the site's tens of thousands of users, many of whom—like those students angry at being charged $999 for a single e-textbook—lob up course materials, textbooks, and articles they purchased in university. Other people seed the shadow library obsessively in order to enrich its offering. I know several authors, myself included, who upload their books there, knowing they will be received by their ideal readership.

Like Memory of the World, AAARG had its roots in meatspace. The site was started in 2005 as a place to house teaching texts for a free open university run by Sean Dockery and called the Public School, a "school with no curriculum," as a way of providing free education for a global network of folks who were not affiliated with academia. Since then, branches of the Public School have opened in cities around the world. But in time the

online wing, AAARG, grew faster than the school ever could, and Dockery turned his attention to it.

Until I became affiliated with a university more than a decade ago, I was shut out of libraries specializing in critical theory. Sure, I had access to the New York Public Library, but the books available there to an average user were limited to the most famous works by critical theorists and philosophers, whereas the more obscure stuff was locked away in offsite collections in New Jersey. Of course, I could have bought these books from a bookstore or Amazon, but doing so would be very expensive, particularly if I just needed a citation or quote. (But, you might ask, if I just needed a small chunk of text, why not go to Google Books? Because most of what I needed to cite wasn't available—instead I would get a "no preview" or "snippet-text" notice.) So I turned to AAARG. In order to pay AAARG back for what I've gotten from it, I try to upload as much as I can. After this book has its commercial run, I'll upload it. Yes, you could get it on Amazon, but for many the price is out of reach. So for those of us whose research is funded by our academic jobs, the urge to get our ideas out there outweighs the slim financial recompense we often see from our academic publishing. The circulation of ideas propel further opportunities—invitations to present papers at conferences, to lecture, and to teach—which is why many of us choose to upload our books to places such as AAARG. Yes, pirating books jeopardizes university presses, which provide a platform for the circulation of academics' ideas, but I've found with my own books—published by academic presses, commercial presses, and small presses—that after their initial run they tend to fade. My royalty checks, which are small to begin with, quickly dwindle, eventually drying up altogether. At this point, my books have little economic value, either to me or to my publishers, so why not share them? Sharing them makes them alive again. They get quoted and read, which is an author's dream. There's

nothing more depressing to an author than having a book worked on for many years lie dormant after its publication. Pirating and sharing give your books a second life.

Echoing Seth Price, Marcus Boon, author of the blog and book by the same title, *In Praise of Copying* (2013), sees a digital publication as another version or iteration of a print book, one that adds to rather than subtracts from an intellectual ecosystem. He writes, "A PDF of a book is not an illegitimate copy of a legitimate original but participates in other kinds of circulation that have long flourished around the book-commodity: the library book; the photocopy or hand-written copy; the book browsed, borrowed or shared. We all know these modes of circulation exist, as they continue to do today with online text archives."[14]

Over the years, AAARG has run into trouble with publishers, especially academic ones, because it hosts a lot of stuff that's in print and so has been served with cease-and-desist letters. At some point, the site went private, for members only. Invitations, however, aren't too difficult to get. If you have an account, then you can invite anyone to join. AAARG plays cat-and-mouse with legal authorities, often by changing part of its URL: AAARG .org gets an extra *A* on it once in a while, or the domain changes: today it's AAARG.fail.

Despite these dodges, Dockery and Mars have recently been sued by a Canadian author who found his translation of André Bazin's *What Is Cinema?* (1967) had been scanned and uploaded to AAARG by an unknown user. The book was removed each time the plaintiff issued a takedown notice, but nonetheless Dockery and Mars are being sued for $500,000 Canadian dollars. As a result, AAARG has been blocked in certain countries.[15] As of this writing, the case is still winding its way through courts. Initiated by an unaffiliated person, it is being pursued by a single individual with a gripe, about whom Mars says, "Big guys don't go against us, but the small guy does. The AAARG

court case is not about money. We have no money, and they'll get no money from us. And in this way, he's [the plaintiff] just like us. Amazon, Elsevier, and Google are ruining you; we are not your enemies."[16]

Part II: The Institutions

Mars is right: Amazon, Elsevier, and Google are ruining you. But not all institutions are out to ruin you. There are some that function like shadow libraries, using their funding to make cultural artifacts freely available to all. The web is full of places such as Cylinder Audio Archive at the University of California Santa Barbara, which offers more than 10,000 cylinder recordings held by the UCSB Library, both streaming and downloadable at no charge. These sites run by institutions are incredible, and in direct or indirect ways many have partnered with UbuWeb, lending us their server space and bandwidth, making themselves available to counsel us, and sharing a common philosophy that cultural artifacts should be made available to all.

Eclipse / Electronic Poetry Center / PennSound

Sometimes you have to build the library that you want to exist because if you don't, nobody will. Charles Bernstein has constructed three shadow libraries over the past thirty years. Bernstein is an experimental poet and the cofounder of *L=A=N=G=U=A=G=E*, a journal cum literary movement that gained steam in the 1980s based on the Marxian premise that if an author deconstructs a text thoroughly enough, then readers can put it back together in any order they wish, thereby turning readers into writers. Needless to say, it can be obscure and difficult work—many language poems look like little more than a glut

of text, with random words sprinkled across a page waiting to be activated. While there are plenty of precedents for this type of literature, they're very difficult to find and are either self-published or released in tiny editions by independent presses.

In 1987, Bernstein began photocopying these types of chap-books and texts from his own collection, listing them in small, hand-typed catalogues, and selling them via the post. He also went to independent bookstores in New York City, which would take a few on consignment. He hardly sold any, but it was the only way to get these books and magazines into the stores. Charging five cents a page (the cost of a photocopy back then) plus postage, he'd provide interested readers with odd experimental poetry and relevant critical writings. Bernstein felt it was republish or perish: by keeping these works in circulation, he wanted to ensure they weren't forgotten. Through his efforts, they ended up influencing a generation of poets and writers. But back then his audience was a bunch of poets scattered across the world and connected by a mail network. Bernstein wrote in 1978, "Even when published, writing we wish to read often goes out of print with dismaying rapidity—closing off a dialogue. Out-of-print and unpublished works may still circulate among a limited circle of friends. Here, we hope to sustain that dialogue, and expand that circle."[17]

His distribution service kept running until those materials were digitized, migrating to the web. Much of his catalogue today is warehoused on a Salt Lake City–based digital archive, Eclipse, founded by poet and professor Craig Dworkin. Eclipse is a free online archive focusing on digital facsimiles of the radical small-press writing from the past half century, hosting more than three hundred books, journals, and manuscripts, and including sections of experimental literature by various authors categorized around themes such as "The Black Radical Tradition" and "Language Centered Tendencies." In the 1990s,

Dworkin was teaching at Berkeley and writing about the material that Bernstein had been photocopying. With his personal library, Berkeley's university library, and bookstores around town, his research was robust and easy. But when he took a job at Princeton around the turn of the millennium, he found that although the school had a massive library, it was nearly bereft of contemporary avant-garde poetry. He says, "I realized if, in this fantastically privileged position of teaching at this elite university, you couldn't teach the history of twentieth-century poetry, no one, virtually, was going to be able to do it." As it turns out, he was the one hired to do it. But the paucity of materials in his local ecosystem made his job difficult. He also encountered other academics who wished to write about experimental poetry but had never even read the primary documents due to their original tiny press runs and subsequent lack of availability. "In any other field in literary history this would be unthinkable," he says. "You'd never write a book about Renaissance poetry and say, 'Well, yeah, I've never actually read John Donne, but let me tell you what I think about him.'"[18]

He decided to do something about it, creating Eclipse, his own shadow library. Like Bernstein a couple of decades before him, he began pulling obscure publications off his bookshelf, scanning each page at high resolution, and putting them online. The irony is that in order to scan a book, it had in a sense to be destroyed—unbound and taken apart; he's demolished hundreds of rare small-press poetry books from his own collection so that they can be shared with a wider audience. He felt high resolution to be vital so that the reader could "physically feel" the book online, its paratextual qualities as essential to understanding the work as the content itself. The Eclipse site allows you to zoom in to see what kind of paper the book was printed on, how it was bound, and what impact the metal type from a letterpress made on the paper; even the creases in the pages and the holes that

the staples left are of vital interest, making possible a web-based close reading in the absence of a paper copy. On Eclipse, you can either click through a series of big, single images or download a book in its entirety as a PDF.

The other repository where the Bernstein photocopies ended up was the Electronic Poetry Center at the State University of New York at Buffalo, which Bernstein and fellow Buffalo professor Loss Pequeño Glazier founded in 1995. The center became the largest shadow library for experimental poetics on the web, with scads of downloadable materials on authors, manuscripts, digital books, critical essays, and detailed bibliographies. Two years earlier Bernstein and Glazier had started the Poetics List, a mailing list devoted to the discussion of contemporary North American innovative poetry and poetics, which helped spread the word about these then obscure practices.

In 2005, when Bernstein took a job at the University of Pennsylvania, he and another professor, Al Filreis, founded PennSound, a massive audio shadow library devoted to experimental authors reading their own works. Although PennSound is fully funded, its inaugural press release sounds an awful lot like something that would come from Memory of the World, Monoskop, or UbuWeb:

> The recording industry may not want anyone downloading music without paying for it, but a new project at the University of Pennsylvania encourages downloading right to MP3 players and hard drives all the poetry a listener might want. And it's all free for the asking. . . . By right-clicking a PennSound link, a user can save a single poem and listen to it as a high-quality MP3 file. We believe philosophically that, since there is no significant profit to be gained by the sale of recorded poetry—unlike music—many, many more poets will continue to grant us permission to use their work.[19]

Bernstein and Filreis turned out to be right. In 2017 alone, PennSound had more than three million downloads of *avant-garde poetry*. To date, it hosts more than 60,000 MP3s, totaling 6,500 hours of audio, making it by far the largest audio-poetry resource on the web. The depth of the resource is astonishing; for example, it hosts *every* known recording that John Ashbery ever made. "PennSound is as much about preservation as distribution," says Bernstein. "Most poetry sound recordings are at risk of deteriorating if not converted or copied. The beauty of PennSound is that in the course of preserving these recordings, we are also making available a treasure trove of wonderful poetry performances that we believe will attract a whole new generation to poetry as a performance art."[20]

Although there is little chance of exploitation of these difficult works by the for-profit sector—good luck trying to hawk a compilation of Ashbery reading his complete works—PennSound is partially about preventing these works from being sucked into the voracious commercial whirlpool. Bernstein comments:

If we hadn't preserved the Ashbery files, publishers would have claimed the commercial rights on them and locked them down, which is something that happens all the time. It's groundless and pernicious but nonetheless intimidating. In France and Germany, they feel that the publisher has to give permission, going over the heads of artists. There's no legal basis for it, but there's an idea that you want to give authority and private property to some entity, so you decide it's the publisher. And then the publisher decides that you have to withhold it [a work] to protect its rights. In Europe and Latin America there are no comparable archives to PennSound for many reasons, but the primary one having to do with copyright. An assumption that you don't own your own work, and if that person doesn't exist, you invent that person.[21]

It's a story I hear at UbuWeb all the time: copyright claims being made by people who have no rights to them. Although on seemingly opposite ends of the spectrum—one a powerful institution and the other an individual outlaw enterprise—PennSound and UbuWeb have intertwining fates: PennSound hosts many of our files and publicly claims affiliation with us, and vice versa, and, most important, both of us are desperately trying to preserve cultural artifacts from obsolescence and erasure by using the tools we have at hand.

Radio Web MACBA

Confined within the walls of a major museum, the Museu d'Art Contemporani de Barcelona, Ràdio Web MACBA (RWM) has managed to carve out a wildly experimental and independent niche. It was founded in 2006 as the brainchild of Anna Ramos, who has been producing a vast range of experimental audio documentaries, interviews, and performances. Her interests and UbuWeb's interests overlap; oftentimes UbuWeb mirrors content developed by RWM. For instance, we cohost an RWM-produced, seven-part series history of appropriative collage in music called *Variations*, which was instigated by the composer Jon Leidecker (a.k.a. Wobbly), whose own compositions are hosted on UbuWeb. We also cohost a massive, in-depth, twelve-part series RWM produced called *Avant*, which is presented and edited by Barcelona-based musician Roc Jiménez de Cisneros and identifies key moments of Spain's twentieth-century musical avant-garde, much of which has scarcely been documented—never mind known in Spain—up until this time. Each episode has two parts: one hour of interviews with and about a musician and another hour of the artist's music. RWM produces slick and smart programs, but because our reach is broader, we can offer the programs distribution that RWM

doesn't have. In addition, Ubu provides a semistable backup for RWM's materials—that is, stable at least in comparison to the capricious financial whims of the Spanish government—which are preserved and mirrored on our servers.

Ramos dances a fine line between independence and employment by a powerful institution. She is often requested to produce audio guides for the museum's programming but takes liberties with them, inspired by her love of the avant-garde. Ramos reflects on RWM's complicated relationship to the institution:

> The relationship of the contents and our main lines of work is very rhizomatic; there's always a thread that leads us from one place/subject to another and most of the times we end up in unexpected, unexplored sites. But in the end, you can always undo the way and relate that to the Museum's programming or the radio programming. And that's exactly what we are looking for: we don't want to follow literally what goes on in the Museum, rather than expanding it. So you can listen to a mix of extremely obscure West-African percussion music curated by the power electronics legend William Bennett, and we got there by discussing and exploring the world of collecting records; the keyword here is collecting and it is applied to our main source of work at the radio, which is sound, so it is connected to one of the main lines of work at the Museum but at the same time what we are exploring is totally unexpected.[22]

RWM's site—a trove of radio art, experimental music, and sound art—is closer to what happens on UbuWeb than what happens in the museum. But because the museum is such a powerful attraction, a parade of important artists, curators, theorists, and historians pass through to lecture, ending up in the RWM studios, where they are free to go off script when interviewed about their work and life, resulting is a series called *Son[i]a*.

Consisting of nearly three hundred episodes, the series features artists and theorists such as Yvonne Rainer, Laura Mulvey, Andrea Fraser, and Alvin Lucier in candid conversation.

Once upon a time, radio was ephemeral—if you didn't hear it while it was broadcast, you'd miss it. Today, radio is archival, gradually accruing content similar to the way UbuWeb grows. Ramos agrees: "I like to think that an online radio is, by definition, an archive, or at least that it has the potential to archive its output on a long-term basis. Projects like Ubuweb, Resonance FM, WMFU, Sonosphere.org . . . are excellent examples of online archives and/or radio projects that are much more than just files or music: they offer curation, non-mainstream content, access to knowledge."[23]

WFMU

Founded in 1958, WFMU, the long-running free-form radio station in New Jersey has, as I mentioned earlier, played an outsized role in the history of UbuWeb. The station is listener supported and does not dictate in any way what any on-air personality does during his or her time slot. As a result, you never know what you're going to hear. As station manager Ken Freedman says, part of being a WFMU listener is the fact that many times during the week you will probably have to turn off your radio.

When I was a DJ there, much of the ethos of the station permeated the evolution of UbuWeb, which I began a year after I started working at the station. I took the idea of free-form radio into UbuWeb—the art of segueing two songs of disparate styles into a single cohesive statement—which allowed me to reimagine the lineage of the traditional avant-garde as something less pure, more intuitive, and more playful. WFMU was a magnet for strange sounds from around the world, many of which found

their way to UbuWeb. During the time I was on air as a DJ, while records were spinning, I would feed CDs from the library into my laptop, ripping them for Ubu. At the same time, because of the station's fast Wi-Fi connection, I'd be uploading those rips to various file-sharing groups during my show, simultaneously enriching those ecosystems.

WFMU's sweet spot is the thin line between genius and lunatic; the library shelves are packed with visionary artists such as the Shaggs, Jandek, Harry Partch, Lucia Pamela, Wesley Willis, Captain Beefheart, Shooby Taylor, Wild Man Fischer, and Francis E. Dec, several of whom found their way to Ubu-Web. Like Ubu, WFMU has embraced the clash of disparate genres; it was thrilling when Shooby Taylor's (a.k.a. the Human Horn) wildly expressive scat singing was snuggled up against a tense and brittle, hyperattenuated Anton Webern dodecaphonic string quartet in a set. Sometimes the things I'd find in the WFMU library led to obsessive wormholes on Ubu, as in the time I discovered the avant-garde outsider Finnish musician M. A. Numminen. A true polymath, Numminen has recorded everything from folk music to acid rock to bluegrass to classical music, each bearing his own style. Among the vast section of his works in the WFMU library was a CD of him singing sections of Wittgenstein's *Tractatus*. Sometimes accompanied by a lush orchestra and other times by a rock band, he croaks out the philosopher's words, completely out of tune. Not only did I take Numminen's oeuvre from WFMU's collection for Ubu, but Numminen's performances were the start of a Wittgenstein archive on UbuWeb, which also includes a heartbreakingly beautiful thirty-minute composition by the Hungarian composer Tibor Szemző, *Tractatus*, that incorporates fragments of Wittgenstein's text into a sparse, melodic soundscape.

It was at WFMU that I was first introduced to the works of Vicki Bennett, a.k.a. People Like Us, who now houses more than

one hundred albums and films on UbuWeb, and met Otis Fodder, a WFMU affiliate and the curator of *The 365 Days Project*, which was later donated to UbuWeb. For spiritual guidance about how the visionary artist might curiously collide with the avant-garde, I looked to my fellow DJ Irwin Chusid, who wrote *the* book on the subject, *Songs in the Key of Z: The Curious Universe of Outsider Music*, which we used as a guidebook to navigate this knotty turf. Beyond these few figures, WFMU is packed with artists, musicians, performers, and just plain weirdoes who have never made distinctions between genres; watercooler conversation ranged from Hillbilly Hollywood to Nurse with Wound to Erik Satie to Kokomo Jr. the Renaissance Chimp without missing a beat. To say it was an inspiring and stimulating environment bristling with unconventional ideas and approaches would be an understatement.

Over the years, as Ubu was kicked from server to server, WFMU always filled the gap, temporarily hosting us until we could find a new home. It built a twenty-four-hour audio stream for our sound archives and has provided redundancy and backup to our archive over the past several decades. And as I recounted a few chapters back, I learned much of what I know about folk law from Ken Freedman, the station manager, to whom I still go running for advice when something short-circuits on Ubu. In short, without WFMU, UbuWeb would never have been born.

● ● ●

What shadow libraries do is so strange and perverse that we librarians could never go it alone. Our relationships are symbiotic, each representing another aspect of impossibility, each enacting another slice of idealism and utopia, each a bulwark against the circumscription of knowledge only for those who can afford it. Yet it's an uphill battle. With each passing month,

massive business entities vie for exclusive digital rights for cultural artifacts while pushing for tougher copyright restrictions on all types of content. And beyond that, all of the organizations mentioned here function on either no or very little money, unable to adequately protect themselves from the possibility of copyright-infringement lawsuits (in the case of AAARG, the mounting costs of the lawsuit against it has forced it to crowd-source funding). There's also the issue of infrastructure, which costs money that is often paid out of the librarian's pocket, and the more independent of these sites find themselves scrambling from one donated server to another, engaging in a continual cat-and-mouse game as they scramble to find affordable bandwidth and hard-drive space. Even a station as beloved as WFMU finds itself in a perpetual financial crisis, eking by each year by the skin of its teeth. And yet we all persevere. Taken individually, each of us is small; taken wholly, we're substantial; taken locally, we barely exist; taken globally, we're huge. Each of these shadow libraries provides something different from the others, representing one slice of our specific cultural pie. Together, we're out to combat the ever-mounting stupidity, commercialism, and surveillance capitalism that the web has become, offering models of resistance that can hopefully inspire others to do the same. There are vast numbers of us out there preserving those works that are marginal, forgotten, yet crucial, each of us in our way toiling to preserve the "memory of the world."

PART III

POETICS

5

DIRTY CONCRETE

The documentary film *Helvetica* (2007) is about the ideological battles surrounding the classic typeface. On one side are the hardcore modernists who regard its clean lines and no-frills style as the apex of design. On the other is a group of mostly younger designers who, coming of age during and after the 1960s, reject the face as embodying the evils of the industrial-military complex, both politically and aesthetically. To them, Helvetica represents the man in the gray-flannel suit in all his square, buttoned-down correctness. In order to counter the font's power, they create typefaces that are the exact opposite: expressive, hand drawn, and funky. To them, fonts and the way they are used are a political battlefield; Helvetica's monolith can be softened only by dousing it with raw emotion.

For the fan of typography, it's hard not to be sympathetic with both sides. Sure, Helvetica is pretty narrow in its worldview, but nothing is more beautiful, elegant, and clean, representing all that "good design" should aspire to. Self-assured, it knows what it stands for and where it stands in the world. Yet precisely for these reasons it doesn't fit into our time. Helvetica is an artifact born of the Cold War, and although it's a mid-twentieth-century font, it feels about as far away from the twenty-first century as the typographic ornaments, pen

flourishes, and swirly curls of Victorian typography. And our relationship to it is equally romantic. When we encounter it today, it's usually in scare quotes, found marching across the pages of catalogues selling midcentury replicas of modern furniture. Somehow, the one-dimensional simplicity and cleanliness of Helvetica doesn't quite jibe with today's messy world.

The history of concrete poetry breaks down along similar lines, with the difference being that the same practitioners who advocated the strict use of Helvetica in the early 1950s were the same ones who broke with it in the 1970s for social, political, and technological reasons, challenged by political dictatorship and desktop publishing. Charting a path from the utopian to the dystopian, you could say that a secret history of the second half of the twentieth century is embedded in this little movement, one that parallels larger changes across culture. By the late 1970s, when concrete poetry collapsed into a smoldering heap, few could have foreseen that it would arise as a digital phoenix in the computer age, presciently predicting the ways we would interact with language in the twenty-first century.

Sitting on my desk is a catalogue that was made to mark the half-century anniversary of the founding of the seminal Brazilian concrete poets known as the Noigandres Group, consisting of the brothers Haroldo and Augusto de Campos and a fellow student named Décio Pignatari. They set out to change literature by creating a universal picture language, a poetry that could be read by all regardless of what language they spoke. Letters would double as carriers of semantic content and as powerful visual elements in their own right. The poems—written in just about every language imaginable—often came with a key so that even if you didn't know, for example, Japanese, you could get the gist of what a handful of *kanji* compellingly strewn across a page added up to. Delightful to the eye and political in its intent, their

language was nothing short of revolutionary: a visual Esperanto that would ultimately dissolve linguistic—and thereby political—barriers between nations.

The movement, drawing from Poundian imagism and Joycean wordplay, dovetailed with the twentieth century's drive toward condensed languages expressed in advertising slogans, logos, and signage. By shedding all vestiges of historical connotation—including metaphor, lineation, spontaneous composition, and organic form—concrete poetry planted itself firmly within the grand flow of modernism. These poems, to paraphrase Ezra Pound (a main influence for the group through his use and theories of ideograms), sought to "make it new."

In the black-and-white photographs of the period, the Noigandres Group come off as "serious" intellectuals, never smiling, dressed in thin-lapelled dark suits, crisp white shirts, and skinny black ties. Their journal, which shared the group's name, echoed European modernism, its design inspired by the look and feel of Éditions Gallimard. On the cover, crisp red typography, underscored by thick black rules, was surrounded by acres of creamy, off-white space. The journal was typeset entirely in the Futura font, and the poems—elegant chunks of black-and-white phonemes—danced across the mostly empty pages. When color did appear, it was often primary, declaring these poems to be the linguistic cognate of Mondrian's paintings.

The journal published classic modernist poems and manifestoes alongside the Noigandres Group's concrete poetry. Any given issue would include poems by Stéphane Mallarmé, Pound, and E. E. Cummings alongside radical works by the Noigandres, Oswald de Andrade, and João Cabral de Melo Neto. Entire issues were devoted to the idea of the poster poem, meant to be pasted on city walls and exploring "renewed forms of sensibility in the urban-industrial environment of a new society,"[1] an idea

that grew in tandem with the utopian construction of Brasília. The poems were meant to invoke all the senses, bringing for the first time to poetry Anton Webern's idea of *Klangfarbenmelodie* (sound-color-melody); Pound's theory of *phanopoeia, melopoeia,* and *logopoeia* (the play of image, music, and meaning); and Joyce's neologistic notion of the *verbivocovisual.*

The *Noigandres* journal editors' voluminous correspondence with concrete poets from around the world led to a bona fide international movement with adherents from the United Kingdom, France, Germany, Portugal, Spain, Hungary, Canada, the United States, and Japan, many of whom were published in the journal. By the 1960s, the concrete poets were honored with two special editions of the *Times Literary Supplement,* several influential anthologies appeared, and exhibitions of their works were mounted in galleries around the world. They were in sync with avant-garde ideas of their day, from Marshall McLuhan's media theories to the aleatory music of John Cage. In Brazil, they allied themselves with the youthful Tropicália movement—Caetano Veloso went on to set several of Augusto de Campos's poems to music—leading the poets to ride a global wave of pop. For a few short years, their revolution was a reality.

But political troubles in Brazil were brewing, beginning with the coup that overthrew President João Goulart in 1964. By 1968, the military dictatorship had tightened the screws, which was followed by long years of authoritarianism. Writing about these dark years, Haroldo de Campos lamented:

[It was] poetry in a time of suffocation. On the international level, the crises of ideologies went into overdrive, with imperial capitalism, savage and predatory, on the one hand and the bureaucratic state, repressive and uniforming, on the other, converting the revolutionaries of yesterday into the apparatchik of today and turning art into the squire of party political

dogma. Poetry was drained of its utopian function despite, paradoxically, the advent of the new media created by electronic technology and the unprecedented possibilities they brought, as if putting flesh on the Benjaminian/Mallarméan prophecy of a universal picture language.[2]

De Campos referred to the next two decades of concrete poetic production not as "postmodern" but as "postutopian." With ideology squashed, the poets swapped politics for visuality, using the "new media created by electronic technology and the unprecedented possibilities they brought" to expand the formal parameters of their artistic practice. What had up until this time been a strict adherence to the rigors of modernism—produced mostly with type and paper—exploded into various forms of multimedia, from video environments to massive architectural-based sculptures.

The apogee of this trend was a collaboration in 1975 between Augusto de Campos and artist Julio Plaza called *Caixa preta* (Black Box), which included everything from lavish construct-it-yourself, die-cut paper sculptures to a Caetano Veloso 45-rpm disc wrapped in a gorgeous sleeve designed by de Campos. With the increased availability of wild typefaces, de Campos dug right in, swapping sans-serif fonts for funky lettering that resembled disco typography of the 1970s or the opening credits of a porn film. It's a lot of fun and in a way feels like a relief. De Campos freed himself from the straightjacket of modernism in the same way that the younger designers featured in *Helvetica* did. Even the photographs of the poets from this period bespeak a loosening up: their hair is long and unkempt; they sport wrap-around aviator sunglasses, are draped in floor-length, black-leather coats, and are festooned with thick jewelry. Reflecting the changing style of their times, they're more Rainer Werner Fassbinder than Arnold Schoenberg.

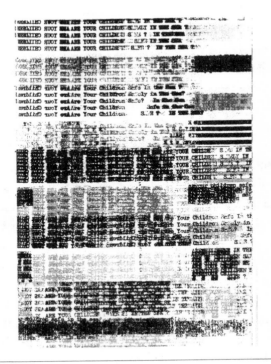

5.1. Bob Cobbing, *Are Your Children Safe? In the Sea?*, 1964.

As Haroldo de Campos remarked, similar changes were felt worldwide, expressing themselves in a variety of ways. In Canada and England, a second wave of concrete poets moved away from pure modernism by steering their production toward "dirty concrete," where the "noise" of the typewriter—misprints, ghost prints, overprints, doubling, and wobbly lines—was purposely courted as evidence of the machine's presence during the writing of the poem. Whereas the earlier poetry required elaborate typesetting, there was something democratic about banging out poems on a typewriter: anyone could do it. The typewriter also changed the look of concrete poetry. The monospaced fonts and gridded movement of the carriage lent the poems a mechanized

flavor, echoing the minimalism raging through the art world at the time; Carl Andre's bricks and typings were but two sides of the same coin. And because there was only one font size available on the typewriter, the focus shifted from the individual letter to buzzy fields of hazy, swarming strokes.

The typewriter's democratization imbued the poems with increased political awareness. The media archaeologist Lori Emerson notes that the term *dirty concrete*

is commonly used to describe a deliberate attempt to move away from the clean lines and graphically neutral appearance of the concrete poetry from the 1950s and 1960s by [Eugen] Gomringer in Switzerland, the Noigandres in Brazil and Ian Hamilton Finlay in England [*sic*]. Such cleanliness was thought to indicate a lack of political engagement broadly speaking and, more specifically, a lack of political engagement with language and representation. As renowned French poet Henri Chopin wrote in 1969, a year after the failed worker/student protests in France: "1968 was the year when man really appeared. Man who is the streets, HIS PROPERTY, for he alone makes it. . . . Yes, 1968 saw this. And for all these reasons, I was and am opposed to concrete poetry, which makes nothing concrete, because it is not active. It has never been in the streets, it has never known how to fight to save man's conquests: the street which belongs to us, to carry the word elsewhere than the printing press. In fact, concrete poetry has remained an intellectual matter. A pity."[3]

Legions of concrete poets heeded Henri Chopin's clarion call for a less-bourgeois poetry by purposely scumbling the surfaces of their poems using the typewriter or, as in Bob Cobbing's case, exploiting the dirty, smudgy quality of mimeo and photocopy machines to "court visual and linguistic nonlinearity and

illegibility."[4] This antiaesthetic bled into punk zines and grunge culture in the following decades. These ideas can be traced to May 1968, when concrete poetry indeed migrated off the page and exploded onto the streets in Paris, where situationist-inspired graffiti doubled as poetry across the city's walls.

Following trends in sixties counterculture, another strain of concrete poetry went pastoral—as exemplified by the "avant-garden" concretism of the Scottish poet Ian Hamilton Finlay—turning its back on the urban upheavals and looking instead for inspiration from the utopian possibilities in nature. UbuWeb hosts a series of poems by Mary Ellen Solt entitled *Flowers in Concrete*. A suite of nine visual poems, they were written from 1963 to 1965, published as a book in 1966, then issued as a portfolio of poster-size prints in 1969. Like the sixties communards who turned toward nature as a possible utopia, Solt's images were intentionally detached from the political foment of the day. Each poem is an image of a flower composed entirely of typographical elements. In "White Rose," for instance, twenty-nine random words bump up against one another, turning into sentences, each forming a petal of the flower. In another called "Lilacs," singular letter forms twist in circles to create small clusters of lilacs. In Solt's most famous poem, "Forsythia," the word

silencio silencio silencio
silencio silencio silencio
silencio silencio
silencio silencio silencio
silencio silencio silencio

5.2. Old concrete: Eugen Gomringer, untitled, 1954.

FORSYTHIA serves as a base or root or planter, with sentences sprouting from each letter, which then turn into branches.

● ● ●

Having lost steam throughout the 1970s, the concrete-poetry movement had pretty much collapsed by the 1980s, subsumed by other trends, such as mail art, where one swapped concrete poems as readily as one swapped cheap cassettes, postage-stamp-size paintings, table-top sculptures, and folded-up posters. Concurrently, small-press culture arose with its networks of readers and writers and voluminous production. Concrete poetry became a mere trickle of the torrent it once was, rendered nearly invisible as a minor note in the greatly expanded field of experimental writing.

Once concrete poetry had run its course as a print medium, it found a new and unexpected role in the digital world, which was emerging at the time of its demise. In fact, many of concrete poetry's ideas about language's materiality ended up being mirrored in computational systems and processes. When the cursor on a computer monitor interacts with language, it does so in a physical way. Take, for instance, the computer's simple cut-and-paste function. When we highlight a word (note the word *highlight*) by moving our cursor over it and pressing down on the mouse, we are picking up that word and moving it elsewhere. When we click on a link, we press down on a word. When in the analog age did we ever press down on words? Similarly, we drag language from one place to another in our word-processing programs. When we hit "send" for an email, we are triggering a series of interactions that physically transfers language in the form of bytes from one computer to another, literally sending those words on a journey halfway around the world. In Photoshop, every time we work with text—stretching and sizing it—we are treating language materially. Whereas it used to

take a typesetter to do this, the fact that anyone could now warp language from a desktop helped to give concrete poetry a renewed relevance. The great dreams of the democratization of concrete poetry by poets such as Henri Chopin have become embedded in our everyday activities. Haroldo de Campos's idea of universally readable visual languages floods our screens in the form of icons, emoticons, and emojis.

Concrete poems being written in the twenty-first century have been strained through the digital—and in some ways have reacted to it; call it postdigital concretism. Even in cases where the poems might look similar to what was done in the previous century, there's something different about them that responds to the digital in the ways they're produced, constructed, and distributed. Concrete poetry in the twenty-first century always winks at its twentieth-century precursors.

After years of poems being laser-printed on vanilla A4 sheets or viewed as lo-res PDFs, we're seeing a fresh surge of poems printed on obscenely thick handmade paper, often swaddled in deluxe slipcase boxes. Books are more beautiful than they were before the digital age. Just walk though any number of art-book fairs popping up in cities around the world: the number of exquisitely produced paperbound artifacts is overwhelming. Poets are migrating to print-on-demand systems as well, producing scads of lo-fi books more cheaply than ever, a return of the "dirty concrete," punk, or grunge aesthetic enabled by the digital. In the twenty-first century, poets have also rediscovered the sensuality of the typewriter and the expressive graphism of the handwritten word, resulting in new forms of asemic poetry, so unique that they can't be made by a computer. And even our cities are suffused with words. The walls of Paris 68 have evolved into the dynamic fields of graffiti and street art, marking the landscape with large, expressive hieroglyphs.

The content of postdigital concrete poetry seems to be influenced by the network as well. There's a lot of appropriated and remixed language, reflecting the cut-and-paste culture of the web, as well as a gravitation toward erasure, perhaps a comment on the fragility of cultural artifacts in the digital age. Although concrete poetry has always been a fast poetry—purposely resistant to close reading—in the information age it seems intentionally designed for short attention spans. Influenced by 4chan image macros and the compressed language of Twitter, much of the new concrete poetry takes the form of snappy one-liners, such as Tom Jenks's poem "I Love Irony" (2011) (fig. 5.3).

Although visual artists such as Lawrence Weiner, Joseph Kosuth, Jenny Holzer, and Barbara Kruger have worked with words for decades, a large number of young gallery-based artists are self-identifying not as "text artists" but as "visual poets." Concrete poetry's great gift was to demonstrate the multidimensionality of language, showing us that words are more than just words. What seemed like a marginal and boutique pursuit in the

5.3. New concrete: Tom Jenks, "I Love Irony," 2011.

twentieth century has turned out to be prophetic in the twenty-first. Language is exploding around us in ways that the founders of the movement could never have predicted.

• • •

I'll never forget seeing the graphical web for the first time in January 1996. It was astonishing to watch an interlaced GIF slowly fill in, one alternating line with another. The way it loaded reminded me of the way venetian blinds open and close or of how a painting by the Israeli kinetic/optical artist Yaacov Agam changes when you look at it from one angle and then another. It struck me that this new technology, echoing earlier display technologies such as rotoscopes and lenticulars, wasn't new at all; it had historical roots that ran deep, from flipbooks to graphic novels to celluloid-film frames.

It just so happened that on my desk at that time was a yellowed paperback book of concrete poems called *Anthology of*

5.4. Interlaced GIF loading.

Concretism from 1967. Inside was a sequential poem by Décio Pignatari that stretched over twelve pages and was arranged like a flipbook: "LIFE," a play on the *Life* magazine logo. First, the logo was split up into individual letters on sequential pages; next, they were combined into morphemes (IF, LIE); and, finally, they were jammed together to make hybrid letter forms (the E plus the I were joined to form an 8). Pignatari's piece is a sly disassembling of an icon (LIFE becomes LIE) and a demonstration of how by simply rearranging a few letters, concretism could challenge something as huge as the *Life* logo, one of the best-known symbols in the world.

In the introduction to her anthology of concrete poetry, *Concrete Poetry: A World View* (1968), Solt identifies three modes that the concrete poem could adopt: "visual (or optic), phonetic (or sound) and kinetic (moving in a visual succession)." She discusses how concrete poetry was multimedia before it was called "multimedia": "When we are confronted with the particular text or poem, we often find that it is both visual and phonetic, or that it is expressionistic as well as constructivist. It is easier to classify the kinetic poem because it incorporates movement, usually a succession of pages; but it is essentially a visual poem, and its words are, of course, made up of sounds."[5]

Included in Solt's anthology is a poem written in 1951 by the Bolivian-born, German concrete poet Eugen Gomringer called "avenidas" (fig. 5.5). It's a classic concrete poem composed of reduced sans-serif language that produces images that are highly evocative but not necessarily specific. When the words are read aloud, their rhythms flow like water running down a staircase. And even though the poem was penned by a German-speaking poet in Spanish, there are few people who can't understand it because it was intentionally written in simple language resembling Esperanto, a reminder of the universality that concrete poetry aimed to achieve.[6] "avenidas" perfectly fits Solt's

avenidas
avenidas y flores

flores
flores y mujeres

avenidas
avenidas y mujeres

avenidas y flores y mujeres y
un admirador

5.5. Eugen Gomringer, "avenidas," 1951.

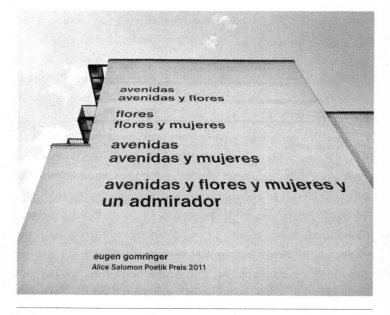

5.6. Eugen Gomringer, "avenidas," installed on site at
Alice Salomon University, Berlin.

three-pronged criteria for concrete poetry—it is visual, phonetic, and kinetic.

In 2011, Alice Salomon University in Berlin awarded Gomringer its Alice Salomon Poetry Prize. Later that year, as a tribute to him, "avenidas" was emblazoned across a wall of one of the school's buildings, where it quietly remained until 2016, when students signed a petition demanding its removal. In an open letter, the students derided the work for its sexism, seeing it as objectifying women by condoning their harassment in the streets of Berlin: "A man who looks out into the streets and admires flowers and women," the students wrote. "This poem not only reproduces a classic patriarchal art tradition in which women are exclusively the beautiful muses that inspire masculine artists to creative acts, it is also reminiscent of sexual harassment, which women are exposed to every day."[7] In response, in 2018 the poet Christian Bök translated "avenidas" into a set of Apple emojis (iOS 11.3) (fig. 5.7).

Bök proposes a new requirement to Solt's criteria for concrete poetry—the ability to seamlessly integrate with the digital age. Still working with imagistic language (or linguistic imagism), Bök restores the ambiguity of Gomringer's original while making it impervious to singularly reductive interpretations. By employing a set of images intentionally designed to be universal and nonspecific, Bök at once alludes to the utopian possibilities of universally understood languages and updates this idea for our time, when images increasingly are words, a new twist on classic concrete poetry where words are images.

Pignatari, Solt, Gomringer, and Bök are reminders of how enmeshed concrete poetry is with technology and electronic media. Although in the beginning concrete poetry was glued to the page, the poems always seemed to want to move off of it, begging to be liberated into the digital space and course through networks in the forms of animated GIFs or streaming video or

5.7. Christian Bök, "avenidas," 2018.

emojis. Just moving the poems to the digital space made them new. Similarly, on the early internet, twentieth-century Russian avant-garde design began regularly appearing on websites as motifs. Like concrete poetry, its clean lines, grid-based compositions, and minimalist color schemes seamlessly transferred to the web.

The intertwined histories of the avant-garde and technology, culminating in concrete poetry, fueled the creation of UbuWeb. But I realized that for all my talk about visual poetry and its influence on the site, we actually had never built a section dedicated to it. So in 2011 I reached out to Derek Beaulieu, a poet and a collector and publisher of visual poetry, and asked him to

scan rare books, historical manuscripts, little journals, and publications he had on his bookshelves to beef up our offerings. He also scoured his global connections, asking contemporary visual poets from around the world to send him their works. The dedicated visual-poetry section we finally launched added nearly three hundred full-length publications to the site, many of which are dozens of pages long.

Suddenly we found ourselves with a diverse range of visual poetry, such as Max Ernst's collage novel *La femme 100 tetes* (1929); the complete run of Ed Sanders's revolutionary *Fuck You: A Magazine of the Arts* (1962–1965), cranked out on a mimeograph machine in a "secret location on the Lower East Side"; d.a. levy's Cleveland-based protopunk zine *Buddhist Third Class Junkmail Oracle* (1967–1969); Marcel Broodthaers's graphical interpretation of Charles Baudelaire, ironically entitled *Je hais le mouvement qui deplace les lignes* (I hate the movement that displaces lines) (1973); Luigi Serafini's asemic encyclopedia of an alien world, *Codex Seraphinianus* (1978); and Cecilie Bjørgås Jordheim's *The Poetry of Repetitive Vertical Movement (at Sea)* (2011), a book of automatic writing derived from making graphical notations of YouTube videos that document ships' voyages in rough seas.

Beaulieu's collection was the long-delayed result of a serendipitous visit I made back in the late 1980s to the Ruth and Marvin Sackner Archive for Visual and Concrete Poetry, which held more than 75,000 examples of visual poetry, concrete poetry, and text art. Schooled in the linguistic art of Lawrence Weiner, Barbara Kruger, and Jenny Holzer, among others, I was stunned to discover an entire history that was little discussed in the mainstream art circles in which I was running. Although the collection (which the University of Iowa Libraries Special Collections acquired in 2019) was stored in an endless parade of flat folder

files at the Sackners' home, much of it hung on the walls in the form of text-based paintings and splayed across the floor as word-art sculptures. The Sackners began collecting visual poetry when they purchased paintings and ephemera from the Russian avant-garde and increasingly fell in love with the way typography was used. From there, they collected newspapers, broadsheets, magazines, and journals of the Russian constructivist period, where text was used as image. This path finally led them to the historical concrete-poetry canon and from there to contemporary text art and digital forms of visual poetry. On any given wall of the Sackners' house you could find rare first-edition proofs of Mallarmé's *Un coup de dés jamais n'abolira le hasard* (1897) next to cheaply photocopied pages from Jenny Holzer's *Truisms* (1978–1987).

The personal vision that drove the collection—a rich jumble of styles, mediums, and periods, all centered around the avant-garde—became another blueprint for UbuWeb. The Sackners intuitively found their way, discovering for themselves what constituted an "avant-garde," one that followed no textbook or previously written history. It proceeded instead on serendipity, intuition, and passion. Somehow it worked—at least to them—but they always came back to visual and concrete poetry. In building UbuWeb—my version of the Sackner Archive—my touchstones are identical. Every time I have a question of whether something—be it a film or a piece of music—can fit into the scheme of UbuWeb, I look to the history of concrete poetry and find the answer. Time and again, concrete poetry has turned out to be dead right.

6

FROM *URSONATE* TO *RE-SONATE*

Kurt Schwitters's catalogue raisonné is an imposing object. Consisting of three fire-engine-red hardbound volumes, it totals 2,018 pages. As you skim through the pages, it's astonishing to see the variety of works that Schwitters made, beginning with his academic work in 1905 and continuing until his death in 1948. Although committed to the avant-garde, Schwitters never stopped painting traditional portraits and bold landscapes, all of which display an astonishing talent. The works are arranged chronologically, and so it seems as if one day he would create a radical Dadaist *merz* collage of found bits of tattered newspaper clippings and spent tram tickets, and then the next he would paint a drop-dead beautiful, creamy Norwegian landscape of the fjords *en plein air*. Schwitters's practice is a reminder that many artists are not easily pigeonholed as being only one thing; usually, they are many things simultaneously.

As you leaf through those pages, letters and words jump out at you. They're everywhere—in his collages and paintings, splayed across the walls of his *merzbaus*, and strewn about the pages of his visual poetry. Taken from matchbooks, postage stamps, newspaper headlines, and ad copy, chunks of everyday language litter his oeuvre, reframing the mundane as poetic. At

other times, words slide off the canvases and onto the page, forming the basis of his radically baroque Dada sound poems, the most famous of which is the *Ursonate*, a forty-five-minute tour de force consisting of globs of odd phonemes and invented words. Many consider it to be the most influential sound poem ever written.

Yet amid the thousands of works listed in his catalog raisonné, there's no entry for the *Ursonate*. In fact, in the book's exhaustive chronology there's only one mention of it (where it is referred to as the "Primal Sonata"):

5 May 1932
Recording of the Scherzo from the "Primal Sonata" and the poem "To Anna Blossom" for the broadcaster Süddeutscher Rundfunk Stuttgart.

It's a glaring omission for a document that pretends to be complete. The editors state: "The catalogue raisonné, in three volumes, contains the *entire* artistic oeuvre of Kurt Schwitters in chronological order, beginning with the oil paintings and drawings of 1905 and ending with the last work, a landscape sketch which was drawn shortly before his death in January 1948."[1] When I wrote the editors asking why the *Ursonate* was not included, they simply responded that "literary works are not included in our *Kurt Schwitters. Catalogue raisonné*."[2]

It's hard to rationalize such divisions when Schwitters's practice was set upon demolishing them. The term *merz* was a fragment of language, a truncation of the bank name "Commerz und Privatbank," an act of naming that signified shattering, questioning the possibility of unity in the wake of World War I: "In the war, things were in terrible turmoil. What I had learned at the academy was of no use to me and the useful new ideas were still unready. . . . Everything had broken down and new things

had to be made out of the fragments; and this is *Merz*. It was like a revolution within me, not as it was, but as it should have been."[3]

Merz destroys singularity, collapsing painting into poetry and performance into architecture. A catalogue pamphlet from 1944 written by Herbert Read on the occasion of Schwitters's solo exhibition at the Modern Art Gallery in London gives a more accurate account of the artist than the catalogue raisonné of 2006 does:

> Schwitters is a complete artist. Here we only see his sculpture and painting, his plastic arts. But he is also a poet, and parallel to James Joyce, has been developing the abstract vocal rhythm. His poems must be heard rather than read, and the poet is their best interpreter (again, one might say the same of Joyce, for it is only after hearing the record of his reading from *Finnegans Wake* that his purpose becomes wholly clear). One is naturally skeptical of any form of abstract *literature*, and perhaps literature is not the name for an art of *abstract incantation*: but to hear Schwitters recite his poems is to be convinced that he has invented still another art form.[4]

Composed over the course of a decade beginning in the mid-1920s, the *Ursonate* (also known as *Sonata in Primeval Sounds* or *Primitive Sonata*) is a classical sonata in four movements, each in a related key, but with unique musical characteristics. The inception of the piece began with a poem by fellow Dadist Raoul Hausmann, "f m s b w t ö z ä u" (1918), which was, as Schwitters recalls, originally nothing more than a type sample for a selection of fonts, which Hausmann called a "literary readymade."

Hausmann simply made it into a sound poem by freely interpreting the letters. (There is a recording of Hausmann performing it as a part of a suite of Dada sound poems—it takes a mere

6.1. Raoul Hausmann, excerpt from in-text plate (folio 13) from
Poésie de mots inconnus, 1949.

four seconds to recite.) After hearing Hausmann read it in Prague,
Schwitters began on occasion to perform it, calling it "Portrait
of Raoul Hausmann." Because Hausmann was originally from
Vienna, Schwitters transcribed the inflection of his accent as

> fümms bö wö tää zää uu
> pögiff
> mü

By dropping the "mü," he composed the first two lines of the
Ursonate, at once appropriating Hausmann's words and making
them his own through an act of sound-based transcription. From
there he began to compose the *Ursonate* in ways not dissimilar
to how Joyce composed *Finnegans Wake*, abstractly eliding
common nouns into muscular neologisms. "Dresden" becomes
"DDSSNN R"; "rakete,"—repeated extensively throughout the
poem—is German for "rocket"; and "p r a" is the backward
spelling of the name "arp," as in fellow Dadist Hans/Jean Arp.

At other times, he transcribed letters of the alphabet backward, then sprinkled in "shortened inscriptions on company plaques or printed matter, [and] the interesting inscriptions on railroad switch towers which always sound so interesting because no one has no way of understanding them."[5]

In this way, the *Ursonate* can been thought of as an autobiographical record of words and sounds captured from Schwitters's daily life, forming a sort of travelogue, not dissimilar to Blaise Cendrars's "La prose du Transsibérien" (1913) or Ted Berrigan's book-length, travel-based erotic poem *Train Ride* (1971). The repetitive rhythms of "rakete rinnzekete / rakete rinnzekete / rakete rinnzekete" could easily be a transcription of the sounds of the iron rails.

The piece was precisely composed, consisting of four movements: a first movement, a largo passage, a scherzo and trio, and a finale and cadenza. Each section has its own tempo and emotional tenor; Schwitters calls the first "explosive," the second "metallic and incorruptible," the third "military and masculine," and the fourth "trembling, sheepishly tender." Like a sonata, sections echo one another, with motifs repeating and transforming over time:

[In the second movement] the "rrmpf" and "rrnnff" recall the "rrmmpff tillff too" of the first movement, though the sound is now no longer sheepishly tender, but short and commanding, very manly. Nor does "Rrumpfftillftoo" in the third movement sound as tender any longer. The sound of "ziuu lenn trll" and "lümpff tümpff trill" derives from the main theses "lanke trr gll." The "ziiuu iiuu" in the trio strongly recalls "ziiuu ennze" from movement 1, except that here it is solemn and ceremonial. The scherzo is essentially different from the other three movements in which the long "bee" is extremely important. No "bee" occurs in the scherzo.[6]

Schwitters says that the entire piece should be pronounced as it would be in German, which has led some critics to claim that the piece cannot be properly performed by nonnative German speakers, a suggestion that has happily been disregarded. Schwitters goes on at length to give precise instructions; for instance, the "bbb" is pronounced like three single *b*'s; that the consonants "f h l j m n r s w sch" are not pronounced separately but elongated; and that "rrr" is a longer rolling sound than "r."

And then, contradicting himself, he gives permission for the performer to improvise and interpret: "Of course the use of ordinary script with the letters of the old Roman alphabet can only give a very partial suggestion of the performed sonata. As is the case with any notation system, many interpretations are possible. As with any reading act, imagination is required to read correctly." But he then disavows his own instructions: "To explain in detail the variations and compositions of the themes would be tiresome in the end and detrimental to the pleasure of reading and listening, and after all I'm not a professor."[7] As is typical of some artists, it's neither one nor the other, but both: the *Ursonate* is a score to be followed precisely and an invitation to expand on it in ways unique to each performer.

Although Jan Tschichold designed a beautiful setting of the score in 1932, Schwitters said, "It is better to hear the sonata than to read it. That's why I myself like to and often do perform my sonata publicly and will accept all invitations to organize a sonata evening."[8] Accounts of Schwitters performing his sound poems make them seem like they were incredible to experience live. Hans Richter was eyewitness to one that Schwitters gave in Potsdam in 1924 or 1925 in a private home to a group of retired generals:

> Schwitters stood on the podium, drew himself up to his full
> six feet plus, and began to perform the *Ursonate*, complete with

hisses, roars, and crowings, before an audience who had no experience whatever of anything modern. At first they were completely baffled, but after a couple of minutes the shock began to wear off. . . . I watched delightedly as two generals in front of me pursed their lips as hard as they could to stop themselves laughing . . . and then they lost control. They burst out laughing, and the whole audience, freed from the pressure that had been building up inside them, exploded in an orgy of laughter. The dignified old ladies, the stiff generals, shrieked with laughter, gasped for breath, slapped their thighs, choked themselves.

[Kurt] was not in the least put out by this. He turned up the volume of his enormous voice to Force Ten and simply swamped the storm of laughter in the audience, so that the latter almost seemed to be an accompaniment to the *Ursonate*. The din raged around him. . . . Schwitters spoke the rest of the *Ursonate* without interruption. The result was fantastic. The same generals, the same rich ladies, who had previously laughed until they cried, now came to Schwitters, again with tears in their eyes, almost stuttering with admiration and gratitude. Something had opened up within them, something they had never expected to feel: a great joy.[9]

Later, in England, where he ended his career after being hounded by the Nazis from Germany to Norway to the United Kingdom, Schwitters performing his poems was still something to behold. In 1947, the jazz singer George Melly, who drifted in and out of the British surrealist scene, was working at a gallery that mounted a Schwitters show, which included a series of performances by Schwitters. In his autobiography, Melly recalled how nobody was interested in Schwitters's work, so out of pity the dealer bought out the entire show of collages for five pounds

apiece. Melly writes how sad it was when Schwitters appeared at the gallery one rainy Saturday afternoon to recite the *Ursonate* to an audience of three half-drunken people, Melly and the gallery proprietor being two of them:

> He stood in the corner of the main gallery . . . and began to intone:
>
> Fumms bö wö taä zaä Uhm,
> pögiff
> Kwii Eee
> Oooooooooooooooooooooooooooooo
>
> His white hair stuck out wildly. His eyes were bright blue and staring beyond us. His mackintosh was open. He was over six foot tall anyway but seemed to have grown taller.[10]

Stories like these made people want to hear recordings of Schwitters performing the *Ursonate*, but to little avail. The only recording Schwitters ever made in his lifetime was a six-minute excerpt that he recorded for South German Radio in 1932, which was issued as a 78-rpm disc accompanying *Merz* number 24 (in the same issue was Tschichold's graphical rendering of the poem). For the next six decades, the only document of those legendary performances appeared to be that one disc. Then in 1993 a CD was released on Wergo, the formidable German record label, claiming to be a full-length performance of the *Ursonate* by Kurt Schwitters himself.

The release came about when a visual artist named Jack Ox wanted to hear the *Ursonate* but couldn't locate a copy. Ox writes that a friend "said quite casually that he had Kurt Schwitters's own performance once copied by his friend Dick Raaijmakers."[11] That tape ended up being released on the Wergo disc, accompanied by a statement from the artist's son, Ernst Schwitters: "By now, the almost incredible, the miracle has happened. Today I

collected the tape of the *Ursonate* at the post office. And indeed, it is an original recording—probably the only—by my father himself in exactly the same way as I still know it."[12]

But the moment it was released, there began to be doubts whether the person performing was really Kurt Schwitters; many suspected that it was Ernst's voice on the recording. The Dutch sound poet and Schwitters expert Jaap Blonk sensed that something was off. Intimate with Schwitters's energetic and expressive voice performing the *Ursonate* from the recording made in 1932, he found the Wergo disc dull, slow, and expressionless; others felt the same. So in 2006 the Kurt and Ernst Schwitters Foundation hired an expert to compare several recordings and determined that in fact the voice was Ernst's and not his father's.

The tape that Raaijmakers had was evidently from a rare LP of various people performing Schwitters's sound poems (including Schwitters reciting his poem "An Anna Blume," which was also recorded during the session in 1932) and of Ernst performing the *Ursonate* in its entirely. Recorded in 1951 and released by a gallery in London in an edition of one hundred, the LP was so rare that Blonk had neither seen nor heard it. Happily today, it can be heard on UbuWeb. In the liner notes at the site, Ernst declaims: "Under pressure from all sides I have finally agreed to try to recite it. Though I am aware my recital can, in no way, be compared with my father's, I have one advantage over all other people, I drank it, so to speak, at the same time as my mother's milk. I heard it at least two or three hundred times. I followed closely its development. I admired it immensely, as I admired my father. I believe I shall never forget the intonation and pronunciation of it. Anyhow, it is the best I can do."[13]

Today, the *Ursonate* has become the ur–sound poem, the closest thing to a masterpiece in the genre. But it wasn't always this way. Blonk recounts the resistance he encountered when first

performing it in the 1980s, provoking a similarly hostile response as Schwitters's Potsdam appearance forty years earlier:

> The culminating point . . . was a performance of the *Ursonate*, opening for a concert of The Stranglers at Vredenburg Music Center in Utrecht in 1986, for an audience of about 2,000 fans. When it was announced, even before I had opened my mouth, people started calling out: "Rot op!" ("Fuck off!"), and when I started, the atmosphere became very much that of a football match, but clearly an away game for me. With massive roaring they tried to drown out my voice, but of course the P.A. made me louder. Six stage guards were working hard to keep people from climbing the stage and hitting me, and hundreds of half-full plastic beer glasses flew about me. But in the course of the performance I managed to win over at least a few hundred people, who were roaring in my favor. The next morning one newspaper had the headline "Jaap Blonk Shocks Punk Audience With Dada Poetry," which for me was a nice testimony to the fact that Schwitters's piece was still very much alive, in spite of its age.[14]

That same year Blonk had trouble when he tried to release a recording of the *Ursonate*, which Ernst blocked, insisting that this recording was illegal and that all copies be destroyed. Blonk speculates that Ernst was convinced that the only genuine version of the *Ursonate* was the six-minute fragment made by his father and that any other interpretation was to be suppressed (all the more ironic for the fact that Ernst mistook his own voice for his father's on the Wergo release). While Blonk's discs weren't actually destroyed, they were prohibited from being distributed or sold in shops. Another version by Eberhard Blum on a Swiss record label was similarly censored. The label, hat ART, was taken to court, and selling the recording in Germany was

illegal until 2002, when after Ernst's death the Schwitters estate was taken over by his grandson and the ban finally lifted.

Today UbuWeb happily hosts all of the previously suppressed versions as well as many others. Blonk writes, "Nowadays one can hear many different versions of the *Ursonate*, both in live performances and on recordings, and almost all of them testify that the piece is strong enough to shine in whatever garment it is dressed: the true mark of the masterpiece."[15] The dozen versions of the *Ursonate* hosted on Ubu couldn't be more different from Schwitters's—or from one another. Christian Bök performs the piece at double speed, clocking in at eighteen minutes, as opposed to Ernst's thirty-six. He takes great liberties with the score, including overly expressive heavy-metal-like growls, yelps, and screams. The Canadian composer André Cormier, who leads a group called Ensemble Ordinature, strains Schwitters's text through Macintosh computer voices, and the Finnish group Linnunlaulupuu—a group of actual humans—turns the *Ursonate* into something resembling a rowdy football chant. The Japanese sound poet Tomomi Adachi subjects the first page of Schwitters's score to various manipulations, including systematic repetitions, spontaneous improvisations, removal of consonants and vowels, and the running of parts of it backwards, so that it at times sounds like a glitching CD. The Israeli experimental vocalist Anat Pick, accompanied by a double bassist, employs extended vocal techniques, electronic processing, overdubs, and feedback loops, using Schwitters's score as the basis for an abstract soundscape.

The American sound poet Tracie Morris takes another tack by drawing upon African American musical traditions and using Ernst Schwitters's recording of the *Ursonate* as the basis for a call-and-response improvisation entitled *Re-Sonate* (2016). Using her extensive experience as an improviser, Morris decided to perform along with the recording. Over the years, when she

encountered the *Ursonate*, she'd find herself humming along with it, singing along with it, and riffing on it. She eventually decided to collaborate with it, a duet across the decades between Ernst Schwitters and Tracie Morris, reminiscent of the way that, say, Natalie Cole electronically collaborated with her father, Nat, after his death or how holograms of dead musicians go on tour backed by live bands. But unlike the Coles' recording, where the two are made to seem as if they're in the same room with one another, Morris wants to emphasize that she is collaborating with a *recording* rather than with a person. Leaving the dry sound of the LP and its scratches intact, she went into a digital state-of-the-art recording studio, which captured her full-bodied, throaty poetics. It's a wonderful and uncanny pairing of a dead white European male and a living African American woman.

Morris went into the studio without a score and spontaneously improvised to Schwitters's every utterance, tenuously and delicately at first, then confidently and aggressively as the piece unfolds. Treating Schwitters's nonsensical expressions as musical words, she responds accordingly, sliding into a jazzy duet reminiscent of Charlie Parker and Dizzy Gillespie encircling one another, trading riffs, point–counterpoint. Drawing out the inherent musicality in the piece, Morris reflects, repeats, imitates, and parodies Schwitters's melodic passages.

Morris lovingly attempts to translate Schwitters's *merz* vocabulary, repeating back what she thinks he is saying, sometimes as a declarative response and other times as a question. When Schwitters says, "Ziiuu," Morris answers, "See you!"; "pögiff " becomes "forgive" or "fuck it"; "kwiiEe" becomes "please?" or "really?" or "plié"; "tillff" becomes "fifth"; "bee bee" becomes "baby"; "böwö" is answered with two laughs—"ha ha"; and "böwörötääzää" becomes "da-dada-da," intoned by Morris with a scat-inflected voice.

Vocal collaboration comes naturally to Morris. She heard a lot of it growing up in the public-housing projects of East New York around the time hip-hop was beginning. There she was exposed to collaborations such as Nikki Giovanni with the New York Community Choir. Morris was drawn to the thick, complex music of Lou Rawls, Isaac Hayes, and, in particular, Eric B. & Rakim. "As hip-hop emerged, I just knew, as part of my cultural history, that the internal rhyme, interacting with dissonant, distracting electronic sounds, had community value, meaning. It wasn't just some 'talent' or some 'noise.'"[16]

In the mid-1980s, Morris began connecting with the New York rock scene, joining the Black Rock Coalition, a group that formed to combat racial discrimination in the music industry. At the time, she considered herself more of an activist than a poet but accidentally ended up performing at a coalition event at the CBGB Canteen in 1991, when, helping to organize a festival of poetry and music, she discovered to her dismay that no women were slated to perform. So she signed up for a slot, shyly climbing onstage to nervously mumble a few poems. To her astonishment, the poems were well received; the community encouraged her to perform her poems more often, which she did. Over time, as her confidence and performing style grew, she found herself in demand as the rare poet-improviser who was able to work with musicians, culminating in her first effort at "sitting in with a band," performing with saxophonist Steve Coleman's band the Five Elements at the Knitting Factory in 1992. Listening carefully to Coleman's sound, she decided not to perform her poems on top of the music, but to perform within it in order to get "deep inside the music, poetically," which is exactly what she did a quarter of a century later with Schwitters. "If I could sit in with Coleman—known for his complex time signatures—I could sit in with anybody. That one performance changed everything for me."[17]

During that period, she also fell into the slam scene, which she excelled at, but missed the dynamics she had while improvising with complex sound-based work. So she decided to present poetry that was more of a challenge for her to write when she participated in the Grand Slam spoken-word tournament at the Nuyorican Poets Cafe on the Lower East Side in 1992 but lost after performing dense, difficult writing.[18] This freed her to chart her own course. "Had I won that slam, I would've been just another slam poet for too long in my career, rather than moving on to the new work I needed to do." Straddling the worlds of slam and improvisation, she had a minor hit with a poem called "Project Princess," a deconstructed spoken-word piece that breaks up narrative lines, soaked in washes of echoes and stutters. Scholar Tammie Jenkins writes that it's the disjunction that drives the poem: "Project Princess emerged as non-chronological storytelling, language and accepted meanings, signification (signifying), and created counter-narratives that opened discursive spaces as sites of resistance."[19] As in the *Ursonate* duet, words become sounds, and sounds become words. It's as much about *how* she says it as *what* she says, although what she says—a catalog of what it's like to be and look like a young, black female in the projects—comes through loud and clear.

But a funny thing happened. She was on her way to the Apollo Theater in Harlem to perform "Project Princess" in a show staged for teenagers. As she was getting ready to go to perform a work she had performed many times before as a hip-hop poem, she started hearing additional dissonant sounds in her head interjecting themselves into the poem. On the subway, she tried to practice the poem in her usual way, but those dissonant sounds kept imposing themselves. As she went farther and farther uptown, the sounds became more cacophonous and strange. It was as if the echoes and repetitions in the original poem were engulfing the narrative lyrics to the point where it all became a

jumble of pure sound. As she walked to the theater, she told herself, "This poem is going to be some kind of other poem. It has drowned out the other version, squeezed it out of my head." She went onstage and performed the new version. When she finished, a stunned silence fell over the theater. Then she got a screaming standing ovation. Morris intuited that the audience would naturally embrace her artistic choice: "My definition of the avant-garde is black. The avant-garde starts with black culture and that audience of kids reinforced that idea. We understood hip-hop and innovation as a culture. It's about density."[20]

After that experience, she no longer bothered to make distinctions between music and poetry, sound and abstraction, slam and experimental; it was a single practice that fluidly moved across scenes. One night she'd be performing with slam poets at the Nuyorican Poets Cafe, the next with a jazz band at the Knitting Factory, and the following with language poets at the Ear Inn. She belonged to many communities, all of which felt natural and nonconflicted.

Discussing her relationship to the avant-garde, Morris also sees it as organic and fluid: "I never felt what I was doing as an experimental poet was against my core as a black poet or writer. I felt like it was all part of my way of being a black writer and performer. Innovation in sound and language didn't originate with 'experimental poetry'; I grew up with those kinds of innovations; I just didn't grow up with them in school." She also refuses to make distinctions between her influences: "I'm equally indebted to Schwitters, Fluxus, and Sonia Sanchez, as I am to Rakim, Sarah Vaughan, and Cecil Taylor. They're all innovators. I was never in communities that required I separate those things out in order to be black or in the black tradition."[21] Although Cecil Taylor is most famous as a musician, Morris thinks of him primarily as a poet: "My first experience was with his poetry and the dense, rich, heavy language that he used. It's thick."[22] That

thickness and complexity—reaching back to Giovanni and Eric B. & Rakim—is the key to Morris's aesthetic: the thicker and denser, the better.

UbuWeb hosts a disc of Cecil Taylor's sound poetry called *Chinampas* (1987–1989), which is just his voice—sometimes solo, other times overdubbed—accompanied by him playing tympani, bells, and small percussion. Like Morris's work, *Chinampas* blurs the line between sounds and words. Single words, phrases, and sentences form a dense soundscape, which also includes him growling, singing, whispering, shouting, yelping, and humming. As in Schwitters's *Ursonate*, his words are repetitive and nonlinear, weaving in and out of language and music. Trying to notate them without his vocal inflection doesn't do them any justice. The Gertrude Stein scholar Ulla Dydo, who turned her attention to Taylor's poetry later in her career, writes, "Cecil's poetry is not like any other poetry that can be reproduced, printed, and read with the eyes or performed out loud. It is a different form, a hybrid. Printing it reduces it down to something else, and in that sense destroys it. Though you can call it a score, it is not music. It is not painting, decorative art, or photography and cannot be a visual stand-alone. To print it, even in facsimile, is to violate and falsify what it is."[23] The literary critic David Grundy has tried to decipher the textual method of Taylor's scoring, finding it equally resistant to clear interpretation:

> As I've found in attempting to make transcriptions of Taylor's recitations here and in live performance, it's virtually impossible to capture on the page the distinctive tempo and timbre of Taylor's phrasing. Sometimes, indeed, Taylor appears to use found texts, chopped up and played with in recitation: it's the "delivery" and the ritualized context of performance as much as the text itself that makes it a poem. Above all, it's the time and the timing of reading, the way breath and tongue and teeth

spin out the phrase or line, that "notation" or transcription can't capture.[24]

Taylor would often begin his musical performances with a poetry reading, and on occasion he'd do readings in poetry venues. I recall seeing him once at St. Mark's Poetry Project, where, instead of standing at the podium and reading like other poets, Taylor was a blur of motion, pacing, squatting, ducking, and weaving. Grundy describes Taylor exactly as I remember him: "holding a sheaf of musical and poetic notation on sheets of loose paper, reciting the names of voodoo or Egyptian gods, lines emerging in repetition and a kind of *Sprechstimme*—squawking, scratching, rasping, sometimes in strange tones of parody, verging on the edge of hilarity."[25] Grundy could almost be describing Schwitters performing in Potsdam more than half a century earlier.

The word *chinampas*, "floating gardens," refers to a type of Mesoamerican agriculture where sticks and soil are woven into a fertile planting ground that sits above shallow bodies of water. In Taylor's case, it might be a metaphor for the way words, sounds, and music interweave with one another in order to sustain and grow an ecosystem of poetry. As in the agricultural metaphor, each element is codependent with the others, through growth, decomposition, ultimate collapse indistinguishable from one another, reminding us that the organic elements of nature and the organic elements of the poetic are inseparable, renewable, and eternally fruitful.

Along with improvisation and jazz, a sort of hybrid modernism was one of the key elements in Taylor's practice, one in which boundaries were permeable: "The thing that allows me to enter into what [Charles Olson and Bob Kaufman] do is the feeling that I get. It's the way they use words. It's the phraseology that they use, much the way the defining characteristic of men like

Charlie Parker or Johnny Hodges is the phraseology. . . . [I]n other words, the harmony and the melodic. Well, I also see that in word structures."[26] Word structures and music structures become melded and interchangeable, but in the end poetry was the way Taylor primarily chose to define himself: "I've always tried to be a poet more than anything else, I mean, professional musicians die."[27]

The legacy of Schwitters's sound poetry courses through various aspects of what has come to be called "sound art," a field that takes into its purview everything from electronic music to ambient noise to microsound (the loud amplification of barely audible sounds). Often overlapping in gallery and museum spaces, it also finds its métier in various recordings that mingle with other boundary-blurring categories, such as new music and body art. In particular, one strain of sound art is directly related to Schwitters in that it's produced exclusively by artists who use the body as the primary source for their audio works.[28] Some use words, some simply use their bodies—or others' bodies—as a compositional tool. Although much twentieth-century classical music employed extensive use of *Sprechstimme*—for instance, Schoenberg's "Pierrot Lunaire" (1912) and Cathy Berberian's "Stripsody" (1966)—sound art and sound poetry brought the voice and the body to the foreground as the site of composition. Beginning in the first decades of the twentieth century, while the futurists explored poetry based on nonverbal and nonlinguistic mouth sounds, it wasn't until after World War II with the advent of the tape recorder and *musique concrète* that compositions based on altered and amplified microsounds derived from the human body were possible.

The French sound poet Henri Chopin in particular applied *musique concrète*'s principles of amplification to his own body. In the 1960s, he coined a description for this practice, "*les corps est une usine a sons* [the body is a sound factory]." Chopin took his

directive literally, using his own body as the site of sound. He wrote, "I'm fond of my noises and of my sounds, I admire the immense complex factory of a body, I'm fond of my glances that touch, of my ears that see, of my eyes that receive."[29] To that end, he did things such as roll contact microphones around inside his mouth. By doing so, he turned the studio inside out: where once the performer entered the studio to make a recording, after Chopin it was possible for the studio to enter the performer. Instead of manipulating pre-recorded voices to make compositions as the *musique concrète* composers did, Chopin made live recordings of his body and voice, which became compositions in and of themselves. When you are listening to his music, it's hard to tell that it's body derived. It often sounds instead like much electronic music of its time, awash in ethereal swishes, punctuated by deep booms. It's only after reading the liner notes that you learn that the source of a certain composition was, say, Chopin banging his head against the side of an amplifier or chopping at his larynx repeatedly with the blade of his hand while humming.

The result was the human body as site of sound. In 1951, John Cage famously told of his visit to a "soundless" chamber at Harvard in 1951:

> It was after I got to Boston that I went into the anechoic chamber at Harvard University. Anybody who knows me knows this story. I am constantly telling it. Anyway, in that silent room, I heard two sounds, one high and one low. Afterward I asked the engineer in charge why, if the room was so silent, I had heard two sounds. He said, "Describe them." I did. He said, "The high one was your nervous system in operation. The low one was your blood in circulation."[30]

This experience allowed Cage to refute the idea of silence. After visiting the anechoic chamber, he realized that no matter where

we are, there is noise. And no matter what type, all noises contain the formal properties of music: pitch, timbre, and duration. Therefore, he was able to claim that music is all around us, if only we have the ears to hear it.

But let's imagine another scenario, where Cage went into the chamber and came up with the identical conclusion, but rather than perceiving music all around us produced by agents outside of ourselves, he seized upon the idea that the body is a sound factory, working twenty-four/seven. So instead of listening to music around us, we are constantly creating music from within.

7

PEOPLE LIKE US

To say that Vicki Bennett, who performs under the name "People Like Us," is prodigious is an understatement; every few months I get another email from her asking UbuWeb to host her latest. Everything Vicki does is posted on Ubu and given away for free. By maximizing a combination of free and paid economies, she makes a living entirely from her art, working on commissions, giving lectures, doing radio shows, performing in festivals, and constantly touring.

Bennett works entirely with preexisting materials, cutting up and reassembling old movies and LPs, then collaging them into something entirely new. She's a wonderful live performer, mixing the soundtrack live in the theater to accompany her films. Humor plays a big role in her work—something rare in the world of avant-garde. Her sources are decidedly lowbrow, everything from goofy B-grade horror films to obscure sci-fi movies, which she then pairs with frenetic, chopped-up soundtracks of cheesy AM pop-radio hits from the same genres and periods. Her work is often about utopias gone bad; for this reason, she favors wide-eyed, optimistic, and innocent musical and visual content as her source material, which always seems to end in catastrophe. She is a pop-culture addict, transforming junk into profound

statements that, in spite of her avowed lack of interest in political interpretations of her work, are rife with cultural and political urgency. As much as she belongs to an avant-garde alchemical tradition—think of the collaged works of Joseph Cornell or the pop films of Kenneth Anger and Bruce Conner—she is also part of a long line of women working in electronic music and turntablism, such as Daphne Oram, Maria Chavez, Ikue Mori, Pamela Z, and Marina Rosenfeld.

UbuWeb hosts many artists who work primarily with found materials, including Craig Baldwin, Christian Marclay, John Oswald, DJ Food, Wobbly, and Negativland. Yet each artist's work bears a unique authorial stamp. Sometimes that stamp is apparent in the choice of source material (in Bennett's case low-end pop) or in the way the source material is assembled (Bennett usually retains the pop structure of her source material, whereas others shatter that structure into abstract shards) or the way it is presented (many sample-based musicians are studio-only artists, whereas the performative component is just as essential to Bennett). Bennett's oeuvre is proof that choice is, indeed, a form of authorship; by stitching secondhand sounds and images together, she creates something entirely new.

Her works often feel like MTV music videos gone terribly wrong. What begins innocently and cheerfully quickly darkens, growing increasingly chaotic as the film unfurls. By the time it's over, it's thoroughly turned itself inside out, becoming so fragmented and dizzy that it topples over and collapses. Take her film *The Sound of the End of Music* (2010), a three-and-a-half minute mashup of the opening scenes of *The Sound of Music* and *Apocalypse Now*. As Julie Andrews spins around on the tops of Austrian peaks, teams of menacing Vietnam-era helicopters appear over a nearby ridge, ready to drop their payloads. Bilious white clouds clinging to snowy mountaintops turn gray when mingled with smoke from the napalm fires burning in the

flower-strewn fields behind her. Under leaden skies, Andrews singing "The Sound of Music" is mashed up with Jim Morrison crooning "The End." Like a classic Andrews and Gene Kelly duet, Andrews and Morrison swap lines: "The hills are alive with the sound of music / this is the end / with songs they have sung for a thousand years / of everything that stands, the end." Working intuitively, Bennett sensed that "both wanted to sing together, they were in the same key already but one was a slightly different length, so I helped them."[1] With Bennett's editing, instead of triumphantly dashing through the fields, Andrews is running for her life, dodging the walls of flames that scorch the once-verdant alpine landscape.

Much of the original *Sound of Music*'s opening scene was shot from a helicopter, with crew members hiding in bushes yelling directions to Andrews with megaphones because she couldn't hear them over the roar of the hovering choppers. In addition, she was barely able to stand up due to the downdrafts from the helicopters. As you watch Bennett's film, it's also hard to ignore the fact that *The Sound of Music* was released in 1965, the same year that the United States was escalating its military forces in South Vietnam, culminating with that year's carpet-bombings during Operation Rolling Thunder. But Bennett refutes specific political interpretations of her work, instead preferring the surreal juxtapositions to speak for themselves: "You can elevate people into a more fluid mental state where they are willing to perceive things differently, in a non-straightforward way, particularly with collaged audio composition or radio. The incongruous nature of humor, and also collage, leaves space for various levels of interpretation."[2] She also refuses singular artistic categorization: "I don't fit in the film world, I don't fit with the music world, I don't fit in with the fine-art world. I like all of them, but if you ask me to commit to any one of them, I won't. I consider myself an UbuWeb artist, if anything."[3]

As one of the few women working in the field of sound and film appropriation, she dismisses the label *feminist* as rapidly as she does any other. Although she participates in festivals such as City of Women and Ladyfest, she sees them as just another outlet, claiming, "I don't want to be chosen because of my biological makeup; I want to be chosen because of my output. And if that is true—that I'm one of the few women working in this field—wouldn't I be doing better than I am now? I'm not doing badly, but I could be doing a lot better."[4]

As a child growing up in rural Suffolk, England in the 1970s, she was a voracious home taper, recording all the audio she could off TV and radio. From early on, the idea of singularity—just one of something—never made sense to her. When she was fourteen, she put ads in underground zines with her address, asking to be in touch with other isolated kids. She soon became a part of postal network, in which kids would send each other homemade tapes and weird video cassettes. The mail network turned into real-world friends, whom she would visit: "I did the analog internet, which meant the post, trains, and buses."[5]

Those networks provided her with ever-increasing exposure to alternative culture. She soon became a fan of the films of Kenneth Anger, whose use of pop culture and found footage resonated with her. She also responded to the religious and occult aspects of his works, which would prove to be foundational to her future aesthetic. When she was fifteen, she taped *Scorpio Rising* (1963) off U.K. Channel 4 TV late one night:

> I knew of Anger as an occult film maker, which intrigued me. I also loved it that the chance element entered *Scorpio Rising* in terms of the Christian film being delivered to him by accident. Also his innocent use of sampling—in the true folk way—that you just take it and use it. That's what pop music is for: to use. In terms of permission, the film seemed like a cross

between a sort of fan flick and also an appropriation or collage film. I loved the playfulness and humor but also the underlining sinister edge, the menace.[6]

Bennett's reference to "the Christian film" concerns an incident that occurred while Anger was editing *Scorpio Rising* at his home in the Los Angeles Silverlake neighborhood. One day a 16mm-film package was left on his doorstep. Since it was a film, he assumed it was for him and opened it. To his surprise, it turned out to be a Sunday school film that had been ordered from a local branch of the Lutheran Church. Puzzled, he looked at the package more carefully, whereupon he realized that it was addressed to the identical house number, but on a different street; through a postal service error, it had arrived on his doorstep. He kept the film, taking it as a sign and thinking, "Well, I'm just going to keep this and cut it into my film. And that's how I got *Last Journey to Jerusalem* (1948). I thought of it as the gods acting up, doing a little prank, doing me a favor. The film was perfect for my purposes."[7] This story inspired Bennett to embrace serendipity and magic. "As an artist my relationship to the occult is that the 'occult' means hidden, or perhaps buried, and the purpose of magic (by different definitions of the word) is to reveal, uncover." She does this through collage as a way to disorient the viewer-listener and let the unconscious guide the construction and reception of her works. "We can only break free from the cycle of repetition and mundane by breaking things," she says, "by breaking through, turning things upside down."[8]

She attended art school briefly in 1987, studying "alternative practice," one of the few media courses being offered at the time at Brighton Polytechnic. She found her professors to be bitter, insisting on tearing down vulnerable students rather than offering constructive criticism. They accused Bennett of being there only to use the edit suite (which was in part true). In response,

she decided to dedicate her life to making art that elevated rather than criticized. Dropping out in 1989 and finding herself without the expensive college editing suite, she relied on what was readily available, remixing her own audio on a double cassette deck and a secondhand Amiga 500 computer with an 8-bit (£26) cartridge sampler, and two VHS video recorders, which she would use to make experimental artworks that combined rental-store videos with live-TV feeds.

From 1990 to 1993, she did a radio show in Brighton based on these tapes, which eventually became the basis for her early LPs. Her infatuation with radio never ended. Since 2003, she has been doing a radio show on WFMU that blurs the boundaries between radio host and artist; the show, which she mixes live, sounds an awful lot like her albums. In 2012, she organized Radio Boredcast, a 744-hour experimental online radio project that included everything from BBC maritime shipping forecasts to punk-rock cover versions of Balinese *kecak* chants.

She self-released her first LP, *Another Kind of Humor*, in 1992, a twenty-minute collage of found sounds comprising James Brown–like organ riffs, snatches of recorded television speech, blasts of Moroccan horns, drones of Gregorian chants, sound bites of Frank Sinatra, and overly familiar Beatles riffs—all floated atop waves of radio static and bursts of random noise. Although the album was formative, its relentlessness and flow signified the direction her mature works would later take. Bennett's influences include the collaged sequences in the Mothers of Invention's albums *Absolutely Free* (1967) and *We're Only in It for the Money* (1968) as well as early Residents albums such as *Baby Sex* (1971). But Bennett owes her aesthetic mostly to Nurse with Wound's *Sylvie and Babs Hi-Fi Companion* (1985), composed of sampled easy-listening records, which Stephen Stapleton described as "a record that was stolen from

other people's records."[9] With John Oswald's notorious album *Plunderphonic* (1989)—which used unpermissioned samples of everybody from the Beatles to Beethoven—Bennett found a genre that felt like home. Oswald figured that if he gave the record away instead of selling it, he'd be able to sidestep the thorny copyright issues. Even so, when the Canadian Recording Industry Association caught wind of the recording, they ordered it destroyed, which only made it more famous. Today, it's all over the internet, including on UbuWeb.

From 1994 to 1999, Bennett released a string of CDs on Staalplaat, an independent label dedicated to sound art. With each successive release, she honed her aesthetic. Moving away from the anything-goes nature of *Another Kind of Humor*, she began to focus more specifically on surgically constructing pop-oriented pieces based on older found material. The works became more nostalgic, more emotional, and more autobiographical, drawing heavily from the media sources available to her in the rural upbringing of her youth in the 1970s—soundtracks from the variety shows and old movies that she taped off TV, dusty LPs she found in charity shops, the sound of easy-listening and pop music streaming from AM radio. She also reached farther back to media sources of the 1940s, imbuing her audio works with a gauzy sense of requiem for an empire in decline. Combining the sounds of high-toned BBC radio narrators and dry ballroom orchestras with throwaways from Paul McCartney and Wings, she traces an audio arc that stretches from the glories of Winston Churchill to the austerities of Margaret Thatcher. By doing so, she offers an alternative narrative of postempire Britain, one different than the more familiar mix of unemployment, punk rock, and urban decay. In these works, youthful rage is swapped for wistful interiority, suggesting more Gavin Bryars ("The Sinking of the Titanic") than Johnny Rotten ("God Save the Queen"),

resulting in an intimate and personal music. Bennett creates a sample-based music that is warm and rich, a rarity in a field that tends toward the cold, clinical, and cynical.

In the late 1990s, Bennett began incorporating found footage from the Prelinger Archives into her work. The archives are a vast online repository of more than 60,000 ephemeral films that Rick Prelinger had been collecting since 1983, when he began fishing decaying 16mm reels out of dumpsters from libraries that were looking to lighten their load. Many of the films were educational or industrial films from the 1950s; there were also a lot of home movies. Orphaned, unloved, and unclaimed, they became his property. Over the years, Prelinger has made nearly 7,000 of them available for free on archive.org, encouraging their creative reuse and remixing. At the same time, he licenses the identical footage to commercial entities who are required to pay in order to clear copyrights. So if you've ever seen a Hollywood film that uses a clip of the famous Cold War propaganda film *Duck and Cover* (1951), Rick is getting a paycheck from that. But if, like Vicki Bennett, you want to use *Duck and Cover* in an artistic project, then it's yours for free. Prelinger figured out how one cultural artifact can flow through two different economies—at the same time—without interfering with each other. Access to the Prelinger Archives made Bennett's practice much easier; instead of laboriously ripping scenes from VHSs and DVDs, she was now able to procure previously digitized films, which could easily be tagged, edited, and repurposed.

Bennett's earliest films are a series of shorts made as music videos for her CD *Thermos Explorer* (2000). Yet unlike most music videos, Bennett used a reverse process. In the late 1990s, she received a bunch of VHS footage of old educational and industrial films from a friend in her mail network. She loved the dated sound of these films—stiff, white, authoritative, male narration over easy-listening music. She ripped the soundtracks

from them, remixed them slightly, and released them as stand-alone audio pieces. A year or two later, when the Prelinger Archives went online, Bennett found these same films there, downloaded them in digital form, and soon forged a friendship with Rick Prelinger, who would digitize films upon her special request, which she would remix to correspond with the audio works as sort of reverse ready-made music videos.

She soon began downloading films en masse from Prelinger, stitching together found footage from the 1950s similar to *Duck and Cover* to create works such as *The Remote Controller* (2003). Clocking in at a mere nine minutes, the film disassembles masculinity through the metaphors of the Cold War and its machinery. One scene shows two boys and their toys, remote controls in their hands, gazing up at the night sky as a deadpan narrator intones, "This work doesn't even require separate motors, while the driver contains just enough of the control to be the real boss at all times." In another, we see a man furiously twisting a bank of knobs as the same narrator says, "In no other application does the use of remote control benefit us so much. Ours is merely the life task of remote control. Remote control is a big factor in modern living." Circling back to reference Bennett's own practice, remote control is also a large factor in the way she constructs her works—composing and filmmaking, sampling, and digital editing.

Beginning in 1998, she began giving away MP3s of her work at no cost, reasoning that "the more you give away, the more people find out about your stuff." Since the collapse of the CD industry, the common wisdom is that you'll never make any money from the sales of physical media, and the only way artists can make a living is from incessant touring, an idea that Bennett refutes. Instead, she insists, a combination of various free and paid artifacts and performances works. She gives her work away for free on UbuWeb, while at the same time selling it on

Bandcamp. Explaining this discrepancy, Bennett posits: "I think that people who are buying it are people who can't be bothered to look for it online elsewhere, they're coming from a different network. The people who buy my stuff on Bandcamp are people that I've never heard of. But I always know who the people are that buy my physical product. They're fans who tend to buy everything I produce."[10]

In a quarter of a century of remixing other people's works without permission, she has had copyright troubles only once, when she mashed up Andrei Tarkovsky's *Stalker* (1979) with *The Wizard of Oz* (1939). Surprisingly, the cease and desist came from the Tarkovsky end rather than the lucrative *Oz* franchise. While sitting through a screening of the notoriously languid *Stalker*, Bennett had an epiphany: the only other film that turned from black-and-white to color that she could recall was *The Wizard of Oz*. Making a mental note of this, she went back to her studio and downloaded both films. Viewing them side by side, she realized that beyond the color transformation, both are shamanic journeys in which the protagonist is forced to go through a traumatic experience. Loading both films into a video-editing program, she began running one film forward and the other backward from the point at which both go from black-and-white to color. She called the resultant film *The Zone*, which she describes as "revealing delightful harmonies and synchronicities both in images and narrative occurring far more than either pure chance would dictate or the imagination construct. . . . Most of all I wanted to see if something magical happened, like making a spell. And for me, that magic did happen."[11]

She completed the film in two weeks, and it was written up in the London-based music magazine *The Wire*, whereupon the British Film Institute offered to screen it. The notice of the screening caught the eye of a Tarkovsky scholar, however, who was so outraged that Bennett would dare edit or alter the

director's work that he got in touch with *Stalker's* Russian distributors, Mosfilm, who sent Bennett a cease and desist days before *The Zone* was going to be shown at the opening night of the Transmediale festival in Berlin. The British Film Institute cancelled the screening, as did Transmediale, which instead of showing the film projected a slide image onto the large empty screen: "Tonight you were supposed to see the video work *The Zone* by People Like Us. This work of appropriation art refers to two historic films: *The Wizard of Oz* (1939) by Victor Fleming is screened on the left, on the right *Stalker* by Andrei Tarkovsky (1979). . . . But unfortunately the legal department of one of the copyright holders, Mosfilm, insisted on stopping the distribution of *The Zone*, which is why it has been withdrawn from circulation. Therefore we are not able to show the work right now."[12]

The film was buried and never shown again, so Bennett was surprised when a few years later Curzon—the big U.K. cinema chain—got in touch with her and invited her to show *The Zone* as part of a Tarkovsky festival in their theaters. She wrote back, telling them of the cease and desist, whereupon she received a reply informing her that in fact Mosfilm had never owned the rights but were simply trolling, sending cease-and-desist notices to everyone (including the British Film Institute), who believed them without question. Upon further inquiry, Bennett learned that the true owner of the film was now Curzon, which was why it was doing the Tarkovsky festival and inviting her to be in it. For logistical reasons, things never worked out with Curzon, but Bennett is now free to show the film as she pleases.

Bennett's works can take decades of collecting, assembling, and editing. She's constantly gathering material—scanning through thousands of films and editing out bits that attract her attention. She then tags them and files them away for future use. Certain motifs eventually tug at her, and she goes into her archives and begins to cull material related around a certain

subject. Once she decides on a theme, she digs deeper, using every available resource—from social media to the web—where she harvests more focused material. Finally, when she feels she's collected enough, she prints out the file lists and descriptions, cuts them into small strips, lays them out on the floor, and begins intuitively arranging them into complex navigational maps. Through that largely unconscious process, a film emerges. When it finally begins to take shape, she moves the storyboard back into the computer and begins constructing the film.

A recent film is called *The Mirror* (2018). As the title suggests, it is organized around the theme of mirrors and reflectivity, samples of which she had been collecting for years. Where she used just two films for *The Sound of the End of Music*, here she mashes up scenes from the span of cinema history—from *Metropolis* (1927) to *The Matrix* (1999)—into a relentlessly dense and dizzying thirty-four-minute dream state. The amount of source material she used is staggering, comprising more than 300 films and nearly 6,000 audio samples.

The film is a montage of footage of mirrors, reflections, surfaces, doors, water, escalators, revolving doors, windows, circles of Busby Berkley dancers, flashing lights, disco balls, and so forth. As the film progresses, these images ultimately break down—escalators start running backward, revolving doors jam, water overflows and floods, dancers spin faster and faster, and windows blow out. The mirrors eventually crack, then break, unleashing chaos and destruction as fires erupt and earthquakes devour entire buildings. As in a cubist painting, there are no solid surfaces in the entire film; rather, the images form a whirl of motion, with one scene sliding into another. Although there's a vague narrative arc—from birth to chaos to death and back to birth—instead of telling a story Bennett displays the various—mostly paranoid—psychological states that occur when one views oneself in a mirror. The history of

psychology and the mirror is well known, so Bennett sidesteps direct references to, say, Lacan, choosing instead to illustrate those psychological states with preexisting film footage.

The soundtrack comprises sounds with metallic and repetitious tones: clocks, harpsichords, and looped samples of tinny pop songs. Sometimes the songs used refer to mirrors, as in the case of "Both Sides Now." Other times the music illustrates on-screen content, as when she creates a mashup of the Velvet Underground's "I'll Be Your Mirror" and Don McLean's "Vincent (Starry, Starry Night)" to accompany reflective nighttime footage of UFOs swiped from *Close Encounters of the Third Kind* (1977) overlaid with scenes from *The Ten Commandments* (1956).

The film is chock full of familiar movies, ripped out of context, run backward, and spliced together with other films. Bennett cuts Tippi Hedren from *The Birds* (1963) fighting off swarms of birds that enter a house through the fireplace with armies of chimney sweepers tumbling down fireplaces from *Mary Poppins* (1964). In one moment we see Cinderella gazing into a mirror, and in the next piles of dishes tumbling off shelves as passengers scramble up the deck of the sinking Titanic. Reminiscent of *Scorpio Rising*, *The Mirror* includes lots of campy religious content, such as Charlton Heston parting the Red Sea in *The Ten Commandments* and Linda Blair's fitful possession in *The Exorcist* (1973). The last ten minutes get even more religious, with whirling parades of demons, columns of circling nuns, toppled altar candles that set crosses and churches ablaze, possessed priests, and frightened parishioners. The film's final scene is a Blue Meanie from *Yellow Submarine* (1968) sucking the world and all its impending chaos right up into its nose, whereupon it disappears, sucked into a white void.

Her hard drives stuffed with untold numbers of film and music, Bennett very well might go on recycling previously existing material forever. But that's exactly the point. Remixing

preexisting materials is a portal to new and unexpected connections, sensations, thoughts, and consciousness. Reflecting on her process, she gets to the heart of what is so transformative—artistically and spiritually—about her practice of remixing the world that surrounds her:

> We're forever experiencing all sorts of things that we're missing out on because we've only got two eyes and two ears; but our nervous system makes it necessary that we have to limit our appreciation through that. I try and make my art to be like the experience we get with our senses, but you know, collage is a very deep thing in that it's many, many layers of things, and I like it that people bring their own experience to it, but obviously I'm in there too, because I'm obviously manipulating and affecting their experience as well, but hopefully in an elevating, positive way.[13]

8

ASPEN

A "Multimedia Magazine in a Box"

n 2002, UbuWeb received an email alerting us to a site called Understanding Duchamp, a lovely primer about the life and work of Marcel Duchamp. I wrote back thanking the sender for sharing the site with us, along with a compliment about how thoroughly researched and well designed the site was. A San Francisco book dealer named Andrew Stafford replied to thank me for my comments and then told me his story. Around the turn of the millennium, he had become infatuated with the potential to translate what was sitting on his shelves onto the web. He taught himself Flash and built understandingduchamp.com. "Fair enough," I replied, "but why are you reaching out to UbuWeb about this?" He responded that if I liked his work on Duchamp, I should see his next project, which he had under lock and key, password protected. I responded that I'd be interested and was sent a URL. When I saw what was there, I couldn't believe my eyes.

Stafford had meticulously digitized the entire run of a legendary multimedia avant-garde magazine called *Aspen*, subtitled *The Multimedia Magazine in a Box*. Published between 1965 and 1971, each issue came in a box—resembling a thin typewriter-paper or multidisc LP box—crammed with booklets, phonograph recordings, posters, postcards, and spools of Super 8 movie film.

Each box had an editor, and every box had a different theme. For instance, "The Pop Art Issue" (1966), designed by Andy Warhol, included items such as Lou Reed's writing about rock 'n' roll ("The only decent poetry of this century was that recorded on rock-and-roll records"); a forty-five-second lock-groove flexi disc of a feedback-drenched guitar solo by the Velvet Underground's John Cale; a set of a dozen postcard-size reproductions of paintings by artists such as Jasper Johns, Bridget Riley, James Rosenquist, and Willem de Kooning; underground movie flip books containing snippets of Jack Smith and Warhol films; a collection of papers given at the Berkeley Conference on LSD; and a copy of *The Plastic Exploding Inevitable*, a Warhol Factory-produced one-shot underground newspaper.

The next several issues were just as rich, focusing on topics such as Marshall McLuhan, minimalism, swinging London, performance art, Fluxus, and psychedelia. In all, there were 235 contributors, many of whom, such as Roland Barthes and Susan Sontag, were cultural giants of the 1960s (both Barthes's seminal essay "The Death of the Author" and Sontag's essay "The Aesthetics of Silence" found their first English-language publication in *Aspen* numbers 5–6). Issues, sold by subscription ($4 an issue, $20 a year), were quickly snapped up by collectors and libraries. In its day, the magazine's circulation was 15,000 to 20,000. Today, a copy of the "Pop Art" issue signed by Andy Warhol goes for nearly $23,000, while a complete unsigned run costs around $13,000. Aside from in private collections and dealers, today the physical *Aspen* issues can be found in museums and libraries, with limited access to the now-fragile materials.

Stafford, who honed his web-building skills on understandingduchamp.com, turned his attention to digitizing a set of *Aspen* issues he acquired during the 1990s. Working a few hours each evening, he digitized the full run in about a year. He converted flexi discs into MP3s and, using a film projector, Super 8 reels

into QuickTime files. He even adapted a seven-foot-tall Tony Smith metal sculpture into both a 360-degree QuickTime model that you could rotate and a cardboard model that you could print, cut out, and assemble in miniature. He re-created a piece by Mel Bochner—originally a series of seven transparent plastic sheets—into a web interface, whereby running your mouse over each one and clicking would bring the lower layers to the fore. Even in 2018, Stafford's meticulous conversion is still an outstanding example of how materially based documents can be elegantly transferred to the web so that anyone interested can have access to them. No appointments made in libraries or museums: it's all right there on your screen.

But why did Stafford go through all this effort? Citizen-based activism promoting access to cultural artifacts. Stafford wrote me, "I was in the rare-book trade and was a big fan of *Aspen*, and it bugged me to see them vanishing into art museum collections where nobody would ever get to see them or read them. I thought getting the content in front of people would be a worthwhile project."[1] But back in 2001, when he created understandingduchamp.com, he was hit with a cease and desist from the Duchamp estate over his use of images. The estate demanded $3,125 at first; after Stafford pushed back, the fee demanded was lowered to $2,000. Stafford stood his ground, claiming that his use was a case of fair use. The estate finally went away, but the incident left Stafford rattled. "Arguing with one artist's estate was headache enough for me," he wrote. "I felt sure that posting *Aspen* on the net would bring 250+ more complaints. Who needs it? UbuWeb had earned a place as one of my desert island websites, *Aspen* seemed like a good fit, and you appeared unintimidated."[2]

In December 2002, a month after UbuWeb launched *Aspen*, the *New York Times* wrote it up. When the reporter contacted me, I repeated the same thing I've been saying for decades: "Over

the years I've found that people only come after you for rights when you're making money. Since UbuWeb is completely free, nobody has ever really bothered us about rights." The article continued: "[Goldsmith] said he removes entries when living artists complain, but that rarely happens. 'Most artists who find their stuff on UbuWeb are thrilled,' he said. 'Avant-garde artists rarely expect royalties. They want an audience.'"[3]

The *Times* asked some of the original contributors how they felt about having their work online without their permission. Jon Hendricks, who edited "The Performance Art Issue," said, "The idea was to get the information out rather than to think of it as property." And the executive director of the Cunningham Dance Foundation had no objection to the audio of Merce Cunningham's voice on UbuWeb without the foundation's permission, stating, "The educational value of having Merce's thoughts out there on the Web outweighs our motives of ownership."[4]

Stafford remained concerned that his work would eventually be eroded by lots of tiny copyright claims—death by a thousand cuts, so to speak. "Losing just 10 percent of the contributors would reduce its [the *Aspen* collection's] usefulness by at least half," he told the *Times*.[5] But his fears turned out to be a mirage; like so much copyright of avant-garde materials, few bothered to enforce them. Yet years later, in 2011, I received an email from a lawyer representing Yoko Ono, requesting the removal of all of Ono's and Lennon's films on Ubu. Not wanting to tussle with a multimillion-dollar estate with unlimited resources, I quickly apologized and removed the films in question. A few days later I received another request from the same lawyer saying that he had discovered Ono and Lennon's *Aspen* materials (Lennon's diaries and Lennon/Ono experimental audio works) and requested that they be removed as well. Keeping Stafford's wishes in mind, I responded that I would remove the files if he wished,

but I just wanted to ask you whether, in this one case, you might make an exception. The files you cite are from *Aspen* magazine, a multimedia arts magazine from the 1960s, and Ono's works are very important to its history. About a decade ago, someone digitized the entire edition and we've been hosting it ever since. It was deemed so historically important that the *New York Times* wrote up the fact that *Aspen* was digitized on Ubu. The Ono and Lennon works are a part of this history and it would be really great if you'd permit them to stay. Would you consider giving us permission to host these few MP3s?[6]

Surprisingly, I received this affirmative response: "Provided you will take the referenced files down in the event we request so in the future, you may retain them on UbuWeb for now."[7] Nearly a decade later they're still there.

But not all stories end as peacefully. Eight years after the Cunningham Foundation said that having Merce's words on *Aspen* was invaluable, we received a takedown notice in 2010 from the Cunningham Foundation on those exact materials. I politely referred the newer employee to the *Times* article and pled for clemency, to no avail. He insisted that the file—one MP3—be removed. But the claim turned out to be fraudulent: Stafford provided scans of the flexi disc, and there printed in bold letters were the words "Copyright: Section 12, *Aspen Magazine, No. 5+6*." Back when those recordings were made, Merce Cunningham didn't bother to copyright them under his name, unlike the more business-savvy Ono and Lennon, who did. I sent the scans to the Cunningham Foundation, and to this day Merce's recordings remain on the site, and *Aspen* as a whole remains completely intact.

● ● ●

Aspen is as direct a precursor to UbuWeb as there can be. There's a generosity in *Aspen* that I found inspiring. In the spirit of its

time, *Aspen* proposed an alternative distribution system to the commercial galleries and auction houses. *Aspen* was utopian: What if elitist and unique artworks could be transformed into multiples that anyone could possess? While *Aspen's* gesture was radical at the time, today the reformatting of physical artifacts is the way we often experience artworks. Instead of an emulsion-based photo, we have a representation of a photo on Instagram; instead of celluloid projected on a huge screen, we have a representation of cinema on YouTube; instead of a lusciously bound book, we have a representation of a book as an EPUB. And what of authenticity and uniqueness? Judging by the hundreds of artists who contributed to *Aspen*, they were delighted to do so (*Aspen* was done in collaboration with these artists). Politically and aesthetically, they were happy to make their work available to more than just a select few. More than half a century ago, *Aspen* proposed a more flexible understanding of an art object: that an artifact might have more value if distributed democratically than if squirrelled away, silently accruing value in a free-port warehouse halfway around the globe. One glimpse at the number of art-book fairs around the globe, where you can pick up editions and multiples cheaply, coupled with the abundant treasures of the web, and *Aspen* appears absolutely prescient.

The magazine showcased artists adapting their meatspace practices to a portable mass medium. Several prominent artists such as Marcel Duchamp, Richard Hulsenbeck, John Cage, and Morton Feldman, for example, permitted their voices and music to be recorded on cheap plastic flexi discs, which at the time were mostly found glued to the back of breakfast-cereal boxes or bound into the pages of popular magazines. But between 1963 and 1969, the Beatles recorded an annual Christmas flexi disc for their fan club, which sometimes included experimental or noncommercial material, making Lennon and Ono's *Aspen* flexi discs a natural fit. Included with *Aspen* number 7 was a flexi disc

by John Lennon called "Radio Play," where he twiddles with a radio dial for nearly eight minutes; it was published in the spring and summer of 1970 right as the Beatles were breaking up. In the same issue, Lennon published a miniature facsimile of his diary for 1969, which, at two inches by three inches, contained 132 pages. Each page is rendered in large—and largely illegible— script. Most daily entries are variations on the theme "got up. went to work. came home. watched telly. went to bed. fucked wife."[8]

Lennon's sexist rejoinder was answered loudly on the pages of *Aspen*. More than 10 percent of the contributors in *Aspen* were women—not great numbers, but for its day better than average— and many of the works were explicitly political and feminist. In particular, *Aspen* number 6A, "The Performance Art Issue," published in the winter of 1968–1969, featured several women

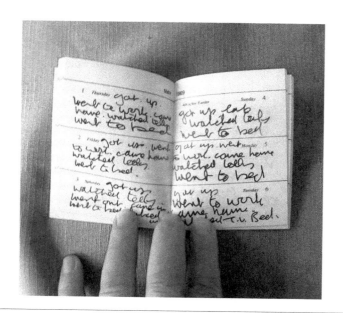

8.1. John Lennon, "The Lennon Diary," 1969.

whose works were focused on dismantling patriarchy and protesting the Vietnam War. Their contributions were taken from a festival at Judson Church in October 1967 called "Twelve Evenings of Manipulation," which was curated by the issue's editor, John Hendricks, a painter who, frustrated by traditional visual art's inability to have a direct impact on the Vietnam War, became an activist and turned to performance art and happenings. Given the chance to edit an issue of *Aspen*, he reprinted documentary materials by artists that were a part of his festival.

In an editorial note in the issue, Hendricks advocated the role of the artist as social activist: "This is a unique communiqué to you from artists who are concerned with the corruption of culture by profit. We believe the function of the artist is to subvert culture, since our culture is trivial. We are intent on giving a voice to the artist who shouts fire when there is a fire; robbery when there is a robbery; murder when there is a murder; rape when there is a rape."[9] Remaining consistent to Hendricks's antiprofit motives, *Aspen* number 6A was the only issue distributed free of charge.[10] An accompanying poem by Hendricks printed at the bottom of his editorial note made his feminist intentions explicit:

> our culture is not
> essential. our culture
> is a decadent play
> thing of the rich.
> our culture is a
> manipulator of the
> poor and oppressed.
> there is no "Black
> Culture" there is no
> "Poor Culture." there is
> only a culture of the
> big prick.[11]

Aspen number 6A features the second-wave feminist Kate Millett's eight-page documentation of her performance at Judson on October 21, 1967, called *No*. She describes a large, closed wooden cage with dowels as bars that she built in the middle of a gallery for visitors to observe as a beautiful minimalist sculpture. After a short while, the viewers were led out of the gallery and made to wait. During this time, a few dowels were removed from the front of the structure, creating an opening. With the lights darkened, the audience was brought back into the gallery and led inside the structure. The missing dowels were then quickly replaced, and when the lights went on again, the audience unexpectedly found themselves imprisoned. Millett describes the piece and the process in detail, including the prisoners'

8.2. Kate Millett, *No*, 1967.

reactions, which swung from euphoria to severe paranoia. After an unspecified time, the prisoners literally broke the bars, opening up a path of egress, out of which everyone quickly flowed and fled the gallery, many quite traumatized.

A mix of Stanley Milgram's electric-shock experiments and minimalist art, Millett's work was slyly critiquing power structures as they applied to the art world and addressing the larger political landscape of the time. The timing of the piece was intentional. She wrote, "The Judson series had been named 'Destruction and Manipulation.' This event was given on the day of the march on Washington and the Pentagon. Claustrophobia is appropriate on many occasions." Although she expressed misgivings about the act of caging others, she felt the action was necessary to frame, in the most literal way, her ongoing battle against patriarchy: "Cages are not new to me: I have known them for a long time."[12]

On October 20, 1967, the day before Millett staged her piece, Lil Picard, a sixty-eight-year-old artist and refugee from Nazi Germany, did a performance in the same series called *Construction-Deconstruction-Construction*, which was realized in *Aspen* as a four-page booklet consisting of notes and collages entitled "Peace Object." Picard, who began performing in Berlin's Weimar cabarets, brought that era's song and pantomime into her protest pieces of the 1960s, which consisted of her performing exorcisms on symbols of power such as flags or media images of Vietnam War atrocities. For one performance, she washed an American flag, while the Warhol superstar Julian Burroughs spoke unscripted for half an hour about what was wrong with America. At Judson, she burned images of global violence in front of the audience. She then put the ashes in plastic bags and shone various powerful colored lights on them— white for purity, red and green for war and peace. She also hung

a quilt from the ceiling and projected war imagery upon it, after which she washed it with clear water, turning traditional women's labor activities of washing and cleansing into an antiwar, feminist statement.[13]

On October 19, 1967, as part of the same series, Carolee Schneemann performed *DIVISIONS AND RUBBLE*, which appeared in *Aspen* as two legal-size sheets of paper printed on both sides. Like Millett, Schneemann constructed a cage in the gallery—this time out of wire—to which she attached photos of atrocities committed during the Vietnam War. When visitors entered the cage, strong fans were turned on, blowing the photographs so that they slapped the visitors as they moved through the space. Schneemann wanted to create "an environment which people will have to destroy to enter it, to move in it: means of action altering action/means of perception altering perception. An exposed process."[14] To this end, the cage was packed with detritus from consumer culture—old clothes, food containers, discarded toys, dirty papers—that she found on the streets and through which visitors had to kick or climb over. The intention was to create an environment that was "grim, dark, and dirty." The assaultive nature of the work, like Millett's piece, was meant to physically engage the viewers in uncomfortable ways, making manifest the uneasiness and pain of the current political situation.

Schneemann's contribution to *Aspen* is at once a documentation of a performance as well as a prose poem. Sandwiched between descriptions of the performance are paragraphs of disjunctive word bursts ("STAR LUST ROCKET SHIP remember star lust lust lust to be star to be shaking sky ward lust") and political musings ("those north americans hard stiff cold repressed brutality sentimentality wouldn't hurt a dog might just kick a dog moving into icy psychic technological 'cool' have to turn them all on and on falling in love they are full of hope and

fearful emotion").[15] Her intentional "destruction" of her text mirrors the intention of her installation and performance.[16]

● ● ●

Aspen number 8, edited by conceptual artist Dan Graham and designed by Fluxus founder George Maciunas, focuses on information-based art. In his editorial statement, Graham proposes that his issue of *Aspen* could be more than just an avant-garde artwork cum magazine. Perhaps it could be a critique of a magazine, one that "redefine[d] the magazine's place in (and as) art in (and as participant in), the larger world."[17] He also saw how, as he explained in the mid-1980s, in the age of mechanical reproduction the image of an artifact would outlive the artifact itself, perhaps becoming an entirely new artifact:

> Through the actual experience of running a gallery, I learned that if a work of art wasn't written about and reproduced in a magazine it would have difficulty attaining the status of "art." It seemed that in order to be defined as having value, that is as "art," a work had only to be exhibited in a gallery and then to be written about and reproduced as a photograph in an art magazine. Then this record of the no longer extant installation, along with more accretions of information after the fact, became the basis for its fame, and to a large extent, its economic value.[18]

"In the case of pop art," he stated in an interview in 1994, "instead of taking things out of media, I decided to put them back into media. Instead of having a show that had a photograph and a critical piece of writing about the show to validate its meaning, the idea was to stage the entire thing directly in a magazine."[19]

Like the art done by many others in the period when *Aspen* was published, Graham's own work questioned the institutional

structures of the artwork as well as its place in the traditional market system. By the mid-1960s, he rejected galleries as his primary art practice, instead turning toward media interventions. In 1968, he bought ad space in *Harper's Bazaar* and placed a work of conceptual art in it. The piece, entitled *Figurative* (1965), is a photograph of a paper adding-machine tape that displayed columns of numbers. Taken on its own when it was created a few years earlier, the photograph was a sly play on the word *figure*, which means "number" and is defined as "especially one that forms part of official statistics or relates to the financial performance of a company" as well as "a person's bodily shape, especially that of a woman and when considered to be attractive" (*Oxford Dictionary of English*). Graham was proposing that numerical systems were interchangeable with the systems by which we measure out bodies, or what today we refer to as the "quantified self." Yet when this identical piece was published in a fashion magazine and wedged between two ads—one for Tampax

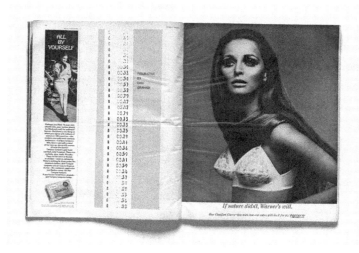

8.3. Dan Graham, "Figurative," 1965.

and the other for a bra—it became a critique of capitalism's intertwinement with, investment in, and exploitation of the female form (economic figure/female figure).[20]

In his loopy editorial introduction to *Aspen* number 8, Graham expounded on these ideas, proposing that all the works he selected for this issue could find another life as collaborations with advertising agencies, which would distribute these works in glossy magazines, as he had done with his *Harper's* intervention. Because so many of these artists trucked in information and photography, the distribution through the mass media would replicate their artworks on an industrial scale, while the ad agencies would stand to gain in reputation by their affiliation with these artists. He also proposed that the revenue from these ventures should not only go to the artists but also fund exhibitions of their collaborative ventures that the public could attend for free (the corporations would naturally pick up the admission fees).

Graham called this form of art not "information" but "in-formation," claiming that the form and distribution of information and ideas are restless and ever changing. What appears in a magazine at one moment can reemerge as a museum exhibition elsewhere. And beyond that, the nonlinear nature of his editorial introduction had a purpose; he wanted to keep readers off balance so that their idea of what he was saying would constantly be "in-formation" rather than complacently settled and received as "information."

"In-formation" strikes me as a good way to describe the way cultural artifacts flow across our networks. When Word documents can become PDFs with a click, which can then be spammed to a listserv, which can then be printed out, the materiality of that artifact is constantly and restlessly "in-formation" while at the same time remaining "information." Editorial/art

and advertising have dovetailed in ways that Graham anticipated. What museum show today is not underwritten by a corporation? And, likewise, what corporation does not gain from an affiliation with prestigious artists, particularly ones with strong markets and the cache of "genius"?[21]

Graham's *Aspen* editorial ends with a postscript, a visual poem entitled "Exclusion Principle" (1966), which is a cosmological schema—from the nearest to the farthest—rendered in eleven short lines:

1,000,000,000,000,000,000,000,000.00000000 miles to the edge of known universe
100,000,000,000,000,000,000.00000000 miles to edge of galaxy (Milky Way)
3,573,000,000.00000000 miles to edge of solar system (Pluto)
205.00000000 miles to Washington, D.C.
2.85000000 miles to Times Square, New York City
.38600000 miles to Union Square subway stop
.11820000 miles to corner of 14th Street and First Avenue
.00367000 miles to front door of Apartment 1D, 153 First Avenue
.00021600 miles to typewriter paper page
.00000700 miles to lens of glasses
.00000098 miles to cornea from retinal wall[22]

In addition to reconfiguring the universe as both "information" and "in-formation," Graham displays a relativist map for what would become land art, encompassing everything from anthills to volcanoes. If media were one way of moving outside of the gallery and commodity system, then land art was another. *Aspen* number 8 featured a number of works by land artists, including a dense textual work by Robert Smithson. Beginning his career as a painter, Smithson gradually expanded his practice to include conceptual art, video, poetry, and critical theory, eventually exploring the nexus between the gallery and the wilds. Smithson never really stopped showing in galleries,

but he found a way to bring nature into the gallery in symbolic form.

Smithson's contribution to *Aspen* number 8 is entitled "Strata, a Geophotographic Fiction." It's a dense, all-caps text interspersed by photographic bands of rocks and fossils, structured around a progressive geologic timeline. Like Graham's distances in "Exclusion Principle," its timeline is vast, stretching from the formative Precambrian period 4.5 billion years ago to the Cretaceous period, the end of which signified the extinction of the dinosaurs. Crammed between bands of photos is a rambling text that feels like a transcribed notebook, containing citations from geological textbooks; lines of poetry; notes from museum visits; descriptions of rock formations, mud, fossils, and so forth. Part diary, part narrative, part fantasy, "Strata" accumulates lines of

GLOBIGERINA OOZE AND THE BLUISH MUDS. *CRETA* THE LATIN WORD FOR CHALK (THE CHALK AGE). AN ARTICLE CALLED GROTTOES, GEOLOGY AND THE GOTHIC REVIVAL. PHILOSOPHIC ROMANCES. GREENSANDS ACCUMULATED OVER WIDE AREAS IN SHALLOW WATER. UPRAISED PLATEAUX IN AUSTRALIA. SEDIMENT SAMPLES. CONIFERS. REMAINS OF A FLIGHTLESS BIRD DISCOVERED IN A CHALK PIT. CAUSES OF EXTINCTION UNKNOWN. THE FABULOUS SEA-SERPENT. THE CLASSICAL ATTITUDE TOWARD MOUNTAINS IS GLOOMY. A DISPLAY OF PLASTER TRICERATOPS EGGS IN A GLASS CASE. THE ROCKS OF MONTANA. GLIBIGERINA CRETACEA ENLARGED 30 TIMES IN A BOOK. THE WEARING PROCESS CONTINUES. A CONSTANT GRINDING DOWN OF ROUGH TERRAINS. SOMETHING HAD FANGS 6 INCHES LONG. KILLED BY THE HEAT OF THE SUN. THE SACRED THEORY OF THE EARTH CAUSES BEWILDERMENT. SOME BOOKS CONCERNING THE DELUGE BRING CHAOS TO MANY. GRAY MISTS AND MUCH HEAT. PERPLEXED BY PEBBLE DEPOSITS. COLUMNS OF BASALT ILLUSTRATED IN DE RERUM FOSSILIUM. PAINTINGS OF CRETACEOUS PERIOD SHOWN AS *ARTIST'S CONCEPTIONS* ON LARGE PANELS. FROM 135 TO 70 MILLION YEARS AGO. TRAITE DE PETRIFICATIONS. WOODCUT SHOWING TWO STONES FALLING FROM THE HEAVENS DURING A STORM. A DEAD TORTOISE. IN THE ZONE OF AIR—THUNDERBOLTS, E.G. *CERANUNIUS*, BELEMNITE, ETC. CERTAIN BEDS OF THE KEOKUK IN THE CENTRAL MISSISSIPPI VALLEY. *THE FLAMING RAMPARTS OF THE WORLD* (LUCRETIUS). DE MINERALI- BUS BY ALBERTUS MAGNUS. FEATHER IMPRESSIONS EXHIBITED IN A PALEONTOLOGICAL MUSEUM. FOSSILIZED VENOM. THE TREE ONICA WHOSE TEARS HARDEN INTO THE MINERAL ONYX. (FROM THE HORTUS SANITATIS). SOME GRAINS OF SAND WERE SQUARE AND OTHERS PYRAMIDAL. CAMERAS LOST IN SHELLS AND SKELETONS.

A LABEL UNDER A STEGOSAURUS SKELETON. BONY PLATES. THREE OUNCES OF BRAIN. 45,000,000. NO WORDS COULD DESCRIBE IT. CRAGGY CLIFFS, INDEPENDENT OF LIFE. EXTENSIVE LAKES OR INLAND SEAS MARKED AS BLUE STRIPES ON AN OVAL MAP. PLASTIC SEAWEEDS IN THE MUSEUM. A GREAT COLLECTION OF FOSSILS IN THE ASHMOLEAN MUSEUM AT OXFORD. MUNDUS SUBTERRANEUS, KIRCHER AMSTERDAM 1678. STONE PLANTS. JOHN CLEVELAND'S NEWS FROM NEWCASTLE OR NEWCASTLE COAL PITS PUBLISHED IN 1659. AGE OF CYCADS. A FINE CHALKY DEPOSIT (PERHAPS DUST BLOWN FROM RAISED CORAL REEFS). MONO LAKE—THE DEAD SEA OF THE WEST. BELEMNITES SWARMED IN THE MUDDY SEAS. POETS CELEBRATING GROTTOES. THE RECENT MONKEY-PUZZLE HAS NOTHING TO DO WITH THE JURASSIC PERIOD. WELL-PRESERVED PTERODACTYLS. THE BURNET CONTROVERSY. MANY CRAWLED ON THE OCEAN FLOOR. DELTAIC SANDSTONES OUTCROPPING IN YORKSHIRE. A MODEL OF A BRYOZOA ONE MILLION TIMES LIFE SIZE. MEANDER- ING RIVERS. *GO MY SONS, BUY STOUT SHOES, CLIMB THE MOUNTAINS, SEARCH THE VALLEYS, DESERTS, THE SEA SHORES, AND THE DEEP RECESSES OF THE EARTH* (SEVERINUS). IN BRITAIN THE JURASSIC CONSISTS MAINLY OF OOLITES AND CLAYS. RHAETIC BEDS. SEVERAL LAND-MASSES NOT SHOWN ON A MAP. LUXURIANT VEGETATION. PARADISE LOST. INVASION OF THE OCEAN. ARCHAEOPTERYX. FLESH-EATERS WALKED ON THEIR HIND LEGS USING THEIR FORE LIMBS FOR GRABBING PREY. BONES WITH AIR CAVITIES SHOWN IN LINE DRAWING. LOW TIDE. DEAD JELLY-FISH IN A LAGOON. PAINTING OF FERN FOREST. POST CARDS OF ZION CANYON. A BOOK ON URANIUM. AN *ARTIST'S CONCEPTION* OF DINOSAURS IN A SWAMP. CHART TELLS OF THE EVOLUTION OF WASTE. OVER-EXPOSED PHOTOGRAPHS OF THE SUNDANCE SEA. A NOVEL ABOUT THE LIFE OF AN ICHTHYOSAUR. NO ICE SHEETS MARKED THE POLES. INFRA-RED PHOTOGRAPHS OF THE GULF OF GEOSYNCLINE.

8.4. Robert Smithson, "Strata, a Geophotographic Fiction," *Aspen*, no. 8 (Winter 1970–1971).

poetic text the way sedimentary rock forms in layers, one atop of another. Smithson's piece is thought processes as geological metaphor, a visualization of the way one's mind works.[23]

If a notebook could be seen as a geological timeline of knowledge and thought, could we begin to view other geologies of knowledge similarly? In *The Archaeology of Knowledge*, Michel Foucault proposes that the archive is similar to geological strata, formed through disruption (metaphorically earthquakes and volcanoes) and in a constant state of disruption by similar effects. He proposes that all archives are unreliable and always, as Dan Graham would put it, "in-formation": "What appears . . . [is] a series full of gaps, intertwined with one another, interplays of differences, distances, substitutions, transformations, a sort of great interrupted text . . . describing systems of dispersion."[24] Smithson's geological strata, interrupted by photographic bands, serve as a good illustration for Foucault's theories.

Both Foucault's ideas and Smithson's piece extend into the digital age, where sedimentary archaeologies of knowledge take the form of the database or computer directory. As in Graham's "Exclusion Principle," the ability to draw a line from prehistoric geological formations to computer-directory structures requires the leap of imagination that Smithson's works inspire. When I open a folder on my laptop in a list form, I see a stratified visualization of knowledge resembling Smithson's geologic timeline. There, folders and files are nestled atop one another, sorted by date. My UbuWeb folder, for instance, which contains the entire history of the site going back some twenty-five years, is legible to me in a quick glance. Like stratified rock, my most recently modified file sits at the top of the directory, while the oldest, last modified on October 1, 1996—a month before the site launched—is at the very bottom. Like surfaces of rocks etched by steady drips over time, my file ecosystem is in a perpetual state of decomposition. Occurrences such as viruses, crashes, and

hackings alter directory structures the way earthquakes and tsunamis reconfigure geological formations. System updates render certain programs obsolete, petrifying their associated files.

Smithson's piece in the magazine is both a site and what he calls a "Non-site," a materially based translation of an actual event, thing, or place into another—often symbolic—form. In this case, Smithson is taking a geological strata rock form and creating a textual nonsite, one that is mimetic and imitative; Smithson has transformed rock sediment forming in nature into a poem on a page. Smithson describes his nonsites this way: "Instead of putting something on the landscape, I decided it would be interesting to transfer the land indoors, to the Nonsite, which is an abstract container."[25] He likens the nonsite to a map, which is a nonsite for geography, an abstract representation. In Smithsonian terms, the web is not composed of sites (websites), but of nonsites. UbuWeb is built on site—on my computer—then "displaced" to a server, where it creates a representation of itself, a nonsite (which we refer to as a "website"). But things become more complicated when on our websites we draw material from other websites, RSS feeds, and databases in order to create a page. In the early days of the web, site maps were often provided as ways of navigating a site; today, the map—Google—has truly become the territory.

What we have ended up with is a chain of nonsites that stretch back over half a century. When the *Aspen* editors, for instance, took a 16mm or 35mm film and converted it to Super 8 so that it could be included in a box, they created a nonsite. When Andrew Stafford took that Super 8 film and made a MOV file of it, he displaced in into a second nonsite. When UbuWeb transferred Stafford's MOV into an MP4 so it could be streamed on the web, then situated it within a vast archive of the avant-garde, it created a third and perhaps fourth nonsite. When a UbuWeb viewer streams that MP4 on her own computer, she displaces

the film one more time into a fifth nonsite. Thousands of people watching that film and simultaneously sharing it far and wide create a vast network of nonsites, reminding us that the web itself is a giant Smithsonian displacement machine of infinite scale, as Graham put it, from "the cornea" to "the edge of known universe."

9

STREET POETS AND VISIONARIES

One day in the mail I received a wonderful book of visual poems. They were similar to Apollinaire's *Calligrammes* but more detailed, dense, and intricate, resulting in hallucinogenic visionary images of stars, planets, and figures. As if that weren't enough, the poems doubled as autobiography, recounting bizarre stories from the author's life. One critic described them as "a cross of George Herbert's poems in the forms of angels and altars, with Burroughs, Blake and the harmonies and fractures of jazz."[1] But perhaps the most incredible thing was that they all were made with a primitive version of Microsoft Word.

I corresponded with the poet, a man named David Daniels (1933–2008), and was later lucky enough to meet him a few years before he died—by then an old man with a long, white beard—and to hear his life story.[2] In the 1950s, he was an up-and-coming New York School abstract expressionist painter. Bound for stardom, he said the wrong thing to a prominent member of the art world one night at a party—he wouldn't tell me anymore details—and was expelled from the group. Shattered, he dutifully obeyed, and after kicking around New York for several years working odd jobs, he landed in Boston, where he drifted through the streets of Cambridge, looking for a direction. Unable

to find one, he decided to cast his life to the wind by simply saying "yes" to anything that anyone asked him.

At that moment as he was walking through Harvard Square, a young panhandler asked him, "Can you spare a dime?" David answered "yes" and gave him the money. The panhandler looked at him again and asked, "Can you spare a quarter?," to which David responded in kind. This was followed by a request for a dollar and then five—all which David handed over—whereupon the fellow asked him if he could spend the night at David's house. David acquiesced. Before long, David had a roommate. Word soon got out among the young panhandlers, acid heads, political revolutionaries, and hippies. In time, David's house became a commune, which remained one of the largest in Cambridge throughout the 1960s and 1970s. Whoever needed a place to crash asked David, who always, true to his promise, responded "yes."

The house became a hub of activity, much of it illicit. When a prostitute asked him if she could turn tricks there, David said "yes." Later, when one of the many prostitutes who became fond of David asked her to marry him, he said "yes." He also said "yes" when she asked if she could have children with him. Over the years, David found himself in the position of a counselor to these young people, many of whom were MIT and Harvard dropouts. At the commune, he would hold group-therapy sessions, giving sage advice. In time, he became a sort of guru. And over the years, he simply forgot about his art.

By the late 1970s, the commune was breaking up. Drugs had taken their toll, and at the dawn of the 1980s, with the appearance of AIDS, there was further devastation. One day David got a call from one of the earliest members of the commune, who at this time was residing on the West Coast and was involved in computers. He suggested that David relocate to the Bay Area. It turned out that many of the communards, shaking off their

sixties and seventies bohemianism, had migrated West and were evolving into Silicon Valley moguls. To express their gratitude to David for saying "yes," they purchased him a modest house in Oakland and gave him a life-long stipend. The only thing they asked in return was that David restart his legendary group-therapy sessions in the Bay Area, which he did. For nearly twenty years, he held weekly sessions in an East Bay warehouse for some of the most successful entrepreneurs in America.

But the silver lining was that they gave David a PC loaded with Microsoft Word. Although he had never touched a computer, he began intuitively experimenting with Word as way to write visual poetry. It was in this way that, decades later, he reconnected with being an artist. Ultimately, he mastered Word, turning it into a way to create visual poems. Over the years, they evolved into baroque bodies of word art that he worked on every day until his death in 2008.

David Daniels is a visionary artist. Like many outsiders, he was a refugee who dropped out from a more established field—the New York School—and began marching to his own beat. The works he produced bore the mark and sophistication of the New York art world but swerved far from its orthodoxies. I like to think that David, unlike more traditional outsider artists, is emblematic of the sort of visionary with one foot inside and the other out, straddling the world of "official" art and the world of imagination. David was white and male, and to have the luxury to drop out, you needed to have been invited in in the first place, a privilege less available to women, artists of color, and artists working in non-Western traditions.

But the categories of insider and outsider often elide, and it can be difficult to tell who is who. Careers and canons are constantly being reevaluated; some outside artists are brought inside (Jack Smith, for example), and some inside artists are positioned more like outsiders when they work outside of the field for which

they're primarily known—as in the case of painter Jean Dubuffet and his electronic music. It's this flickering, this both and neither at the same time, that hits UbuWeb's sweet spot.

I don't think that anyone sets out to become an outsider artist. Most outsiders are simply artists doing their work, paying little attention to the mainstream art world. When they are "discovered" by the art world—as in the case of Rev. Howard Finster—they then are labeled "outsider," a market term that enables them to be brought inside while still keeping them out. In spite of some attention, many working outside the mainstream remain there, while those who drop out of more inside scenes, like Daniels, don't do so by choice but by necessity. Some of the artists I profile here—David Daniels, Bern Porter, and Nicolas Slonimsky—dreamed of being insiders, but in each case something went very wrong, forcing them to go it alone. Christopher Knowles, an autistic artist, was born outside but was brought inside by Robert Wilson. Jean Dubuffet, the consummate insider when it came to visual art, remained an outsider for his entire life when it came to his music. And what of their legacies? In these artists' cases, not much. Unlike William S. Burroughs, the proverbial outlaw and self-appointed outsider who inspired dozens of widespread alternative practices, these artists have had a negligible legacy and influence at best.

In the years after getting his computer, David Daniels was insanely prolific. He self-published two thick books, *The Gates of Paradise* (2000) and *Years* (2002), each in a limited edition of ten. *The Gates of Paradise*, written between 1988 and 2000, is 400 pages long and contains 350 visual poems composed entirely of alphanumeric text and printers' characters. Each poem is a shape—human figures, animals, geometrical forms, cosmic bodies, body parts, and typographical abstractions. Although made with Word, they have the feeling of being woven, reminding us

that the words *text* and *textile* derive from the Latin term *texere*, "to weave."[3] In some sense, Daniels feels like a folk artist.

Gates attempts to cram the memories of a lifetime between the covers of a book. A fractured narrative of random events that took place over the course of Daniels's life, the poems are as diverse as experience itself, recounting the pain of childrearing, telling harrowing tales of rape, and offering quiet meditations on death. The texts are a mashup of light verse, doggerel, list poems, snippets of dialogue, stories, and diary entries, written in long, unpunctuated, run-on sentences. Describing these "gates" elsewhere, Daniels writes that they "are paradisiacals of people, and animals, and objects, from dancing body parts in Las Vegas lounge singers, from Brooklyn Dodger fans to cyborg Babbits, from nerve wracked saints to L.A. bottom feeder rabbits, from lovely air heads to heads of state to heads of lettuce, from black holes to pear shaped planets, with one often transforming into another as the poems proceed."[4]

Years, consisting of seventy-eight poems, is visually similar to the *Gates*, with several poems running on for dozens of pages. It's a chronological autobiography, each poem narrating a year in his life. As an autobiography, *Years* is a bit choppy and doesn't really correspond to the version of his life that Daniels told me, swerving in and out of fantasy. Sometimes the narratives veer off into arcane code names and self-invented mythological casts of characters. Other times Daniels falls into deep wormholes about mystical Jewish visions, lending a Talmudic flavor to the book (the Talmud also relies on the interplay of text as image). And there are long passages describing detailed sexual fantasies and encounters with various women. Language is often subservient to image; sometimes stories end midsentence because they have to be crammed into, say, a part of an animal or a genie emerging from a lantern. Printed in miniscule letters with variable spacing, these stories are nearly impossible to read.

Yet making the effort to read them can be rewarding. For instance, the poem "1983" (fig. 9.1) takes the form of a squirrel. It recounts a lunch that Daniels had with a female friend at a hotel overlooking a spectacular view of nature, when all of a sudden their meal is interrupted by the appearance of a feral squirrel, who proceeds to wreak havoc on the patrons. The poem begins with description of the dramatic landscape in normative English but soon veers off into a Lewis Carrollesque erotic rhyming fantasy: "Yet someway humble in its grand / eur: Feelinq: Laying back on / cheap French park chair / like the antelope skin rust just un / der Cleopatra's papyrus truss: The / brillo puff stuff under / dark Lady Mac Beth's rough: The gentle p / uff under Gertrude's rude puff: The / Huff hot fluff under / sweet Tatiana's gossam muff: [*sic*]." The line breaks are determined by the image,

9.1. David Daniels, "1983," undated.

running through the center of the squirrel's body, from its paws to its serpentine tail, shattering Daniels's doggerel into shards of linguistic disjunction.

As the book progresses, his skill with the Word program increases; the poems become more visually sophisticated, employing a battalion of fonts and printers' characters, resulting in riotous colorful visual poems. It's hard to believe that they all were done in Microsoft Word. Most people use Word to hammer out conventional prose, but Daniels reimagined the program as a poetry machine or tool to create images from words. Because of the labor involved, his "hand" is all over his work, lending it a warmth and humanness that much digital work lacks. Although other programs could have accomplished what he was trying to do in a much easier way—Adobe Illustrator, for instance—Daniels stuck with a basic word-processing program, out of which he wrought maximal complexity and beauty.

● ● ●

Drafted into the Army Corps of Engineers in 1940 as an assistant physicist, the poet Bern Porter (1911–2004) was assigned to the Manhattan Project in Oak Ridge, Tennessee, an endeavor so stealth that its mission was unknown even to those working on it. He remained there until 1943 and then continued to work on the project at the University of California at Berkeley until 1945. After the atomic bombing of Hiroshima and Nagasaki, he was horrified and as a result became a lifelong pacifist and devotee of the arts. From then on, he was involved with a parade of major American figures of twentieth-century art, literature, and science. He began a small press called Bern Porter Books that published avant-garde writers such as Antonin Artaud, Robert Duncan, Philip Lamantia, Kenneth Patchen, and Henry Miller. In the late 1940s and early 1950s, he ran a gallery showing then unknown Bay Area painters such as Richard Diebenkorn and

Sam Francis. He bounced around the country, picking up teaching and scientific jobs, but was finally fired from an electric company after "it was clear that he could no longer fit into a team of scientists,"[5] resulting in a stay in a psychiatric hospital for several weeks in 1967.

Finally, landing back at his ancestral home in Belfast, Maine, Porter worked as a publisher, poet, and performer, putting out scores of self-published pamphlets, broadsheets, cassettes, chapbook, drawings, and books. Joel Lipman of the Maine State Library writes, "Though Porter worked on the development of television's cathode ray, he never owned a TV. He had no phone. He neither owned a car nor drove. The Founds of *486B:Thy Future* are indicative of his proximity to 1960-era mainframe computers, but he never used a personal computer."[6] By the time Porter died at the age of ninety-three in 2004, he was a cult figure: influential to a few but little known to the larger world. His archives, donated to the Ohio State University Avant-Garde Literature Collection, eerily resembled Warhol's *Time Capsules*. Amid rare broadsides, chapbooks, editions, and artworks from some of the most important midcentury American artists were boxes filled with hunks of Styrofoam, unfinished scraps of pine, plastic soda bottles crammed with garbage, among other things, which to the untrained eye looked like boxes of trash but were in fact full of Porter's "found sculptures."

Porter's great passion was the found poem, the literary equivalent of a Duchamp readymade. Over the course of his lifetime, he made thousands of them by clipping chunks of text from magazines and newspapers and isolating them on the page. Running the gamut from advertising copy to recipe ingredients, these chunks became surreal and funny poems when taken out of context.

In 1972, a big book of these poems, entitled *Found Poems*, was published but quickly fell out of print. Then in 2011 the book was

14 The Happy Jackie,
The Sad Jackie,
The Bad Jackie,
The Good Jackie

The Happy Jackie,
The Sad Jackie,
The Bad Jackie,
The Good Jackie

Jackie—happy, sad, bad, good

9.2. Bern Porter, untitled found poem, 1972.

reissued with a foreword by David Byrne. After tracing some of the precedents for Porter's works—Renaissance pattern poems, Dada poetry, the books of Quentin Fiore and Marshall McLuhan, the lyrics of John Lennon—Byrne discusses how Porter's found poems were the inspiration for Talking Heads songs. In the early 1970s, after encountering Porter's work, Byrne was inspired to transcribe an entire broadcast of the game show *The Price Is Right*—commercials and all. Byrne writes, "The idea that holding this stuff up for examination might yield something was in the air. Somehow leaving it raw and unfiltered seemed the way to go . . . it was simply meant to say 'this is here.' I continued making lists and questionnaires around the same time I was beginning to write songs. Obviously I was ready to receive this stuff."[7]

In 2010, Mark Melnicove, the executor of Porter's estate, got in touch with me, offering UbuWeb the PDFs of a series of five rare books collectively known as *Wisdom of the Questioning Eye*. In his introduction to the works, he wrote: "Bern Porter was [a] contemporary and mentor to many of the artists on UbuWeb.

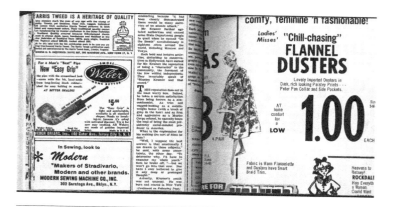

9.3. Bern Porter, detail from *Aphasia*, 1961.

In acknowledgement, and gratitude, I am publishing five of Porter's books from the 1960s here on UbuWeb, three of them for the first time anywhere."[8] For this series, instead of clipping individual elements from newspapers and magazines and presenting them as found poems, Porter presented entire newspapers as found novels.

He made them by taking stacks of newspapers, trimming the pages, and binding them directly into one-of-a-kind books. At nearly 500 pages, *Aphasia* (1961) is composed entirely of pages from the October 29, 1961, edition of the *Boston Sunday Herald*. Flipping through the book, you see snippets of stock tables, underwear ads, letters to the editor, and comics strips. Several images repeat over the course of the book, leading one to conclude that Porter simply went to the newsstand, purchased the entire stack of papers, and bound them as is.

Another book in the series, *468B Thy Future* (1966), is made entirely from computer printouts Porter stole when he was working as a low-level technician on the Saturn moon project at Huntsville, Alabama. Melnicove writes,

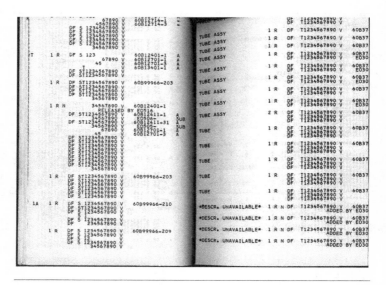

9.4. Bern Porter, detail from *468B Thy Future*, 1966.

The book is written entirely in computer code. These are instructions for the construction of the rocket to send the first men to the moon. Others at the time were trying to write computer poetry that made machines sound human. Porter turned his attention to poetry as unintentionally written by machines, in machine meter. This, Porter told us, is the poetry of the future: a poetry of numbers, repetition, function, gravity, and trajectory, redefining the standards of human emotion and tone.[9]

Similarly, the book *Dieresis* (1969) is composed entirely of found black-and-white images from newspapers and magazines. The images range from the cropped legs of a swimmer to a shot of the latest modern kitchen to fashion spreads. Inspired by pop art, it echoed the paintings of James Rosenquist while anticipating the media-based work of artists such as John Baldessari,

9.5. Bern Porter, detail from *Dieresis*, 1969.

Barbara Kruger, and Cindy Sherman. With its randomly juxta-
posed, seemingly endless images, the book also predicted image
platforms such as Flickr and Instagram.

Porter was also a wonderful performer of his own works.
UbuWeb hosts several recordings of him, including "Found
Sounds" (1978), which features him reading from the phone book
accompanied by ambient sounds made by improvisational musi-
cians, rendering the banal names and numbers from the White
Pages transcendentally Whitmanic. We also host an incendiary
incantation of his poem "The Last Acts of Saint Fuck You" (1988),
a monologue of an angry, old man on his deathbed, reciting a
litany of revenge for all who have wronged him during his
lifetime. In performing this list poem written in an abecedary
form, Porter makes his dire pronouncements in a shaky, gravelly
voice: "I, I, now the great Saint, I will get even . . . all of those
who have betrayed me, all of those who have lied to me . . . I

will get even. And I herewith pronounce my will, which has now been called, The Last Acts of Saint Fuck You. Fuck you, guys, I'm gonna get even."[10]

From there, Porter growls and spits bile for nearly ten minutes. The poem begins with A:

> The abnegating of treaties
> The acidifying of alkalis
> The affiliating of bastards
> The aligning of booby-traps
> The ambulating of cripples
> The annulling of Covenants
> The assessing of polls

And it ends with Z:

> The zeroing of gains
> The zesting of misery
> The zinging of drums
> The zipping of stays
> The zooming of dirigibles
> The zoning of beaches
> The zounding of oaths[11]

The piece very well might be autobiographical. At the end of his life, Porter was neglected, living in poverty in rural Maine, sometimes subsisting on the food and drink he secured during openings at local art galleries and university museums. His biographer James Schevill writes, "Porter lives mainly on social security. He seldom cooks at home, where his refrigerator and oven are full of completed Founds [found poems] and found material instead of food."[12]Although so many around him

had gone on to success in the worlds of art and science, Porter followed the path of the outsider. A decade and a half after his death, although Ben Porter is still largely unrecognized in the art world, in the UbuWeb world he is a hero. Porter's works spanned many media—books, posters, sound art, performances; his role as a curator was inseparable from his practice as an artist. In this way, he predicted a multimedia sensibility that many artists have adopted today, refusing to distinguish between curator, publisher, and practitioner. From the perspective of a time when most artists fluidly move from one medium to another—think of how on a laptop we edit videos, download images for our paintings, write novels, and make music—Porter's practice feels ahead of its time.

● ● ●

In his introduction to Porter's *Found Poems*, David Byrne mentions that he was also inspired by the typings of Christopher Knowles (b. 1959), the obsessively beautiful series of works Knowles made on the typewriter in the 1970s. Like Porter and Daniels, Knowles had one foot in the world of high culture and another outside of it. In Knowles's case, his status was marked by his autism. Hilton Als, the cocurator of a survey show of Knowles's works at the Institute of Contemporary Art in Philadelphia in 2015, writes about how his autism affected his artistic production:

As a child he learned to speak through repeating and memory, such as recalling what the Beatles intoned, what songs were popular, and how his little sister, Emily, felt when she watched the TV. Recording his responses, Knowles's early work was a startling combination of words and performance—the voice looking for an "I." Knowles measures himself, as he becomes

an "I" in his sharing and documenting of the regulating rou-
tines of life—work, eat, watch, play, listen, sleep. Knowles's
art . . . places him squarely in the tradition of twentieth-
century artists who opened a large window on performance
production, interiority, and the shifting registers by which an
individual's voice enunciates against relative social settings
and pressures.[13]

When Knowles was eleven years old, his mother gave him a
reel-to-reel tape recorder, which he used to document the sounds
around him. Like Vicki Bennett, he started taping things off
the TV and radio, using those sounds as the basis for sound
poems and performing verbal improvisations along with them,
which he also taped. When a family friend passed one of these
tapes to Robert Wilson, the avant-garde theater director was
intrigued by what he heard, feeling he had found a modern
incarnation of Gertrude Stein. "I knew it was clear in his mind,
but I couldn't follow it, so I transcribed the text, and it was
visually stunning," Wilson said. "If you looked at the piece of
paper from far away, you could see the use of language was
mathematical. There were patterns vertically, horizontally, diag-
onally."[14] Wilson invited the very young Knowles to perform
some of his works live, which ultimately led to a collaboration
between them, with Knowles commissioned to write the libretto
for *Einstein on the Beach*.

Many of Knowles's texts and tapes came from songs and DJ
announcements he heard on top-ten radio, which he'd then type
out as long, repetitive poems (fig. 9.6). When he worked with a
pop song, his text came close to the actual lyrics but would be
slightly off, skewed, and lovingly warped. It's not hard to see
what attracted Wilson to Knowles's work; like Wilson's theater
and his collaborator Philip Glass's music, it's at once pop *and*

```
                    I FEEL THE EARTH MOVE
I feel the thing moving a lot. It could be it to start of a sound. This one.
I feel everything now. It could be some movements of tribes. It is.
It could get some interment like that. It could see your heart for.
It could be the real thing, it could get us free, it could be shown up.
It could be to know to shop well. It could get some leaks of looks.
It could get some of those men to do.
I feel the earth move under my feet. I feel tumbling down tumble a.
I feel the thing moving a lot. It could be it to start of a sound. This one.
I feel everything now. It could be some movements of tribes. It is.
It could get some interment like that. It could see your heart for.
It could be the real thing, it could get us free, it could be shown up.
It could be to know to shop well. It could get some leaks of looks.
It could get some of those men to do.
I feel the earth move under my feet. I feel tumbling down tumble a.
I feel the thing moving a lot. It could be it to start of a sound. This one.
I feel everything now. It could be some movements of tribes. It is.
It could get some interment like that. It could see your heart for.
It could be the real thing, it could get us free, it could be shown up.
It could be to know to shop well. It could get some leaks of looks.
It could get some of those men to do.
I feel the earth move under my feet. I feel tumbling down tumble a.
I feel the thing moving a lot. It could be it to start of a sound. This one.
I feel everything now. It could be some movements of tribes. It is.
It could get some interment like that. It could see your heart for.
It could be the real thing, it could get us free, it could be shown up.
It could be to know to shop well. It could get some leaks of looks.
It could get some of those men to do.
I feel the earth move under my feet. I feel tumbling down tumble a.
I feel the earth move. I feel tumbling down tumble a. Tumbling down there.
```

9.6. Christopher Knowles, "I FEEL THE EARTH MOVE," 1974–1977.

avant-garde, seductive *and* edgy. Here's an excerpt of a Knowles poem based on Carole King's pop hit from 1971, "I Feel the Earth Move," which he used for the *Einstein on the Beach* libretto:

> I feel the earth move under my feet. I feel tumbling down tumble a.
>
> I feel the thing moving a lot. It could be it to start of a sound. This one.
>
> I feel everything now. It could be some movements of tribes. It is.
>
> It could get some interment like that. It could see your heart for.
>
> It could be the real thing, it could get us free, it could be shown up.
>
> It could be to know the shop well. It could get some leaks of looks.
>
> It could get some of those men to do.[15]

It's a remix of Carole King's song strained through Gertrude Stein. Although there's no evidence that Knowles knew Stein's work, the connections are clear. On Ubu, there's a recording of Gertrude Stein reading her poem "If I Told Him: A Completed Portrait of Picasso" (1923):

> If I told him would he like it. Would he like it if I told him.
> Would he like it would Napoleon would Napoleon would
> would he like it.
> If Napoleon if I told him if I told him if Napoleon. Would
> he like it if I told him if I told him if Napoleon. Would
> he like it if Napoleon if
> Napoleon if I told him. If I told him if Napoleon if
> Napoleon if I told him. If I told him would he like it
> would he like it if I told him.[16]

For Wilson, collaborating with Knowles was like discovering a lost link between modernism and top-ten radio.

In 1974, Knowles wrote the libretto for Wilson's opera *A Letter for Queen Victoria*, which we host in its entirety on UbuWeb. Like the libretto for *Einstein*, it's full of grammatical swerves, creative misspellings, and hypnotic repetitions. The libretto begins with a fictitious letter from Queen Victoria that the then fifteen-year-old Knowles dreamed up on the spot one day when, while hanging around with Wilson, he blurted out of the blue: "Dear Madam, most gracious of Ladies, albeit in no way possessed of the honor of an introduction and indeed infinitely removed of the deserving of it. . . ." Astonished, Wilson asked him what that was, and Knowles answered: "A letter to Queen Victoria."[17] An opera was born.

The opera begins with Knowles's letter and then proceeds into a nonnarrative verbal chaos so extreme that a *Time* reviewer

claimed that "in the realm of language [Wilson] makes Gertrude Stein at her murkiest sound like a paragon of pellucid clarity,"[18] which was exactly Wilson's point. The libretto is set in all capital letters, and all the voices in the piece speak simultaneously, echoing the Dada sound poetry of Richard Huelsenbeck, Marcel Janco, and Tristan Tzara, who in 1916 delivered a text, "L'amiral cherche une maison à louer," to be performed simultaneously in three different languages in order to purposely confound linear comprehension.

A section of the *A Letter for Queen Victoria* libretto reads:

YEAH

YEAH THE SUNDANCE WAS BEAUTIFUL

THE SUNDANCE KID WAS BEAUTIFUL

BECAUSE HE WAS BEAUTIFUL

VERY BEAUTIFUL

THE BEAUTIFUL SUNDANCE KID

THE SUNDANCE KID WAS BEAUTIFUL

THE SUNDANCE KID COULD DANCE AROUND

THE SUNDANCE KID COULD DANCE AROUND

THE ROOM THE SUNDANCE KID WAS
 BEAUTIFUL BECAUSE

THE SUNDANCE KID COULD DANCE AROUND
 A LOT

YEAH THE SUNDANCE KID WAS BEAUTIFUL
 YEAH

BEAUTIFUL

 SO BEAUTIFUL

SO VERY BEAUTIFUL[19]

It continues in this manner for five pages. UbuWeb hosts a recording of Wilson and Knowles reciting this section as a duet during the New Year's Day poetry marathon at St. Mark's Church in New York in 1975 (the recording was later released on John Giorno's Dial-A-Poem Poets LP *Big Ego* in 1978). The recitation is just Wilson and Knowles trading lines—they make a great duo, Wilson clear and precise, Knowles muddier, slurring and stumbling over his words. The piece runs for a full eight minutes. At first, the audience seems amused—in the background you can hear nervous titters—but around the five-minute mark the audience begins applauding, attempting to end the performance. By six minutes, the room is filled with ambient conversation. For the remainder of the performance, the duo are met with catcalls and whistles. Even for a downtown audience accustomed to avant-garde performance, Wilson and Knowles proved to be too much.

Coming from such disparate places, Wilson and Knowles meet in the murky middle ground of experimental art. Blurring the lines of inside and outside, they challenge traditional notions of the canon, and in the end it's hard to determine who is inside and who is outside—which appears to have been their goal. Over the years, Knowles slid in and out of sight, often disappearing from public view for long stretches of time to pursue a rich studio practice of painting, sculpture, installation, and performance, occasionally reemerging to perform with Wilson in art venues. Although he has continued to garner attention—in addition to his aforementioned retrospective, a top-tier New York gallery represents his work—he remains mostly unknown, at least in comparison to his well-known collaborator Robert Wilson.

● ● ●

Housed in UbuWeb's Sound section is of one my favorite records. It's an obscure LP that contains world-premiere recordings of

modernist music from the 1930s by a fearless conductor named Nicolas Slonimsky (1894–1995). They are the premiere recordings by composers Edgard Varèse, Charles Ives, and Carl Ruggles. Everything about the record is forbidding. On the recording of Varèse's composition "Ionisation"—written for percussion instruments and sirens—Varèse himself manned two sirens that he borrowed from the New York City Fire Department and is accompanied by Henry Cowell playing percussion.[20] The rest of the musicians were recruited from the New York Philharmonic. Also included is the debut recording of Charles Ives's "Barn Dance" from the "Washington's Birthday" section of *A Symphony: New England Holidays*, a recording whose bill Ives footed (since nobody would publish or record his music, Ives always paid; his day job was as an insurance executive). It's a lovely LP, full of dry, scratchy, mono sounds transferred from old 78-rpm recordings; hearing it, you feel as if you're listening to the real thing, which, in truth, you are.

Slonimsky was as radical a modernist as could be. Born in Russia, he was a child musical prodigy who went on to become a pianist and arranger for Serge Koussevitzky in Boston. After falling out with Koussevitzky, he decided to go out on his own to conduct pieces that no one else would play. He founded a small orchestra in Boston devoted to playing the work of difficult modern American music, becoming so adept at conducting these pieces that he forgot how to conduct the regular repertory, eventually forsaking it altogether. In 1931, he convinced Ives to sponsor a tour of these works in Paris and Berlin, which were met with great success. Confident that he was on the cusp of a revolution—German reviewers called his conducting "astonishing"—he was invited to conduct the Hollywood Bowl Symphony, where he directed five concerts in 1933. As Slonimsky later described the concerts, "There were all these old dowagers there who gave money and suddenly they were confronted

by something called 'Ionisation.' They didn't know what it meant. Finally they decided they didn't want any of my performances, so that was that. . . . The bad reviews and the flight of indignant audience members resulted in an inglorious end to my conducting career. The word spread that I was a dangerous revolutionary who inflicted hideous noise on concertgoers expecting to hear beautiful music."[21] His radical approach, coupled with the changing political climate—the Depression and the rise of European fascism—made audiences impatient with formal invention and hungry for music that directly addressed the social needs of the day. However, one audience member, John Cage, who attended every one of Slonimsky's concerts, later said, "Those concerts he conducted at the Hollywood Bowl were a great experience for me. They gave such a wide and rich view of twentieth century music and the twentieth century was quite young then. Those concerts were not popular, they were statements of belief. . . . Those concerts in the Hollywood Bowl were instrumental in changing my life."[22]

For his contributions to the avant-garde alone, Slonimsky would have a prominent place in the UbuWeb pantheon. But a strange thing happened. By chance, he was also included in a collection of outsider music that we acquired called *The 365 Days Project*. The project's description reads: "365 days of cool and strange and often obscure audio selections. Some words to describe the material featured would be . . . Celebrity, Children, Demonstration, Indigenous, Industrial, Outsider, Song-Poem, Spoken, Ventriloquism, and on and on and on. The best thing to do is to simply listen."[23] Although nowhere in this collection is a hint of the avant-garde, it does include three songs Nicolas Slonimsky made late in his life that sound nothing like the rigorous compositions of Varèse and Ives. He sounds instead like a European-inflected Bern Porter—a cranky old man playing ditties on the piano, croaking out-of-tune songs.

What's going on here? Exactly the same thing that happened to David Daniels and Bern Porter: Slonimsky made the transition from insider to outsider. Just as Daniels was excommunicated from the abstract expressionists and Porter from the Manhattan Project, Slonimsky after his Hollywood Bowl fiasco was excommunicated from the world of conducting. After casting about for a few years, he began writing music criticism for the *Christian Science Monitor*, gradually finding his voice as a musicologist. He went on to write two epic tomes, *Music Since 1900* and *Baker's Biographical Dictionary of Music and Musicians*, along with many other erudite works of musicology. And like David Daniels after his decades-long absence from art, Slonimsky in time returned to playing his own music. But it wasn't the same as before. He became a sort of cabaret act, interspersing his virtuosic piano playing and odd singing with stories from his life. He was charming beyond belief.

The 365 Days Project recordings were part of a suite of songs he wrote in 1925 called *Five Advertising Songs*, which literally transformed texts found in ads from the *Saturday Evening Post* into lyrics, not too different from Porter's fascination with the language of media. Slonimsky recalled:

I was fascinated by the type of American language which found its reflection in the advertising section of newspapers, but particularly the *Saturday Evening Post*, which I read voraciously. I thought that those advertisements were extremely revealing of the *Homo Americanus*, or perhaps of our society in general. I was particularly fascinated by the advertising (incidentally not so much different from advertising that goes on in TV commercials now, but this was my first acquaintance with this type of advertising) where all you had to do was to use a certain type of toothpaste and then you had immediately acquired happiness and success in society and so forth. And then all

kinds of ailments that could be remedied by pills. And such fascinating advertisements as "Children Cry for Castoria."[24]

The five songs are "Children Cry for Castoria," "Pillsbury Bran Muffins," "Make This a Day of Plurodent," "Utica Sheets and Pillowcases," and "Vauv Nose Powder." The ad copy for Castoria, a children's laxative, supplied the lyrics for Slonimsky's song:

> Children cry for Castoria!
> Yes, they cry for Castoria.
> Mother! Relieve your constipated child!
> Hurry, mother . . .
> Even a fretful, bilious, feverish child
> Loves the pleasant taste of Castoria.
> Castoria, Castoria.
> O, gentle harmless laxative which never fails to
> sweeten the stomach and open the bowels!
> It never cramps or overacts.
> Ask your druggist for genuine Castoria.
> All the instructions are printed on the bottle.
> Children cry for Castoria![25]

Although the songs were written in 1925, they weren't published until the late 1980s. "Eventually, I decided to publish them," Slonimsky wrote. "To my surprise, the Pepsodent Company refused to let me use their brand name, so I changed it to Plurodent, and revised the text accordingly. The nose powder went out of existence, so I did not have to bother about the copyright. Amazingly, the Castoria people gave me unqualified permission to use their name."[26]

There's a great video online of a one-hundred-year-old Slonimsky in a flannel shirt and suspenders belting out "Children

Cry for Castoria" as he plays an out-of-tune upright piano in his Los Angeles living room, where he gives an extra yelp as his voice cracks "open the BOW-ELS!" But by that time, 1994, the tables had turned once again, and Slonimsky was a star, hanging out with the likes of Frank Zappa, who was taken by his tremendous aura. Zappa noted that "he had that look, a look of a real guy from that era; his shoes, his crinkled tweed sport coat, trousers that were too short, he was wonderful—a fully developed character."[27] Zappa had that album of Slonimsky's conducting of Varèse, Ives, and Ruggles, a disc that was a huge influence on him.

When in 1981 Zappa found out that Slonimsky was living in Los Angeles, he invited the eighty-seven-year-old former conductor to his house to play a few piano pieces. The next night Slonimsky appeared onstage with Zappa, accompanying the band on an older song, "A Pound for a Brown," improvising on electric piano and taking an abstract solo, while the Mothers of Invention wailed behind him. From then on, Slonimsky made occasional appearances with the Mothers. The *Washington Post* reported: "In the spring of 1981 Frank Zappa of the Mothers of Invention filled Santa Monica's Coliseum for one of his wild, high-decibel extravaganzas. The high point came when Zappa introduced 'our national treasure,' Nicolas Slonimsky, who performed a section of his avant-garde *Minitudes* on electric piano to deafening applause."[28] And so it swings—from insider to outsider and back again.[29]

● ● ●

There's another wonderful composer on UbuWeb whose works fall somewhere between cacophonous modern classical music and free jazz. They are full of warped layered tapes, scratchy out-of-tune violins, various exotic instruments, prepared guitars, and batteries of percussion; on occasion, multitracked voices

weave in and out of the din. It's one of the more popular pages on Ubu. The composer's name is Jean Dubuffet (1901–1985). Many of UbuWeb's fans discover later that he also happened to be a famous painter.

When these works were recorded in the early 1960s, Dubuffet had little knowledge of contemporary music, nor was he familiar with serialism, dodecaphony, electronic music, or *musique concrète*; in fact, it wasn't until 1973 that he first heard those terms. His music instead grew out of jam sessions in the studio of his friend, the Danish COBRA painter Asger Jorn. Both were barely trained musicians—Dubuffet played a bit of piano, and Jorn a little trumpet and violin. They brought an old piano into the studio, turned on the tape recorder, and began playing. Over time, they added a battery of exotic instruments, including Saharan flutes, hurdy-gurdys, zithers, xylophones, and French folk instruments such as *cabrettes* and *bombardes*. They never learned how to play any of the instruments "correctly," instead simply improvising.

They also had no experience of recording technology, so their sessions were caught on amateur equipment and were full of dropouts, flaws, and ambient street noises, which Dubuffet found essential, believing those ruptures essential to break down the borders between art and everyday life. Like his *art brut* (raw art), he sought a dirtiness in both the playing and the production of his music; he'd often walk around Paris with his tape recorder, grabbing sounds off the streets and throwing them into his mixes. As time passed, he became more devoted to his music, transforming the better part of his house into a music studio. In between his sessions with Jorn, he'd become a one-man band, playing his fifty-odd instruments by himself, overdubbing the tracks. He'd then chop up the tapes with scissors and reassemble them in a process that echoed his thick, layered paintings.

Dubuffet's recordings, which were put out on tiny private labels as ten-inch EPs in editions of fifty copies each, were unknown until 1973, when the prominent Turkish electronic-music composer İlhan Mimaroğlu released a collection of them on his avant-garde label Finnadar. Mimaroğlu recalled that although Dubuffet was world famous as a painter at the time, only a handful of people knew of his music. Mimaroğlu became aware of it only after he composed a piece based on one of Dubuffet's drawings, and the painter casually mentioned that he, too, was a musician. After hearing his music, Mimaroğlu claimed Dubuffet to be "the most original and revolutionary composer since Varèse."[30]

Even though Dubuffet was totally inside the art establishment, his invention *art brut* romanticized outsiders, folk artists, visionaries, untrained artists, and prisoners who made art. Feeling that painting had become too insular and intellectual, Dubuffet wanted to disassemble all strains of professional art and destroy the complicity of insiders. Although it was impossible for him to claim to be an outsider painter because of his canonical position in the art world, he was able to actualize these attitudes in his music, making him the most inside of outsiders:

In my music I wanted to place myself in the position of a man of fifty thousand years ago, a man who ignores everything about western music and invents a music for himself without any reference, without any discipline, without anything that would prevent him to express himself freely and for his own good pleasure. This is what I wanted to do in my painting too, only with this difference that painting, I know it . . . and wanted to deliberately forget all about it. . . . But I do not know music, and this gave me a certain advantage in my musical experiences. I did not have to make an effort to forget whatever I had to forget.[31]

Dubuffet's outsider attitude toward music preceded by almost a decade some of the more radical political strains of the avant-garde—namely, the effort to end artistic elitism by admitting untrained musicians into the ranks of the professional orchestra. In 1969, Cornelius Cardew, Michael Parsons, and Howard Skempton created the Scratch Orchestra, which was open for anyone to join who wished to do so; Gavin Bryars's founded Portsmouth Sinfonia in 1971, which incorporated people without musical training into its ranks. Dubuffet also anticipated the idea of forcing professional musicians to deskill their practice in order to critique structures embedded in the musical world. For instance, Maurice Kagel, for his composition *Exotica* (1972), required his ensemble of highly skilled European musicians to play a battery of non-Western instruments as a way of critiquing colonialism and the dominance of Western music within the classical field. Similar to the moves made by Daniels, Porter, Knowles, Slonimsky, and Dubuffet, only by intentionally moving those musicians outside, Kagel felt, could they properly reclaim their status as insiders.

10

AN ANTHOLOGY OF ANTHOLOGIES

'm stranded at an airport. To pass the time, I decide to listen to some sound poetry by Henri Chopin. I can't grab my discs by him, nor can I access my MP3 collection, so instinctively I go to Apple Music. Taking a chance and plunking his name into the search box, I'm not surprised when I mostly get results for the singer-songwriter Harry Chapin. And though I like Harry Chapin (I grew up when "Cat's in the Cradle" was an AM radio hit), he's not exactly what I was looking for. But if I were, Apple Music offers me a seemingly infinite amount of his albums, compilations, and playlists, the most curious being "Dad Rock Essentials," which in all honesty I'm tempted to click on. Apple Music is a pretty easy target—although, in fairness, it has lots of difficult music, such as Stockhausen, Cage, Feldman, and Xenakis, not to mention tons of great pop music—but UbuWeb's Sound section fills gaps by collecting things that you're not going to find anywhere else—or at least with as much context and depth. So whereas you won't find much Henri Chopin on Apple Music, Ubu hosts almost everything he ever released, including sixteen full-length albums, interviews, and a collection of thirty-plus tracks culled from compilations. If I wanted to, I could listen to Henri Chopin on Ubu for a day or two straight. Chopin's page on Ubu began when

we digitized an anthology called *Futura Poesia Sonora* (1978), a sweeping seven-LP, sixty-track survey spanning a century, beginning with futurism and ending with a survey of sound poetry from the late 1970s, laying the foundation for our Sound section. The two Chopin tracks from *Futura Poesia Sonora* were the first MP3s on our Henri Chopin page. In fact, our entire Sound section began by absorbing that entire anthology onto the site.

UbuWeb's anthologizing of anthologies was a way for us to quickly build a collection based on what others before us considered to be important. We figured if someone went through all the trouble of sorting out obscure and esoteric types of culture and building an anthology, then it was probably worth absorbing that anthology into UbuWeb's collection. Besides, anthologies are breadcrumbs leading us to artists and visions we wouldn't have known about otherwise. It was also a way of easily expanding the site; by hosting a few anthologies focused on a specific type of music or literature on the site—say, for example, concrete poetry—in a short time we could have a fairly substantial section on it. UbuWeb began by taking two seminal anthologies of concrete poetry from the 1960s—one edited by Emmett Williams and the other by Mary Ellen Solt—scanning every poem in them, and making web pages for them. In a sense, those older anthologies acted as a framework or scaffolding upon which we were able to build our archive.

What is the responsibility of the anthologizer? It's hard to give a single answer. People anthologize for various reasons. We tend to want to give the anthology the benefit of the doubt when it comes to expertise on a certain subject, but as this book has shown, such acts are often riddled with problematic subjectivities. Perhaps, then, the best way to view an anthology is through the lens of error. Rather than seeing an anthology as totemic,

maybe it's better to see it as a tenuous and unstable attempt to try to make sense of a field. At their best and most honest, anthologies mark the beginnings of future conversations.

My focus here is primarily sound anthologies. Although Ubu also hosts film anthologies and literary anthologies, its Sound section has more compilations than any other wing, some consisting of hundreds of tracks from hundreds of artists. What follows is a rundown of some of the key anthologies on the site. While by no means an exhaustive list—we host more anthologies that can possibly be written about here—the anthologies discussed here are some of the ones that helped make the site what it is today. I like to think of the list as a *Baedeker* of UbuWeb, an anthology of the anthologies that compose our anthology.

The *Tellus* Cassettes and Giorno Poetry Systems

Perhaps no collection of audio inspired UbuWeb more than the *Tellus* cassettes, a series of twenty-seven compilations released between 1983 and 1993. By smartly assembling compilations based on wildly diverse themes, the series respected few boundaries. The titles alone speak of their variety: *All Guitars!*, *The Sound of Radio*, *Dance*, *Power Electronics*, *Tango*, *Video Art Music*, *New Music China*, to name a few. Thrillingly eclectic, the cassettes were never academic; instead, their choices felt smart and intuitive, encouraging UbuWeb to follow suit. The artist Joseph Nechvatal and the curator Claudia Gould founded *Tellus* in 1983 as a subscription-only bimonthly publication and focused their distribution efforts on powerful institutions such as museums, galleries, libraries, and universities, where the compilations were

absorbed into curriculums and written about by critics and scholars. In this way, many strains of sound art found their way into various canons.

Although the entire series is inspiring, one cassette, *Audio by Visual Artists*, was particularly vital to UbuWeb. After we absorbed the *Futura Poesia Sonora* box, the *Audio* cassette broadened our scope to include audio work by visual artists. From futurist noise music to sample-based electronics, the cassette traced the arc of artists' sound works in the twentieth century. It was here that for the first time I heard a recording of Marcel Duchamp reading texts in English from "A l'infinitif," written between 1912 and 1920 and recorded for *Aspen* magazine in 1967 shortly before his death. Today, UbuWeb's extensive Duchamp audio archive contains interviews, readings, documentaries, and recordings of his own chance-inspired musical compositions. It was also the first time I discovered that Martin Kippenberger fronted a punk band; and although I knew about Joseph Beuys's felt and fat sculptures, I never knew that his prodigious audio output includes everything from sound poetry to orchestral works to new wave rock 'n' roll. Through this cassette, I also encountered powerful sounds by women, including Joan Jonas's reading of a Canadian maritime narrative accompanied by the sounds of foghorns and a piece by Polish sculptor Magdalena Abakanowicz that consists of nothing more than thirty-five seconds of her rough, hacking cough, a sonic equivalent of her rough-hewn figurative sculptures.

Artists often treat sound as material—more like stone or wood or oil paint. And there is freedom that comes from *not* knowing what you are doing. After *Tellus* was produced, it was hard to make the claim that artists' sound works were some sort of a sideline to their "real" work in painting or sculpture. What was once considered marginal or tangential now had to be considered central.

The other major collection that served as a blueprint for the UbuWeb Sound section was a series of twenty-four LPs released by Giorno Poetry Systems from 1972 to 1989. Most of the tracks came from the poet John Giorno's Dial-A-Poem service, through which, beginning in 1969, you could call a New York City–based phone number and hear a different poem each day. As in the *Tellus* cassettes, the material presented in this phone service was eclectic, ranging from an ethereal Frank O'Hara reciting "Having a Coke with You" to White Panther leader John Sinclair giving a political rant. When asked how Giorno Poetry Systems came about, John Giorno (1936–2019) said:

> The use of modern mass media and technologies by these artists made me realize that poetry was 75 years behind painting and sculpture, dance and music. And I thought, if they can do it, why can't I do it for poetry? Why not try to connect with an audience using all the entertainments of ordinary life: television, the telephone, record albums, etc.? It was the poet's job to invent new venues and make fresh contact with the audience. This inspiration gave rise to Giorno Poetry Systems.[1]

The phone company eventually pulled the plug on Dial-A-Poem due to legal threats from parents who became alarmed when their kids dialed in and heard poems about radical politics, sex, and drugs. In the aftermath, though, Giorno was left with a huge audio archive. Deciding to start his own record label, he began releasing these recordings as dense, beautifully designed LP compilations. The early discs focused on the adventurous poetry scene around St. Mark's Church in New York, but the later ones became more eclectic, documenting the vast range of downtown Manhattan performers such as Meredith Monk, Laurie Anderson, and Philip Glass. By the 1980s, they expanded into pop and rock music, including tracks by Hüsker Dü, Sonic

Youth, Cabaret Voltaire, and Giorno's own new-wave-infused John Giorno Band.

The recordings include Warhol superstar Jackie Curtis singing a heartbreaking rendition of "Have Yourself a Merry Little Christmas"; an epic, rambling poem by Patti Smith called "The Histories of the Universe" (recorded six months before the release of *Horses*); a recording of the Fugs singing their bawdy song "Saran Wrap"; a performance poem read by Claes Oldenburg; and John Cage incanting his interpretation of Thoreau's journals.

History of Electronic/Electroacoustic Music (1937–2001) and Women in Electronic Music (1938–1990)

For many years, there was a collection of sixty-two CDs called *History of Electronic/Electroacoustic Music (1937–2001)* floating around torrent sites. But because of its size—in the early days of the web, even downloading a single CD could be arduous—the collection was nearly impossible to download, and before long it ran out of seeders, becoming unavailable. The set was shrouded in mystery: there was scant information about it other than that it was compiled by an anonymous Brazilian student. Over the years, as its mythic reputation grew, I wanted to track it down, which I finally did when it appeared on a private file-sharing group. I downloaded it and posted it on Ubu, where it remains today in its entirety.

The collection consists of 476 tracks arranged roughly in chronological order, beginning with Olivier Messiaen's composition "Oraison" (1937) for *ondes martenot* and ending with François Bayle's revision in 2001 of his piece "Camera oscura" (1976). Some tracks are lengthy: Iannis Xenakis's "La légende d'eer" (1977–1978) is a single track running forty-five minutes. Along

the way are all the big names of twentieth-century electronic music—John Cage, Pierre Henry, Pierre Schaeffer, Luciano Berio, Luigi Nono, Luc Ferrari, and Bernard Parmegiani, to name a few—and many of their most important pieces, such as Karlheinz Stockhausen's "Gesang der Jünglinge" (1955–1956), Pierre Boulez's electroacoustic "Répons" (1981–1984), and Edgard Varèse's "Poème electronique" (1958).

As I recounted earlier, UbuWeb began as a site for sound poetry that grew into a clearinghouse for the "avant-garde." Yet when we incorporated this anthology into the Sound section in 2011, it changed the site's nature. Prior to this point, we had hosted very few modernist electronic and electroacoustic works, feeling that they were somehow too academic to fit in. But when we integrated these tracks into the collection, we found that they participated in a larger conversation about the avant-garde that had already been set into motion, be it regarding the electro-acoustic elements that were part and parcel of sound poetry or the noisy industrial sounds that were the hallmark of much early-twentieth-century experimental music.

Still, there were some problems. No women composers and few composers working outside the Western tradition had been included in *History of Electronic/Electroacoustic Music*. We felt it necessary to post a disclaimer:

> This is from a 62 CD set called *History of Electronic / Electro-acoustic Music (1937–2001)* that was floating around as a torrent, reputedly curated by a Brazilian student. It's sketchy. The torrent vanished and the collection has long been unavailable. It's a clearly flawed selection: there's few women and almost no one working outside of the Western tradition. . . . However, as an effort, it's admirable and contains a ton of great stuff. Take it with a grain of salt, or perhaps use it as a provocation to curate a more intelligent, inclusive, and comprehensive selection.[2]

A few months after I downloaded the compilation onto Ubu-Web, I received an email from the mysterious Brazilian university student, who identified himself as Caio Barros and explained that when he began uploading the collection in 2009, he was studying electroacoustic music at a university. His professor burned sixty-two CDs from his own library and left them for his students to listen to. Barros popped the discs into his laptop, ripped them to MP3s, and threw them onto a file-sharing site. As for the blind spots, Barros requested that I post this note on the site:

> So I'm very proud and happy to see this here. I just want to clarify two things since it seems that my initiative became some sort of legend, which is very funny. First, my college is a kind of a center of the most traditional, western avant-garde electronic music, so I certainly agree that it leaves a lot of people outside, but leaving outside people working at the bounds of this tradition, and the area of Europe-America, was expected. I'm not saying that it's fair! Second and last, although women are certainly an exception, I don't believe it was intentional to have few works by women, it has more to do with the way our society and the tradition this music represent works.[3]

Fair enough. Although the compilation is an incredible retrospective focusing on a particular Western tradition, it's also the impetus of a critique of the way that knowledge flows and an object lesson of how certain narratives are transmitted—told, taught, and reinforced—while others are omitted. Still, we couldn't let the *History of Electronic/Electroacoustic Music (1937–2001)* stand unanswered. So in 2015 we posted a response, *Women in Electronic Music (1938–1990)*, a seven-hour selection of women composers curated by the Bay Area–based sound artists Jon Leidecker and Barbara Golden. Originally broadcast on KPFA

in Berkeley, the series begins with a midcentury Theremin piece by Clara Rockmore and ends with a percussion work by the Romanian composer Ana-Maria Avram from 1990. Along the way are dozens of important and mostly overlooked experimental composers, including Delia Derbyshire, Annette Peacock, Cosey Fanni Tutti, Kaija Saariaho, Hildegard Westerkamp, and Diamanda Galás. As in the other anthologies discussed in this chapter, many composers from this series had their own pages on UbuWeb, or we built new ones for them, resulting in dozens more women's works on UbuWeb.

Leidecker's interest in women composers began when he was making online playlists of electronic music and noticed that women composers had to wait much longer than men for their work to be released. Sometimes the wait period was as long as several decades, as was the case for Pauline Oliveros, who was fifty years old before she was given a chance to release a solo record of her own, even though she had been composing continuously since she was a teenager. He also noticed the contrary fact that users' playlists on streaming services were heavily weighted with women composers, rebutting the overly familiar history told by the Brazilian collection. Finally, he noted that the gender gap in lineups at festivals of electronic music was increasingly becoming a topic for online discussion. Leidecker mused, "People began asking why don't more women make electronic music? And the real question was obviously, why don't more people know the work of the pioneers?"[4]

Pooling their collective knowledge, he and Golden aired their first radio show featuring women composers in 2010 and continued to do additional research for the second and third ones in 2012 and 2017. Their purview was informed largely by the publication of Tara Rodgers's printed collection of interviews with women in electronic music, *Pink Noises: Women on Electronic Music and Sound* (2010), and Elizabeth Hinkle-Turner's book

Women Composers and Music Technology in the United States: Crossing the Line (2006), which traces women's contributions to electroacoustic music from the 1930s to the present.

Leidecker and Golden's radio shows built upon an earlier effort called *Her Noise*, which began as an exhibition focused on sound histories as they related to gender and held at the South London Gallery in 2005. Curators Lina Dzuverovic and Anne Hilde Neset conducted dozens of interviews and compiled sound recordings and printed materials, which would eventually form the Her Noise Archive, a collection of more than 60 videos, 300 audio recordings, 40 books and catalogues, as well as 250 fanzines (approximately 150 different titles), some of which found its way onto Ubu.[5]

Concurrent with Leidecker and Golden's efforts was a groundswell of rethinking about the gendered terms of the electronic music canon. In 2014, Antye Greie-Ripatti's *NERD-GIRLS a herstory of electronic music* appeared as a Mixcloud file that featured fifty artists spanning fifty years of women making electronic music.[6] And in 2015, the group Female Pressure—consisting of more than 1,700 female, transgender, and nonbinary artists—was founded to promote the visibility of these marginalized groups in electronic music. Inspired by an interview with Björk entitled "The Invisible Woman," where she bemoaned the lack of photographic documentation of women at work in their studios, the group put out an open call for women electronic musicians to submit a photo of themselves working, along with a statement and a link to a website. Five hundred women responded, a firm rebuttal to the narrative set forth in the Brazilian anthology.

Leidecker and Golden will continue to produce additional shows; they are confident that more works by women are finding their way to audiences, resulting in greater visibility. Leidecker is optimistic about the future. "Ideally it doesn't need

the frame anymore," he says. "It's not 'music by women'; it's the history of electronic music."[7]

The *Wolf Fifth* Collection

As I mused earlier, the instability of blogs and file-sharing lockers is heartbreaking. People spend years of their lives and expend tremendous effort sharing what they love with others, only to have the product of their efforts ripped down by cease-and-desist notices from labels. This is what happened to *Wolf Fifth*, a blog dedicated to preserving out-of-print avant-garde classical works on vinyl that was shuttered due to copyright threats in 2012. The blog had just posted its 151st album, a selection of string pieces by Arnold Schoenberg and Mel Powell on the Nonesuch label. The preceding 150 discs were a trove of rare vinyl records, such as the box set *Music Before Revolution* (1972), featuring difficult works by avant-garde New York School composers and their European counterparts.

When the blog went down, there was the typical and sadly predictable comment stream from readers, consisting of thanks, sympathy, sorrow, and anger. I was one of those commenters: "I am the owner of UbuWeb and would like to preserve the Wolf Fifth blog. Please contact me and we can arrange something." In late 2012, I received an email from a Canadian architecture student named Justin Lacko, who had been reading the comments. He wrote, "I was a visitor of the Wolf Fifth blog and I saved almost every release, save one or two that I missed due to removal because of copyright claims. I am a big fan of UbuWeb and would like to offer my assistance with providing my copies of the music for you. They have all been tagged to great detail. Let me know if I can assist."[8] Naturally, I responded with great enthusiasm, and we immediately began to work together to

rebuild and stabilize the vast archive, and within a few years the blog in its entirety was preserved on Ubu.

Vast and various like most blogs, *Wolf Fifth* seemed to be put together not according to any system but by passion and whim, narrowly focused on sharing obscure avant-garde classical LPs from the 1950s to the 1980s, with titles such as *Polish Modern Music*, *Computer Music*, and *Musica cubana contemporanea*. Housed within the *Wolf* archive are huge sublibraries, such as the nearly complete run of Deutsche Grammophon's rainbow-colored series Avant-Garde from 1968 to 1971, more than two dozen solo and compilation LPs by important experimental European composers. There are also a number of the Prospective 21e Siecle series curated by François Bayle and Pierre Henry and released by Philips from 1966 to 1972, featuring futuristic metallic-ink covers and focusing on *musique concrète*, electroacoustic music, and electronic music. The series had an international bent, in particular with a four-LP set called *Electronic Panorama*, in which each disc was devoted to a single city—Paris, Tokyo, Utrecht, Warsaw.

Wolf Fifth was curated by a classically trained percussionist named Luuk de Weert, who lives in Utrecht, Holland. While studying at a Dutch music academy in the 1970s, he had a professor who encouraged his students to listen to difficult contemporary music. Feeling his students were lacking delicacy, he had them listen to pieces such as Boulez's "Le marteau sans maître" in order to teach them how to be more sensitive percussionists. De Weert became obsessed with modern music and began collecting as much vinyl as he could, which he later ended up digitally encoding so he could listen in his car or share them with his friends. When blogging happened, it was natural for him to share his rips with others. De Weert says, "Most of these LPs were not ever released as CDs and are out of print now. This incredible situation puzzled me. Why was all this

important and groundbreaking music neglected? These compositions certainly were not intended for easy listening or background music . . . but it seems that nobody was interested in publishing this important material anymore."[9]

He began posting high-quality transfers along with scans of the front and back covers of his LP collection. He had a few guiding rules for the blog. First, everything had to be free. Second, he wanted the blog to be simple and functional, with no information other than the title of the album, a track list, a scan of the cover, and a link to the album. Third, he limited his sharing to experimental and avant-garde "composed" LPs from 1960 to 1985. Last, he insisted on providing the best-quality transfers possible.

The blog was successful, at least by his standards, drawing more than a thousand visitors a day, but he began to run into copyright troubles. The Dutch publishing house Donemus accused him of copyright infringement and ordered him to stop his posts of its Composers' Voice series after a complaint by a composer. Around the same time, he had problems with Schott-Music in Germany, which demanded €10,000 per posted album. In response, de Weert says, "I accused them of kidnapping cultural heritage, trying to kill a mosquito with a cannon. They see this material only in terms of copyrights and (legal) property, as if it were cars or houses or whatever. But music (and of course also literature, fine-art, etc.) is much more than a commercial product; it is a reflection of who we are and who we were; in this sense, it belongs to us all."[10] Although these companies never followed up on their threats, de Weert was rattled, finally surrendering in 2012, after only a year of posting. The acquisition of this archive extended the narrative UbuWeb had already been building with the *History of Electronic/Electroacoustic Music* and *Women in Electronic Music*, once more expanding and complicating our notion of the avant-garde in new directions.

The *PhonoStatic* Cassettes

Writing to John Cage in New York from Paris in the 1940s, Pierre Boulez asked, "How do you compose so far from the centers of culture?" Cage responded, "How do you compose so close to the centers of culture?" Whereas many of Ubu's collections arise from major urban centers such as New York, Paris, and San Francisco, the *PhonoStatic* cassettes were born in Iowa City; yet the community that produced them was global, fueled by the rise of mail art, which distributed the work of authors and musicians working far from the centers of culture. As publisher Lloyd Dunn commented, the remote location forced the *Phono-Static* publishers to be independent: "The fact that we were based in the U.S. Midwest and, like many zine producers, outside of the cultural centers on either coast (and in which we could only participate vicariously) a certain amount of cultural self-reliance was necessary and desirable."[11]

In 1983, Dunn began publishing *PhotoStatic Magazine*, which was precipitated by the rise of cheap photocopy shops. Inspired by Dada journals, punk zines, Russian samizdat, and situationist publications, the overriding aesthetic was the smudgy and dirty photocopy: "We wanted to explore the particular formal qualities of xerography; its expressionistic contrasts, its electric granularity, its charcoal-sketch visual timbres, its ability to fragment and unite disparate images using collage techniques, as well as the performance aspects of interacting in real time with the sweeping scan light of the machine, producing unique prints each time the start button was pushed." Dunn saw the cassette tape as analogous to the photocopy: "In the same spirit, and with the same interests in mind, the *PhonoStatic* audio cassette series was begun a year after *PhotoStatic*'s first issue; and the *VideoStatic* compilation a few years later. It was not just xerox

[*sic*] that interested us; we wanted to generalize the photostatic set of practices and apply them to all accessible media."[12]

In the 1980s, the cassette underground flourished. Sandwiched between mail art and the MP3 revolution, cassettes were a quick and cheap way to get homemade music into the hands of a sympathetic worldwide audience. Mail art and the cassette underground were precursors to file-sharing networks; in fact, after the rise of the internet, mail art as a genre became moribund. The cassette underground was also a site of political and artistic resistance during the Reagan years, a portable revolution that arrived in your mailbox each day. In his introduction to an anthology of writings about the cassette underground, *Cassette Mythos*, Robin James talks about the thrill of picking up your mail:

> Every time you go to your mailbox you could be picking up little packages that contain impossible sounds. . . . It could be something that will pop in and totally blow you away. . . . Lots of possibilities: garage sessions of your kid sister's rock band, or someone in a fancy home lab mixing incredible feats of science, or a pioneer of popular rock, soothing meditation, or difficult industrial noise. . . . [Cassettes] are tickets to many sonic environments. It's probably not going to sound like anything you might hear on the radio.[13]

The *PhonoStatic* cassettes are representative of the sort of stuff that the cassette underground trafficked in: media sound bites, LPs played at the wrong speeds, bizarre answering-machine messages, amateur radio plays, cheap electronic music, sound poetry, B-grade movie soundtracks taped off of late-night television, punk rock, and audio letters. As opposed to *Tellus*, *PhonoStatic* had no mainstream cultural ambitions: "It is perhaps a

reflection of our fragmented attention spans that many of our models came from bodies of work decidedly outside of the art world, but it is surely a reflection, too, of our skepticism of the value of these established venues," writes Dunn.[14] And all of it was free; there was never any expectation of monetary compensation. The full runs of *PhonoStatic* and *PhotoStatic* are part of MoMA's Library Collection, courtesy of Clive Phillpot.

RE/Search magazine

It's hard to imagine today how shocking it was to stumble upon *RE/Search* magazine in the early 1980s. It leaped out of a sea of grubby black-and-white newsprint punk zines, and you felt as if you were thrown across the color threshold in *The Wizard of Oz*. A heady mix of S&M, punk rock, and critical theory, *RE/Search* mashed high with low and modernism with camp, resulting in a stew of art, sex, and danger. Each issue was severe, slathered in bold graphics printed on thick paper stock and boasting glossy covers. The cover of issue 6–7, "The Industrial Culture Handbook" (1983), updated John Heartfield's X-ray collage of Hitler swallowing coins with a photomontage of a skinny, male torso sliced open to reveal its innards, consisting of a set of hand-drawn machine gears. Using a color scheme of blood red and black, the issue felt like something out of Russian constructivism, which in fact it was—the layout and page designs were swiped from a Rodchenko book. Upon opening the book, you found interviews with edgy underground postpunk artists such as Throbbing Gristle, Survival Research Laboratories, and Johanna Went, all of which were illustrated with dark photographs of smoking factories and industrial-waste landscapes.

Issue 4–5 (1982) had a striking black-and-white image of William S. Burroughs, dressed in his standard three-piece suit, tie,

and homburg, staring with disdain at the reader, again set against an astringent red background. The frontispiece was nothing more than a stark page of vertical black-and-white stripes, resembling a piece by the French artist Daniel Buren. The table of contents, delineated by thick, black, quarter-inch rules—a graphical theme throughout the issue—listed only three features: one on Burroughs, one on Brion Gysin, and, once again, another on Throbbing Gristle. Spanning thirty to forty pages, each feature contained in-depth interviews, unpublished manuscripts, transcriptions, travelogues, chronologies, discographies, bibliographies, and critical writing by and about each of the subjects.

The Burroughs section featured a lengthy excerpt of *The Revised Boy Scout Manual*; a novel that had been transcribed from 3 one-hour cassettes from 1970; some new and unpublished pieces; and a long interview. *The Revised Boy Scout Manual* is a series of short how-to texts cut up into snippets—how to use firearms, bombs, and explosive devices; how to assassinate enemies; how to foment biological warfare; how to topple governments; and so forth—and sprinkled with bits of prose and dialogue, all mixed up and glued back together again. The feature is peppered with photos of Burroughs with guns—Burroughs in a San Francisco garden aiming a hand gun, Burroughs amid spent targets at an Oakland shooting range, Burroughs cradling a 12-gauge shotgun with a sly grin on his face, Burroughs firing a Colt Commander with both hands. His interview is all about firearms as well.

About the manuscript, Burroughs stated, "The weapons I wish to advocate are weapons that change consciousness—cutups, scrambling, use of videotapes, etc." He discusses the potential of tape recorders to escalate riots and speech scramblers to misrepresent information, thus introducing the idea of fake news a half-century ago. One creative result of Burroughs's gun mania manifested in his *Shotgun Paintings*. UbuWeb has a video of

Burroughs in his three-piece suit outdoors at a shooting range in Kansas making the paintings by blasting at spray-paint cans placed in front of canvases. "The paint sprays in exploding color across your surface," Burroughs said. "You can have as many colors as you want."

RE/Search was the brainchild of V. Vale, a Japanese American born in an internment camp in 1944 and a former member of the San Francisco–based proto-metal band Blue Cheer. Raised on welfare by a mentally unstable Seventh-Day Adventist mother, he bounced around in foster homes as a child—from a Polish family in Peoria to an abusive macho uncle to an African American home in Whittier, California—which made him feel like an outsider from an early age. He began compulsively reading and writing in journals as a life raft; no matter what home he was in, he could always get lost in his books, which ultimately led him to become a publisher later in life.

In 1968, after leaving Blue Cheer, he went to work at San Francisco's City Lights Bookshop, where he stayed until 1984. Surrounded by volumes of the City Lights Pocket Books series, which included Ginsberg's *Howl* and *Kaddish* and O'Hara's *Lunch Poems*, he quickly understood the value of a brand, even if that brand is underground—"aesthetics determine consumption," he likes to say. Vale learned that anything that City Lights owner and poet Lawrence Ferlinghetti published in this series was going to be something worth checking out. He was also exposed to an incredible amount of used early and midcentury surrealist and avant-garde material passing through the store at bargain-basement prices. Vale would snap up copies of the legendary surrealist magazine *VVV* from the 1940s for $12 apiece—a day's salary—which became one of the primary aesthetic models for *RE/Search* (today a single issue of *VVV* goes for more than $1,000, with a complete mint-condition four-issue set priced at nearly $10,000).

Vale fell into San Francisco's punk scene and in 1977 began producing a zine called *Search and Destroy* modeled on Warhol's *Inter/VIEW*. It was a typically rough affair: a tabloid-size newsprint zine full of grainy photos and text that Vale typed out on an old IBM Correcting Selectric II. Modeled on underground situationist publications of the 1960s, *Search and Destroy* covered everything from the Cramps to the Dead Kennedys and offered long, thoughtful interviews steeped in politics and culture. The zine seemed to embody the line that Greil Marcus later identified in *Lipstick Traces*—that a certain lineage of the twentieth century's underground avant history could be traced directly from Zurich's Cabaret Voltaire Dada performances in 1916 to the original Sex Pistols' final concert at the Winterland Ballroom in San Francisco in 1978. *Search and Destroy* went out of its way to make clear these connections between punk and the historical avant-garde. A typical article entitled "Anarchy, Surrealism, and New Wave" observed that "in a world terrorized ABOVE All by nuclear weapons, nothing better validates the surrealist perspective on life than the emergence of something like new wave, in which outrage and art combine to provide means for revolt to claim new terrain. In a world that has answered surrealism with expanded police supervision, new wave demonstrates that a truly corrosive sense of freedom is still the finest positive agent for the transformation of life."[15] Sprinkled with Breton and Nietzsche pull quotes, *Search and Destroy* was evidence of the intellectual richness of certain sectors of the Bay Area punk scene.

The final issue of *Search and Destroy* was published in early 1979, a year after the Sex Pistols' last concert, after which a media frenzy descended upon the Bay Area, documenting for national television what had previously been an intimate local punk scene. Vale recalls exploitative TV programs such as *NBC Weekend* highlighting the violence and showing footage of slam dancing

and mosh pits, the very opposite of the political and intellectual milieu that Vale and others had worked so hard to cultivate. He took this shift as a sign to exit the scene and start fresh with *RE/ Search*.

With seed money put up by the record label Rough Trade, Vale intended *RE/Search* as a sort of postpunk publication, salvaging the ideals that had been lost after the Sex Pistols. Most of the punks he knew had moved on anyway, reading Burroughs, Gysin, Acker, and Ballard and applying those writing methods to their art forms. Drawing from the intellectuals and dropouts hanging around City Lights, Vale decided to emphasize the more avant-garde elements of *Search and Destroy*, while mostly leaving the rock 'n' roll behind. Although he hired Tobias Moss (designer of the *Life* magazine logo) to design the new *RE/Search* logo (note the similarities), the first few issues of *RE/Search* looked like *Search and Destroy*—printed on the same smeary tabloid newsprint. But in place of band coverage was a dazzlingly eclectic content, featuring topics as vast as genital modification, Fela Anikulapo Kuti, S&M lesbian sex, cryptofascism, pirate fashion, and cannibalism. Vale began to see the magazine as a platform for his own personal brand of cultural anthropology (J. G. Ballard once referred to Vale as an "urban anthropologist"[16]), a notebook or clearinghouse of ideas of things that interested him, not dissimilar to the way Dušan Barok would use Monoskop decades later. Vale sensed that if you threw enough interesting stuff together in one place, something magical was bound to happen.

When Vale left City Lights in the early 1980s, he went into the typesetting business, which gave him access to technology that would produce *RE/Search* in its full glory, rife with multiple fonts, sharp graphics, stunning photographs, and high-quality printing. The result was an entirely new magazine, one that documented the emergence of Bay Area Industrial Culture—a

postpunk movement that romanticized urban decay as the basis for a postapocalyptic utopianism manifesting itself in various strains of music, performance, and visual art that arose in the wake of Jim Jones and the murders of Harvey Milk and George Moscone. Typical of this type of art was the work of Survival Research Laboratories, a collective of Bay Area programmers, hackers, and mechanics who built and programmed robots to do things such as fight with one another, throw flames, and fire projectiles. Part Jean Tinguely and part military weaponry, their works were something out of the dystopian novels of J. G. Ballard, sculptural illustrations of what happens when technology goes wrong. As Jon Savage writes in his introduction to the "Industrial Culture Handbook" issue of *RE/Search*, "Punk, by this time, had not gone far enough: its style had become a pose, window-dressing for packaging and consumption though the usual commercial channels. Something new was needed: what was there?"[17]

As time went on, each issue focused on a distinct theme. *RE/Search* numbers 8–9 (1984), clocking in at 176 pages—more book than magazine—was devoted entirely to J. G. Ballard. The eerie aqua-green cover was emblazoned with a solarized, colorized photograph of a rocket ship reflected in a plate-glass window with the word *THEATERS* etched into it. The photo, taken by the underground photographer Ana Barrado, was one in a series of scenes of crumbling modernism and dilapidated military-industrial complexes strewn throughout the issue, perfect accompaniments for Ballard's dark, technology-inflected writings. Constructivist design elements from the earlier issues were carried forward to this issue, becoming a house style. The book documents for the first time the vast scope of Ballard's career, including interviews, fiction, nonfiction, critical writings about his work, images of his photocopy collages, and extensive bibliographies. It concludes with a previously unpublished list

poem, a riff on Joe Brainard's "I Remember," called "What I Believe by Ballard," which includes lines such as "I believe in the body odours of Princess Di," and "I believe in the history of my feet."

RE/Search issue number 13, "Angry Women" (1991), channels the anger of punk and redirects it in the direction of gender. Decades ahead of its time by advocating for trans rights and gender fluidity, the issue is peppered with sentiments such as "the very act of subverting something so primal and fixed in society as one's gender role, can unleash a creativity that is truly needed by society—like a shamanistic act."[18] The channel through which this subversion might be achieved, according to its editors, is anger. Reflecting the punk milieu from which *RE/Search* emerged, they wrote, "Anger is an emotion which must be reclaimed and legitimized as Woman's rightful, healthy expression—anger can be a source of power, strength and clarity as well as a creative force . . . Could there have been a civil rights movement in the '60s without anger?"[19] The issue featured interviews with artists and thinkers as diverse as Diamanda Galás, bell hooks, Karen Finley, and Annie Sprinkle. Galás sums up the fusion of sex and revolution when she says, "*Strong women* . . . I picture a life surrounded by the most fantastic women in the world . . . women who are very powerful, very exotic, and even though they don't have to be beautiful, it would be nice. I'd like to be surrounded by soulful, lovely, unusual, strong women, like in that Russ Meyer film—."[20] The stakes are nothing less than revolutionary; if patriarchy can be dismantled, so can binaries, opening up unknown possibilities: "We look forward," wrote the issue editors, "to a society which will integrate the female and the male (and all other binary dualisms) toward a new, synthesizing consciousness, in which every individual can re-ignite the *creativity within*. And there are no shortcuts—every single

assumption of our civilization must be challenged. Ultimately, *everything* must be rethought . . . if we are to survive."[21]

Packaged so gorgeously, *RE/Search* was a Trojan horse, bringing outré material into the heart of mainstream culture. Issue number 12, "Modern Primitives" (1989), kicked off the tattoo and body-piercing craze that began in the following decade. In 1983, with the publication of the "Industrial Culture Handbook," the editors had coined the term *industrial music*. Their early support for marginal authors such as J.G. Ballard preceded by many years his mainstream reception through Spielberg's adaptation of his novel *Empire of the Sun*. And the "Angry Women" issue dovetailed with the Riot grrrl feminist punk movement from that decade and anticipated today's #metoo movement. Issue after issue of *RE/Search* was inspiring—"Modern Primitives," "Incredibly Strange Music Vols. One and Two," "Incredibly Strange Films," "Bob Flanagan: Super Masochist," "RE/Search Guide to Bodily Fluids," "Pranks," to name but a few.

Suffice it to say that without *RE/Search* there would've been no UbuWeb. That whole project, summed up in the sentence "Every single assumption of our civilization must be challenged," remains challenging and inspiring—not to mention unanswered and unfulfilled—as it was more than three decades ago. This notion alone gave birth to the future project that would become UbuWeb.

CODA

THE GHOST IN THE ALGORITHM

In today's culture, choice—and perhaps taste—is increasingly dictated by curation algorithms—bots that scrape your web-browsing history and spit it back at you in the form of a recommendation of the next thing you should watch or listen to or buy. These algorithms have become very precise, creating infinitely looping, self-reflexive, cultural filter bubbles. With the rise of what Shoshana Zuboff has termed "surveillance capitalism"[1]—the intensive marketing of your data trails—discovery has given way to predictability; the more targeted your clicks, the easier it is to forecast where you'll click in the future. The result is precisely targeted advertising—the tracking and surveillance of your online activities—a marketer's dream.

But the algorithm is just a string of code deployed to execute a specific task. The algorithm can also be programmed to surprise, as in its randomizing function, a staple of early web culture. When CDs appeared, the players had a shuffle function, something that was impossible with the LP or cassette. Putting a disc on shuffle was a way of breaking up well-known sequences of songs, of de-familiarizing old records. That sensibility did carry over to the web, where the algorithmic randomizer was used as a device to discover new sites—just think

of everything from Google's "I'm feeling lucky" button (which, until 2010, was placed alongside its "search" button on its front page) to Chatroulette, which brought you into contact with random strangers, producing, needless to say, a range of interactions and experiences.

In its early days, the web was tinged with surrealism, employing its methods of drift, disorientation, and disjunction as ways of opening up new and unknown experiences, if one were so inclined. Similarly and historically, other strains of the avant-garde sought to challenge prescribed habits with a panoply of de-familiarizing techniques, be it cubism's shattered painting surfaces or atonal music's jagged edges or modernist poetry's chopped-up words. In the avant-garde, formal innovations were often deployed as methods of discovery: nobody ever walked out of a concert hall whistling a Schoenberg twelve-tone string quartet, which was part of his intention. Instead, each time you listened to the quartet, you would hear something different. John Cage once said, "If you listen to Beethoven or to Mozart you see that they are always the same, but if you listen to traffic you see it's always different."[2]

The result was open-ended artworks, ones that denied singular readings—how you interpret that Schoenberg string quartet is equally valid to my interpretation of it—culminating in a situation in which the audience became, in a sense, collaborators with the works. This thread of communal experience was hard-wired into modernism—be it Gertrude Stein's *Everybody's Autobiography*, James Joyce's "here comes everybody," or Joseph Beuys's famous claim that "everyone is an artist"—rejecting the singular and opting instead for the multiple, the available, the plentiful, the inclusive, and the democratic. These seeds of resistance to our algorithmic world nestled within the historical avant-garde might be worth paying attention to as they resonate in the digital age. I can possess a copy of an MP3, but I can at

the same time share it with a potentially unlimited number of people.

At a time when algorithms increasingly determine which cultural artifacts we engage with and which we don't, it's important to seek out alternatives to these automated, money-driven tastemakers. An algorithm isn't capable of a perverse sensibility, nor can it replicate the capriciousness of human taste. When accretion isn't mandated to proceed by logical order or recommendations made by a supposedly "intelligent" algorithm, other narratives become possible, such as the *dérive*, an unplanned journey in which people let themselves be "drawn by the attractions of the terrain and the encounters they find there."[3] Algorithms abhor surprise; they wish to cater to what you already know and like. Serendipity is the enemy of the mechanical.

Enhanced by new technologies and the access the internet provides, UbuWeb favors older, warmer models of discovery, such as drifting through library stacks or a used bookstore and letting certain books jump out at you or rambling through a flea market without intention, allowing yourself to be pulled by intuition and whimsy. On UbuWeb, alphabetization is our algorithm—our resources are organized A to Z so that nothing is more prominent or promoted than the next. UbuWeb is nonhierarchical; this is not more important than that. Odd neighbors—world famous and completely unknown—rub up against one another, sparking surprising connections. On Ubu, you don't need a "this is like that" algorithm because everything is like everything else; chances are that you will be interested in anything and randomly click on it because the site was assembled by humans around the broad theme of the avant-garde. This might be like that, but not for obvious reasons; their connections can be oblique and subtle or even counterintuitive or nonsensical—all sensibilities that algorithms are incapable of. Ultimately, the curation algorithm is transactional, a means of getting you to keep spending money.

All of the popular algorithms—"people who watched this also watched," "inspired by your recent shopping trends," "sponsored products related to this item," "frequently bought together," and "customers who viewed this item also viewed"—would stall on UbuWeb because of the simple fact that there are no transactions on the site.

UbuWeb is a human-driven work of sorting, curating, and archiving. In the end, the impulse to collect and gather is the impulse to preserve what we love and want to share, which became possible in new ways thanks to the web. By doing so, we write our own histories because—as demonstrated here in the case of obscure, challenging, and avant-garde materials—few are writing them for us. As the poet Charles Bernstein says, "I don't have faith that mainstream interests will preserve protect and defend any of this work. For me, the activity of archiving allows it to exist. If we didn't do this, it would be entirely lost. What would be preserved would be mainstream work, official verse culture. That is my work, organizing alternative forms of exchange. My goal is rather straightforward: Can you create spaces for cultural exchange outside of the dominant killing forces?"[4]

APPENDIX

101 THINGS ON UBUWEB THAT YOU DON'T KNOW ABOUT BUT SHOULD

'm constantly asked what my favorite things on Ubu-Web are. So here are 101 things that live on UbuWeb that I think you should know about. The list is far from complete—thousands more are worthy. Rather, it is an invitation to you to explore the vastness of the site and find things that you might want to include on your own list. While I personally uploaded just about everything that's on UbuWeb, there's just too damn much for me to ever know it all. When I put this list together, I found myself discovering and rediscovering things I had no knowledge of or had forgotten about. Each time you reacquaint yourself with Ubu, like with any massive reference work, you find yourself lost in it, as if you had never experienced it before. God, it's huge.

Oh, by the time you get around to looking these things up, there's a good chance that some of them might not be there anymore. So my advice to you is to consult this list and download things immediately. In fact, download the entire site—it is possible. Make sure your local library is much richer than anything you can find online. Don't trust the cloud—even UbuWeb's cloud.

1. Sean Landers, "The Man Within." A manic twenty-minute rant by Landers, accompanied to the strains of Holst's "The

Planets," about how he is the greatest artist in the history of the world. And the scary thing is that he actually believes it (http://ubu.com/sound/landers.html).

2. Hito Steyerl, *Lovely Andrea*. A personal journey filmed in Tokyo of Steyerl searching for the photographer of a photo series that she posed for as an S&M model in 1987 (http://www.ubu.com/film/steyerl_andrea.html).

3. Kelly Mark, "I Really Should." A litany of procrastination, this fifty-minute poem lists everything Mark really should do but doesn't (http://ubu.com/sound/mark.html).

4. Adolf Wölfli, *Gelesen und Vertont*. While you might know of this early-twentieth-century outsider artist's visionary drawings, you've probably never heard his equally visionary music (http://ubu.com/sound/wolfli.html).

5. Lynda Benglis, *Female Sensibility*. Two women, faces framed in tight focus, kiss and caress. Their interaction is silent, muted by the superimposition of a noisy AM radio soundtrack (http://ubu.com/film/benglis_female.html).

6. Terayama Shuji, *Photothèque imaginaire de Shuji Terayama, les gens de la famille Chien Dieu*. Evidence that the great Japanese experimental filmmaker was an equally great photographer (http://www.ubu.com/historical/terayama/index.html).

7. Frances Stark, *[THIS IS NOT EXACTLY A CAT VIDEO]*. Kids on an unmade bed watching and reacting to David Bowie videos from the 1970s (http://www.ubu.com/film/stark_cat.html).

8. Stan Brakhage, *The Test of Time*. A series of twenty half-hour radio shows featuring incredible music and insightful commentary, hosted by Brakhage in 1982 for University of Colorado KAIR radio (http://www.ubu.com/sound/brakhage.html).

9. *Arabic Calligraphers in Paris from the 1970s*. A selection of intensely detailed visual poetry, mixing traditional motifs with modernist text-based designs (http://www.ubu.com/historical/arabic/index.html).

10. Alison Knowles, *By Alison Knowles*. A compendium of rare Fluxus performance scores, published in 1965 (http://www.ubu.com/historical/knowles/index.html).

11. Alfred Clah, *Through Navajo Eyes: The Intrepid Shadows*. A little-known Native American avant-garde experimental film from 1966 (http://www.ubu.com/film/clah_shadows.html).

12. Cornelius Cardew, *Piano Music of the 1970s*. Following his severe avant-garde period, Cardew composed and played gorgeously lyrical workers' anthems (http://www.ubu.com/film /al_error.html).

13. Václav Havel, *Audience*. A rare samizdat recording from 1978, written by and starring Havel prior to his becoming president of Czechoslovakia (http://www.ubu.com/sound/havel.html).

14. Sophia Al-Maria, *Mirror Cookie*. A short video in which this Qatari American video artist critiques what she calls the "misogyny-industrial complex" of Hollywood (http://www.ubu .com/film/al-maria_cookie.html).

15. *Louis-Ferdinand Céline Sings*. Rare recordings of Céline singing his own lyrics, accompanied by accordion in the French chanson style (http://ubu.com/sound/celine.html).

16. Agnès Varda, *Plaisir d'amour en Iran*. A short film about a love affair in pre-revolutionary Iran, shot in 1976 at the Shah Masjed in Isfahan (http://ubu.com/film/varda_iran.html).

17. *Electronic Music Review, Numbers 1–7*. An important electronic music journal of the 1960s, with articles from leading composers and inventors such as Stockhausen, Rzewski, Moog, and many others (http://www.ubu.com/emr/periodicals.html).

18. Kathy Acker and the Mekons, *Pussy, King of the Pirates*. Acker collaborating with a punk band in the 1990s, sounding like a cross between the Pogues and the Slits (http://ubu.com/sound /acker.html).

19. George Antheil, *Ballet mécanique*. Written in 1924, an avant-garde symphony replete with seven electric bells, a siren, and three different-size airplane propellers (http://ubu.com/sound /antheil.html).

20. Yayoi Kusama, *Kusama's Self-Obliteration*. A rare cinematic work by Kusama documenting her legendary "nude happenings" of 1967, overlaid with her famous dots and accompanied by a psychedelic music soundtrack (http://ubu.com/film /kusama_obliteration.html).

21. Claude Closky, *The First Thousand Numbers Classified in Alphabetical Order*. Exactly what it sounds like it is. An astonishing conceptual poem, even more astonishing in its simplicity (http://www.ubu.com/concept/closky_1000.html).

22. Hanne Darboven, "Opus 60, Symphony for 120 Players." While you might be familiar with Darboven's obsessive drawings and diaries, you might not have heard her gorgeously textured minimalist music (http://www.ubu.com/sound/darboven.html).

23. Crispin Hellion Glover, *The Big Problem ≠ The Solution. The Solution = Let It Be*. An experimental, Residents-tinged spoken-word record by the eccentric actor (http://www.ubu.com/sound/glover.html).

24. Morton Feldman, "The King of Denmark." For sure, the only thorny avant-garde piece ever etched onto a flexi disc. Expertly played by legendary percussionist Max Neuhaus (http://www.ubu.com/aspen/aspen5and6/audio5C.html).

25. Eliane Radigue, *Interview with Eliane Radigue (December 11, 1980)*. Explores Radigue's background as a student of Pierre Schaeffer and Pierre Henry, her compositional technique involving synthesizers and tape recorders, and her life as a composer and Tibetan Buddhist (http://www.ubu.com/sound/radigue.html).

26. Momus, *The Creation Records*. Six seminal discs by the singer-songwriter–performance artist–author made between 1987 and 1993, accompanied by original liner notes along with reflections by the artist on how he feels about those works now (http://ubu.com/sound/momus_hippo.html).

27. Lydia Lunch, *The Gun Is Loaded*. Performance video that trails Lunch in 1988 through a series of location shots in New York as she fires her spoken-word manifestoes directly into the eye of the camera (http://www.ubu.com/film/lunch_loaded.html).

28. Reese Williams, *The Sonance Project*. An entire LP made only of vocal snippets—giggles, breaths, and parts of speech—sequenced into gorgeously looped compositions (http://ubu.com/sound/williams.html).

29. Forum Lenteng, *Massroom Project*. The Indonesian art collective explores the urban poetics and diversity of Jakarta in a series of nine videos (http://www.ubu.com/film/lenteng.html).

30. Hugo Keesing, *Chartsweep.* A compilation of five seconds of
 every chart-topping single from 1956 until 1992, beginning with
 Dean Martin's "Memories Are Made of This" and ending with
 Whitney Houston's "I Will Always Love You" (http://ubu.com
 /sound/keesing.html).
31. Kader Attia, *Inspiration/Conversation.* A video of two black
 men, face to face, blowing into an empty plastic bottle,
 described as "the sound of all of Africa wheezing" (http://www
 .ubu.com/film/attia_inspiration.html).
32. Red Shadow (the Economics Rock & Roll Band), "Under-
 standing Marx." Marxist hippie collective of the 1970s enticing
 you to join the team: "Read Marx and Lenin; it will really turn
 you loose!" (http://www.ubu.com/outsiders/365/2003/006.html).
33. Patti Smith, *Early Poetry Readings & Rock Shows, 1971–74.*
 Where it all started. Includes a poetry reading at St. Mark's
 Church in New York in 1971, with Lenny Kaye on guitar
 (http://www.ubu.com/sound/smith.html).
34. Buckminster Fuller, *Two Interviews with Damien Simpson.*
 Bucky appears on the New Age TV show *Psychic Phenomena,*
 filmed in Los Angeles. Surreal is an understatement (http://
 www.ubu.com/film/fuller_21.html).
35. Silvestre Revueltas (April 4, 1967). An introduction to and
 overview of this underknown Mexican modernist composer's
 work, specifically focusing on its intersections with traditional
 Mexican music (http://www.ubu.com/sound/revueltas.html).
36. Marcel Duchamp, *Jeu d'échecs avec Marcel Duchamp.* Rare
 in-depth interview with Duchamp five years before his death,
 where he discusses his entire career in detail (http://www.ubu
 .com/film/duchamp_drot.html).
37. Peggy Awesh, *Beirut Outtakes.* Found-footage montage,
 composed entirely of film scraps salvaged from an abandoned
 Beirut cinema (http://www.ubu.com/film/ahwesh_beirut.html).
38. Billie Whitelaw, performing Samuel Beckett's *Not I.* A film
 showing only the actress's mouth reciting Beckett's monologue
 of fragmented, jumbled sentences (http://www.ubu.com/film
 /beckett_not.html).
39. *Sound Experiments in the Russian Avant-Garde, 1908–1942.*
 A vast survey of archival recordings by Dziga Vertov, Kazimir

Malevich, Varvara Stepanova, Leon Trotsky, and dozens more (http://ubu.com/sound/russian_avant.html).

40. Furious Pig, *I Don't Like Your Face*. An EP of a British group of rockers who mixed sound poetry with punk rock, sounding like a cross between Indonesian *kecak* and football chants (http://www.ubu.com/sound/furious_pig.html).

41. Ulysses Jenkins, *Mass of Images*. A recorded performance of Jenkins along with TV images that engages black stereotypes perpetuated by the American media (http://www.ubu.com/film/jenkins_mass.html).

42. *Lipstick Traces*, accompanying CD to the book by Greil Marcus. A survey of the underground, from Dada to punk. Especially notable for the recording of Marie Osmond reciting Hugo Ball's Dada poem "Karawane" (1916) (http://www.ubu.com/sound/lipstick.html).

43. Don Cherry and Terry Riley, *Live Köln*. Cosmic jazz meets cosmic minimalism. Pocket trumpets and bubbly synthesizers (http://ubu.com/sound/cherry.html).

44. Sara Sackner, *Concrete*. A documentary about the Ruth and Marvin Sackner Archive for Visual and Concrete Poetry, featuring more than 75,000 works of text-based art (http://www.ubu.com/film/sackner_concrete.html).

45. Brandon Locher, *Conversations*. Hysterical prank-phone-call chains that work their way across America, state by state, until all fifty are accounted for (http://ubu.com/sound/locher.html).

46. Steve Reich, "Livelihood." An unreleased three-minute distillation of ten hours of back-of-the-cab conversations. At the time, Reich was driving a cab in San Francisco, which he bugged with a microphone, secretly recording conversations and noises, mixing them into a tape collage (http://ubu.com/sound/reich.html).

47. *Fuck You: A Magazine of the Arts*, edited by Ed Sanders. Full run of arguably the most important mimeo-revolution publication of the 1960s. Raided by the police and shut down for obscenity (http://www.ubu.com/vp/FuckYou.html).

48. COLAB, *All Color News Sampler*. A collection of clips from an underground New York community-access cable show in the

early 1980s, featuring political and socially oriented works by
artists (http://www.ubu.com/film/colab_news.html).

49. Banksy, *The Punking of Paris Hilton.* Video document of an
anticonsumerist action in which remixed Paris Hilton CDs
were droplifted into record stores across the United Kingdom
(http://ubu.com/film/banksy_hilton.html).

50. Jean Genet, *Un chant d'amour.* Jean Genet's only film, which he
directed in 1950 about gay life in a prison (http://www.ubu.com
/film/genet_chant.html).

51. Theodor Adorno, "Punctuation Marks." A short essay where
Adorno says that exclamation points look like index fingers,
question marks like blinking eyes, colons like open mouths, and
semicolons like drooping moustaches (http://ubu.com/papers
/Adorno-Theodor-W-Punctuation-Marks.pdf).

52. Andrea Fraser, *Little Frank and His Carp.* Filmed by hidden
cameras at the Guggenheim Bilbao, Fraser literally follows the
museum's audio guide to the point of absurd sensuality
(http://www.ubu.com/film/fraser_frank.html).

53. Rolf Liebermann, "Symphonie 'Les Echanges' Komposition für
156 Maschinen." Scored for 156 machines, including 16 type-
writers, 18 calculators, 8 adding machines, 12 hole punchers, 10
cash registers, 8 humidifiers, 8 telex machines, 2 metronomes, 4
bells, 2 doorbells, 10 claxons, 16 telephones, 40 experimental
signal receptors, 1 forklift, 1 copy machine, and an elevator. No,
really (http://ubu.com/sound/liebermann.html).

54. Georges Perec, "TENTATIVE DE DESCRIPTION DE
CHOSES VUES AU CARREFOUR MABILLON LE 19
MAI 1978 (A. C. R.)." The Oulipo writer stands on a street
corner in Paris for a few hours, describing in detail *everything*
passing before his eyes (http://ubu.com/sound/perec.html).

55. Tony Cokes, *Evil 35: Carlin/Owners.* Political slogans writ large
on brightly colored backgrounds, critiquing capitalism,
corporatism, and ownership, set to a new-wave rock soundtrack
(http://www.ubu.com/film/cokes_evil35.html).

56. *Musique Concrète Soundtracks to Experimental Short Films.*
A collection of lost music from celluloid featuring Joan La
Barbara, Bernard Parmegiani, Pierre Boulez, Gershon

Kingsley, Percy Grainger, and others (http://www.ubu.com
/sound/concrete_film.html).

57. Alex Bag, *Untitled Fall '95*. Videos from the feminist punk/
DIY/camcorder movement of the early 1990s featuring Bag, at
the time an art student, "playing" Bag the Art Student
(http://www.ubu.com/film/bag_fall95.html).

58. Judy Dunaway, *Unreleased Balloon Tracks*. A serious classical
composer whose instrument is the balloon. The highlight is a
balloon rendition of Weill and Brecht's "Surabaya Johnny"
(http://ubu.com/sound/dunaway.html).

59. *The Collected Rants of Francis E. Dec.* Paranoid flyers with
over-the-top conspiracy theories mass mailed to random people,
businesses, and media all over the world. In the mid-1980s, a
radio DJ recorded these manic audio versions of the flyers
(http://www.ubu.com/sound/dec.html).

60. Alix Pearlstein, *Two Women*. By juxtaposing a live performer
with a photograph of a nude woman cut out from a magazine,
Pearlstein addresses the problematic relationship between
feminism, desire, and mass media (http://ubu.com/film
/pearlstein_two.html).

61. Amiri Baraka, *A Black Mass*. A recording of Baraka's play
accompanied by Sun Ra's Myth-Science Orchestra from 1968
(http://www.ubu.com/sound/baraka.html).

62. William Forsythe, "Solo." Wild solo performance by the
legendary choreographer, capturing his frenetic movements
across a starkly lit stage (http://www.ubu.com/film/forsythe
_solo.html).

63. *The Early Films of Gilbert and George*. Black-and-white films
from 1972 depicting stiff British leisurely, pastoral activities,
such as drinking gin and walking in parks (http://www.ubu
.com/film/gg.html).

64. Alex Harsley, *A Look at David Hammons*. Footage of Hammons
making drawings by throwing a graphite-covered basketball at
blank sheets of paper (http://ubu.com/film/hammons_look
.html).

65. Peter Gidal, *Clouds*. A beautiful short black-and-white film of
the sky, where a small airplane occasionally darts in and out of
the frame. The epitome of structuralist film; the soundtrack is

the hum of the projector (http://www.ubu.com/film/gidal
_clouds.html).

66. *The Free Jack Ads.* A collection of notes posted on a public
bulletin board in the 1980s by a guy proposing insane service
swaps such as rides to Kennedy Airport in exchange for dinners
with specific ingredients: "prime rib, loin lamb or filet mignon,
1 starch and a vegetable" (http://www.ubu.com/outsiders/jack
/jack1.html).

67. Anna Akhmatova, "To The Muse." A rare chance to hear the
voice of Akhmatova reading an avant-garde poem in 1924
(http://www.ubu.com/sound/akhmatova.html).

68. John Cage and Morton Feldman, *Radio Happenings I–V.*
Recorded between July 1966 and January 1967 for WBAI.
Conversations between two old friends, relaxed, smoking, and
throwing out ideas, full of laughter and long ponderous silences
(http://www.ubu.com/sound/feldman.html#radio).

69. *On the Passage of a Few People Through a Rather Brief Moment in
Time: The Situationist International, 1956–1972.* A short primer
about the Situationist International featuring Greil Marcus,
Malcolm McLaren, and Jamie Reid (http://ubu.com/film
/si_passage.html).

70. *Occult Voices—Paranormal Music, Recordings of Unseen Intelli-
gences.* Audio documents of paranormal phenomena, including
trance speech, direct voices, clairvoyance, xenoglossy, glossolia
with ethnological material, paranormal music, "rappings" and
other poltergeist manifestations, as well as so-called electronic-
voice phenomena (http://www.ubu.com/sound/occult.html).

71. Captain Beefheart, *Poetry Reading.* A collection of the
avant-rocker reading his poetry and lyrics without music
(http://www.ubu.com/sound/beefheart.html).

72. Louise Lawler, *Birdcalls.* Lawler turning the names of famous
male artists into birdsong as a critique of patriarchy (http://ubu
.com/sound/lawler.html).

73. Karlheinz Stockhausen, *British Lectures.* Seven filmed lectures
given at the Institute of Contemporary Art in London, each
lasting up to three hours and including musical performances.
Exhaustive, exhausting, and exhilarating (http://www.ubu.com
/film/stockhausen_lectures.html).

74. Jennifer Higgie, *Ten Women Who Use Film.* The former editor of *Frieze* introduces the work of ten women who were not previously on UbuWeb, including Spartacus Chetwynd, Fiona Tan, and Annika Ström (http://www.ubu.com/film/higgie.html).

75. *Inuit Vocal Games.* Astonishing Indigenous peoples' sound works, where words and syllables are made by two people using their mouths and bodies as audio resonators (http://www.ubu.com/sound/inuit.html).

76. Benjamin Weismann, "Hitler Ski Story." The Los Angeles–based writer intones a hysterical story about Hitler learning how to snowplow and toboggan in the Alps, accompanied by the saccharine strains of Vivaldi (http://www.ubu.com/sound/weismann.html).

77. Harry Dodge and Stanya Kahn, *Can't Swallow It, Can't Spit It Out.* Ms. Kahn is seen with a bloodied nose, a Viking helmet, and a large wedge of rubber Swiss cheese, rambling around Los Angeles, talking to the camera (http://ubu.com/film/dodge_swallow.html).

78. Keiichi Tanaami, *OH YOKO!* Groovy animated music video for John Lennon's song in the vein of Peter Max–era *Yellow Submarine* (http://ubu.com/film/tanaami_yoko.html).

79. Chris Burden, "Send Me Your Money." In 1979, Chris Burden got on the radio and begged listeners to send him money. He starts, "I can't legally do this, but let's just imagine that I am asking everybody who is listening to send me money." His pitch goes on relentlessly for an hour (http://www.ubu.com/sound/burden.html).

80. *Tellus* no. 14, *Just Intonation.* A sweeping retrospective of classical, folk, and modern microtonal music (http://www.ubu.com/sound/tellus_14.html).

81. Robin Kahn, *Jesus Christ Superstar.* The full rock opera, a capella, from start to finish, sung from memory by the artist, who can't keep a tune. Astonishing (http://www.ubu.com/sound/kahn.html).

82. *Yugoslav Black Wave Cinema, 1962–1972.* Two dozen rare experimental films from the country's underground and oppositional cinema (http://ubu.com/film/blackwave.html).

83. Dariush Dolat-Shahi, *Electronic Music, Tar and Setar.* Minimalist-flavored Iranian electronic music based on traditional instruments, tape loops, and nature sounds (http://ubu.com/sound/dolat-shahi.html).

84. Bertolt Brecht, two songs from *Die Dreigroschenoper.* Brecht howls out ditties from Weill's *Threepenny Opera*, accompanied by a cranky pump organ and an out-of-tune theater orchestra (http://www.ubu.com/sound/brecht.html).

85. *40jahrevideokunst.de.* An epic retrospective of rare German video art from 1963 to 2004, comprising fifty-seven pieces. Includes Wolf Vostell, Joseph Beuys, Valie Export, Rebecca Horn, Rosemarie Trockel, and others (http://www.ubu.com/film/40.html).

86. Howard Finster, *The Night Howard Finster Got Saved.* Audio recordings by the renowned outsider artist, featuring traditional folk and acoustic gospel recordings interspersed with sermons (http://www.ubu.com/sound/finster.html).

87. Karen Finley, "I'm an Ass Man." A vital document of the culture wars of the 1980s, featuring Finley performing a powerful monologue about rape, misogyny, and violence against women (http://www.ubu.com/sound/finley.html).

88. *The Complete Recordings of Jean Cocteau.* Spanning three decades, an audio retrospective of Cocteau's plays, poems, and songs, including performances by Cocteau, Edith Piaf, Francis Poulenc, Erik Satie, and Jeanne Moreau (http://www.ubu.com/sound/cocteau.html).

89. Komar & Melamid with David Soldier, *The People's Choice Music.* Artist duo who created a poll to find out which music people most liked and disliked, then made recordings of it (http://www.ubu.com/sound/komar.html).

90. Marina Rosenfeld, *Emotional Orchestra.* An electroacoustic string orchestra performance for forty female improvisers (http://www.ubu.com/sound/rosenfeld.html).

91. *Jacques Derrida Interviews Ornette Coleman.* Two titans of twentieth-century culture discuss improvisation, globalization, and race as they relate to language (http://ubu.com/papers/Derrida-Interviews-Coleman_1997.pdf).

92. Alice B. Toklas, "Recipe for Hashish Fudge." In this recording from Pacifica Radio in 1963, Toklas reads her notorious recipe, given to her for her cookbook by Brion Gysin (http://ubu.com/sound/toklas.html).

93. *The Conet Project.* Eerie recordings of mysterious shortwave radio stations that broadcast only numbers (http://ubu.com/sound/conet.html).

94. Erik Satie, *Pianoless Vexations.* A document of an eight-hour performance of *Vexations* on any instrument except piano, for which it was written. Includes versions for laptops, drums, guitars, and a bluegrass band (http://www.ubu.com/sound/vexations.html).

95. *Dance with Camera.* Ten dances performed specifically for the movie camera, with the intention of being filmed (http://www.ubu.com/film/dance-with-camera.html).

96. RRRecords, *500 Locked Grooves.* LP consisting of five hundred locked grooves by five hundred artists, each getting about two seconds (http://ubu.com/sound/rrr-records.html).

97. Marie Menken, *Go! Go! Go!* Sped-up films of New York City from the early 1960s, tapping into the city's hyperkinetic energy (http://ubu.com/film/menken.html).

98. Jack Kerouac, *The Northport Tapes (1958–1964).* Kerouac reading from his work while getting drunk and occasionally singing along with Frank Sinatra records played in the background (http://ubu.com/sound/kerouac_northport.html).

99. James T. Hong and Yin-Ju Chen, *Suprematist Kapital.* Kasimir Malevich meets globalization (http://www.ubu.com/film/chen_suprematist.html).

100. Charlotte Moorman, *Audio Archive.* Includes collaborations with Nam June Paik, John Cage, and Ornette Coleman. Special bonus: a recording from Moorman's answering machine tape, labeled "Lennon, Cage, Yoko, Thanksgiving, Paik. November 24–December 6th" (http://ubu.com/sound/moorman.html).

101. Mary Ellen Bute, *Passages from Finnegans Wake.* A beautiful and moving attempt to turn the most difficult book ever written into a film (http://www.ubu.com/film/bute_fw.html).

NOTES

Introduction: The Back Door

1. Telephone interview with Clive Phillpot, November 24, 2017.
2. Bob Dylan, in Martin Scorsese, *No Direction Home*, documentary (Paramount, 2005).
3. Marcel Duchamp, *Affectionately, Marcel: The Selected Correspondence*, ed. Francis M. Naumann (Ghent: Ludion, 1999), 343.
4. Description by John Coulthart, tweet, October 8, 2019, https://twitter.com/johncoulthart/status/1181689948203884544.
5. Dick Higgins, *Modernism Since Postmodernism: Essays on Intermedia* (San Diego: San Diego State University Press, 1997), 30.
6. Kimberly Jannarone, "The Political Fallacy of Vanguard Performance," in *Vanguard Performance Beyond Left and Right*, ed. Kimberly Jannarone (Ann Arbor: University of Michigan Press, 2015), 6.
7. Andy Warhol, *The Philosophy of Andy Warhol: From A to B and Back Again* (New York: Harcourt Brace Jovanovich, 1975), 145.
8. Kenneth Goldsmith, *Wasting Time on the Internet* (New York: Harper-Collins, 2016), 96.
9. There is a UbuWeb Facebook group that we have nothing to do with. And years ago I implemented a public-discussion board, which quickly descended into chaos and noise, forcing me to pull the plug a few days into it.

Part I: Polemics

1. "Happy Birthday, Ubu.com!," November 30, 2016, http://custodians.online/ubu/.

2. The impending legislation in the United States to end net neutrality and similar initiatives in the European Union might change this freeness and openness.

3. Jefferson Graham, "Flickr Plans to Start Deleting Your Photos," *USA Today*, February 4, 2019, https://www.usatoday.com/story/tech/talk ingtech/2019/02/04/flickr-begin-deleting-photos-users-if-they-dont -pay-fee/2769812002/.

4. Go Daddy, for example.

5. Current examples include Critical Commons, the public-media archive and fair-use advocacy network that supports the transformative reuse of media in scholarly and creative contexts, and Njalla, an anonymous hosting and domain-name service run by Pirate Bay cofounder Peter Sunde.

6. MoMA hosts very little primary-source films and videos, even of the artists in its collection, for this reason, whereas UbuWeb, operating on no money, hosts more than five thousand. For the process of what it takes for MoMA to clear a single film, see chapter 2, note 6.

7. Yunsung Hong to the author, email, October 17, 2019.

8. Jed Lipinski, "For a Gallery at the Edge, Dame Is Born Tuesday," *New York Times*, October 28, 2011, https://www.nytimes.com/2011/10/30 /nyregion/birth-brings-attention-to-microscope-gallery.html.

9. Guy Debord to Patrick Straram, November 12, 1958, http://www .notbored.org/debord-12November1958.html.

10. Both Tim Reilly and Cory Doctorow have said versions of this.

11. Seth Price, interviewed by the author, February 9, 2018.

1. Folk Law

1. Mick Jagger, quoted in "Sir Mick Jagger Goes Back to Exile," NNC News, May 14, 2010, http://news.bbc.co.uk/2/hi/entertainment/8681410 .stm.

2. Tim Davis, quoted in "RIAA Rent Party," *Wall Street Journal*, November 13, 2003.

3. "File Sharers Settle Out of Court," *NME*, October 1, 2003, http://www .nme.com/news/music/nme-1936-1383174, my emphasis.

4. Jason Schultz, interviewed by the author, November 22, 2017.

5. Peter Jaszi, interviewed by the author, September 12, 2018.

6. Author to Sharan Ghuman, manager, Anti-Piracy Unit PRS for Music, email, March 6, 2019.

7. Web Capio notice to the author, email, March 7, 2018.

8. Lloyd Dunn to the author, email, March 7, 2018.

9. Ken Freedman to the author, email, November 14, 2019.

10. Ken Freedman to the author, email, November 14, 2019. Freedman assumed that the archive was going to be used by radio stations and podcasters, but it's used primarily by filmmakers, many of whom cannot afford to license expensive soundtracks for their films. Soon all sorts of filmmakers began using it, including the Obama administration, which used a track from the archive as a background soundtrack to the president talking.

11. Author to Maria Filingeri, email, November 1, 2018.

12. Jason Christie, "Sampling the Culture: 4 Notes Toward a Poetics of Plundergraphia and on Kenneth Goldsmith's *Day*," n.d., note 2, http://www.ubu.com/papers/kg_ol_christie.html.

13. William S. Burroughs and Brion Gysin, *The Third Mind* (New York: Viking, 1978), 18.

14. Yunsung Hong to the author, email, September 19, 2018.

15. Peter Jaszi to author, email, September 19, 2018.

16. Amy Adler, "Fair Use and the Future of Art," *New York University Law Review* 91 (June 2016): 621, 623.

17. Peter Decherney, "Communicating Fair Use: Norms, Myth, and the Avant-Garde," *Law & Literature* 25, no. 1 (2013): 7.

18. Kenneth Anger, quoted in Katrina Onstad, "A Life of Anger," *The Guardian*, October 27, 2006, https://www.theguardian.com/film/2006/oct/27/londonfilmfestival2006.londonfilmfestival.

19. Mike Everleth, "Martin Scorsese: Champion of the Underground," January 20, 2010, http://www.undergroundfilmjournal.com/martin-scorsese-champion-of-the-underground/.

20. Decherney, "Communicating Fair Use," 5.

21. Todd Haynes, quoted in Peter Decherney, *Hollywood's Copyright Wars: From Edison to the Internet* (New York: Columbia University Press, 2013), 189.

22. Decherney, *Hollywood's Copyright Wars*, 190.

23. Peter Decherney, conversation with the author, December 17, 2017.

24. Peter Decherney, conversation with the author, December 17, 2017.

25. Peter Jaszi agrees but interprets this legal stipulation slightly differently. First of all, the filmmaker had to be American—this stipulation didn't apply to European authors. He feels that the copyright lay not in the first showing but if a copyright notice was present when the prints were first distributed. The purchase of a copy by a museum or a collector was a copyright-triggering event. Jaszi says that even the sale of a unique copy of an artwork—a single copy—constituted a copyright-triggering event from the artist to the buyer. Similarly, if a museum bought a copy, it was a triggering event regardless of when it was bought. Same for rentals.

Once again, these arguments speak of the many ways that copyright law can be interpreted.

26. Peter Decherney, conversation with the author, December 17, 2017.

27. Andrew Lampert to the author, email, September 29, 2018. Lampert: "That is the argument made by Mary Jordan, the documentarian who stirred up trouble for Jack Smith's estate, The Plaster Foundation, from whom she was licensing material. There is an issue about unfinished work perhaps having more copyright protection than legal work, so in Smith's case this is tricky since so much was left unfinished and whatnot."

28. Salvador Dalí, quoted in Deborah Solomon, *Utopia Parkway: The Life and Work of Joseph Cornell* (London: Pimlico, 1997), 89.

29. Andrew Lampert to the author, email, September 29, 2018.

30. Adler, "Fair Use and the Future of Art," 563–64, 587.

31. Jason Schultz, interviewed by the author, November 22, 2017.

32. This unlicensed posting on social media may change if the European Union approves the controversial Copyright Directive, which includes internet "link taxes" and "upload filters."

33. Amy Adler, interviewed by the author, November 14, 2017.

34. Peter Jaszi, interviewed by the author, September 12, 2018.

35. Peter Decherney, conversation with the author, December 17, 2017.

36. Adler, "Fair Use and the Future of Art," 575.

37. Peter Jaszi, interviewed by the author, September 12, 2018.

38. Virgil Abloh, quoted in Thom Bettridge, "Virgil Abloh: Duchamp Is My Lawyer," *032c*, March 25, 2018, https://032c.com/virgil-abloh-duchamp.

39. Alder, "Fair Use and the Future of Art," 617.

40. Peter Jaszi, interviewed by the author, September 12, 2018.

2. From Panorama to Postage Stamp: Avant-Garde Cinema and the Internet

1. All quotations from Andrew Lampert in this chapter come from this conversation on November 17, 2017.

2. Dominic Angerame to the author, email, May 11, 2016.

3. From this point, unless otherwise noted, all quotations from Dominic Angerame in this chapter come from our telephone conversation on January 6, 2018.

4. Keith Sanborn to the author, email, March 12, 2018.

5. Rick Prelinger, interviewed by the author, November 13, 2017.

6. But even those visual artists aren't treated too well on the MoMA website. When I go to Alfred Leslie's MoMA page looking for *The Last*

Clean Shirt, it's not there. Instead, I find only ten of his works online—all drawings—six of which tell me "image not available." Even UbuWeb's copy of the film with two-thirds of it missing was more than what MoMA offers. The same thing happens when I search on MoMA's site for many filmmakers on Ubu; I get thumbnails of film frames, but no moving images. I find it strange that on UbuWeb we've got thousands of films, whereas MoMA, as far as I can tell, has none. Why is that? I asked Lampert. And this is what he told me:

> You want to put a celluloid film online. Alfred Leslie produces this film [in] 1964 on 16mm film. There's a negative of the film that comprises two parts: one is the picture, the other is the sound. A film print is a positive that combines both picture and sound in one strand. Let's say that MoMA wants to put something online and that they would want it in the absolute best quality. They would take the negative and scan it to digital. Then they would color-correct it, synchronize the sound, add onto the digital file any credits they need, such as a MoMA title card or the funder's name. They then would have to make the derivative files, for the web an H264 file. So you have two costs, one is the digitization and the other postproduction. Most likely MoMA would do a twofold process, make a projection master that could be used in galleries and a derivative online file. I think that they probably don't want to show scratched copies of films with splices in them or that are color-faded. They want the absolute best quality that represents how it [the film] would've looked upon its initial premiere. They want to make digital that looks as good as film, but they would want to do it to a very professionalized standard. So that's where the costs come in.
>
> From there, the next question is, How prepared is their IT department to deal with these things? Because even if MoMA wants to put up that film—assuming they have five hundred films they want to put up—is it buried somewhere on the site with a complicated URL? Is it something you could ever find twice?
>
> They'd have to get Al's permission—he may say no, he may say yes—but only for two years or only for education or with passwords and so forth. It's one thing to deal with the artist that's already sometimes thorny, but typically worse is dealing with the estates: the widow, his nieces, nephews, sons, and daughters who think that a place like MoMA—with a $25 entrance fee—should pay them. MoMA would probably want to put a contract up that even indemnifies them.
>
> Al's film . . . has a tune in it called the "The Last Clean Shirt," written by Jerry Leiber, Mike Stoller, and Charlie Otis, which he might

not have cleared the rights for. MoMA would have assumed that the artist had done it or that the artist would have assumed the legal responsibility. So they would probably want to have a contract that indemnifies them from a legal suit.

In terms of legal, what they would probably do is write up a blanket contract stating that they have permission, whether in perpetuity or for a period of time, the right to show the film online. If there is music or found footage in the film, it would indemnify MoMA, putting the liability back onto the filmmaker or estate if legal claims come about. In terms of fees, they may, as a blanket move, offer the estate something symbolic, like $25, or give no fee at all. Dependent upon how ornery the artist or the estate is, the wiggling around and negotiating on this contract, it could take a lot of time.

What's worse is that when dealing with estates, you're dealing with people that often don't know or understand the work who assume that the Anthology [Film Archives], just because we have a big building in New York City and a website, that there's a ton of money there. This is a false assumption about the economy within the avant-garde; that's just not the case. And with MoMA it's going to be worse—but their argument would be that we don't pay people because it's MoMA, it's status, and it's educational.

So, the bottom line is that if they had to produce a digital file, the cost to put up Alfred Leslie's *The Last Clean Shirt* at MoMA's site could potentially cost between $3,000 and $5,000 and take months, if not years, to wrangle. And that's just one film.

(Andrew Lampert, conversation with the author, November 17, 2017.)

7. Beverly O'Neill, email, October 13, 2010, http://www.hi-beam.net/fw/fw44/0382.html.

8. Dominic Angerame, email, June 15, 2008, http://www.hi-beam.net/fw/fw37/0733.html, as given in the original.

9. Esorp [Peter Rose], email, October 13, 2010, http://www.hi-beam.net/fw/fw44/0404.html.

10. Fred Camper, email, October 14, 2010, http://www.hi-beam.net/fw/fw44/0456.html.

11. Henri Michaux, translated and quoted in "Spektr—Mescaline," *Documents* blog, February 16, 2008, http://surrealdocuments.blogspot.com/2008/02/spektr-mescalyne.html.

12. Keith Sanborn to the author, email, March 12, 2018.

13. Kenneth Goldsmith, "An Open Letter to the Frameworks Community," October 18, 2010, http://www.ubu.com/resources/frameworks.html.

3. The Work of Video Art in the Age of Digital Reproduction

1. All quotations from videoartcollector come from my phone conversation with him on March 27, 2018.

2. Greg Allen, "When Fans of Pricey Video Art Can Get It Free," *New York Times*, August 17, 2003, http://www.nytimes.com/2003/08/17/arts /art-architecture-when-fans-of-pricey-video-art-can-get-it-free.html. "Videoartcollector" is named in the article.

3. Matthew Barney, quoted in Stephen Witt, "9 Rare Works of Art Internet Pirates Are Obsessed With," *BuzzFeed*, June 10, 2015, https://www .buzzfeed.com/stephenwitt/9-rare-works-of-art-internet-pirates-are -obsessed-with.

4. Cheryl Donegan, interviewed by the author, March 6, 2018.

5. Cheryl Donegan, conversation with the author, March 9, 2018.

6. Pierre Huyghe and Marian Goodman, quoted in Allen, "When Fans of Pricey Video Art Can Get It Free."

7. Cheryl Donegan, conversation with the author, March 9, 2018.

8. Lori Zippay, conversation with the author, July 6, 2018.

9. Seth Price, conversation with the author, February 8, 2018.

10. Seth Price, "[History of] *Dispersion*," 2002, http://www.distributed history.com/Disperzone.html.

11. Seth Price, conversation with the author, February 8, 2018.

12. Seth Price, *Dispersion*, self-published PDF (2002), http://sethpriceim ages.com/post/42277603863/dispersion-2002-seth-price-download-pdf.

4. Shadow Libraries and Preserving the Memory of the World

1. University of Louisiana Lafayette, Twitter, August 24, 2018, 10:17 a.m., https://twitter.com/ULLafayette/status/1033040644573413376.

2. Virginia Streva, "Louisiana University Tries to Sell E-Textbook for Nearly $1,000," *Philly Voice*, August 29, 2018, https://www.phillyvoice .com/louisiana-university-tries-to-sell-e-textbook-for-nearly-1000 -lafayette-accounting-202/.

3. Jonathan Basile, "Who's Afraid of AAARG?," *Guernica*, August 25, 2016, https://www.guernicamag.com/jonathan-basile-whos-afraid-of -aaarg.

4. Balázs Bodó, "Libraries in the Post-Scarcity Era," in *Copyrighting Creativity: Creative Values, Cultural Heritage Institutions, and Systems of Intellectual Property*, ed. Helle Porsdam (London: Ashgate, 2015), 77.

5. Marcellmars, "PublicLibrary_FairyTale.md," revised November 29, 2013, https://gist.github.com/marcellmars/7711632.

6. Many shadow libraries emerged out of former Communist countries. Library Genesis, for instance, was founded in 2008 as a way of consolidating Russian-language texts that had been digitized by individuals over the years and strewn across the web willy-nilly. Even to the last days, the Soviet Union was a reading culture, so the drive to preserve through piracy was acute. In addition, the underground had long been adept in distributing texts via samizdat self-publishing during the Soviet period.

7. Aaron Swartz, "Guerilla Open Access Manifesto," July 2008, https://archive.org/stream/GuerillaOpenAccessManifesto/Goamjuly2008_djvu.tx.

8. Librarian, "End-to-End Catalog," *Memory of the World* blog, November 26, 2012, https://www.memoryoftheworld.org/blog/2012/11/26/end-to-end-catalog/.

9. Marcell Mars, conversation with the author, January 28, 2018.

10. Marcell Mars and Tomislav Medak, "The System of a Takedown Control and De-commodification in the Circuits of Academic Publishing," in *Archives*, ed. Andrew Lison, Marcell Mars, Tomislav Medak, and Rick Prelinger (Minneapolis: University of Minnesota Press, 2019), 48.

11. Library Genesis is radically transparent in terms of access, making its source code and its catalogue available to anyone wanting to start a library. To date, it has 2.7 million books and 58 million science magazines.

12. Marcell Mars, conversation with the author, January 28, 2018.

13. Dušan Barok, conversation with the author, March 17, 2018.

14. Marcus Boon, "Uploading My Book to AAAAARG.ORG," *In Praise of Copying* blog, October 15, 2010, https://inpraiseofcopying.wordpress.com/2010/10/15/uploading-my-book-to-aaaaarg-org/.

15. AAARG is still available in these countries to all with a VPN, though.

16. Marcell Mars, conversation with the author, January 28, 2018.

17. L=A=N=G=U=A=G=E Distributing Service, catalogue, c. 1978, PDF, October 17, 2018, https://jacket2.org/commentary/language-distributing-service-catalog-c-1978.

18. Craig Dworkin, all quotations from James La Marre, "Poetic Protocols: An Interview with Craig Dworkin," *Jacket 2*, January 5, 2016, http://jacket2.org/interviews/poetic-protocols.

19. PennSound, "PennSound: All the Free Poetry You Care to Download," press release, January 5, 2005, http://writing.upenn.edu/pennsound/news/press-release-launch.php.

20. PennSound, "PennSound: All the Free Poetry You Care to Download."
21. Charles Bernstein, conversation with the author, September 24, 2017.
22. Jens Heitjohann, "Exploring, Documenting, Archiving," interview with Anna Ramos, n.d., http://www.perfomap.de/map3/kapitel4/ramos.
23. Heitjohann, "Exploring, Documenting, Archiving."

5. Dirty Concrete

1. "linguaviagem," in *Poesia concreta: O projecto verbivocovisual*, ed. João Bandeira and Lenora de Barros (São Paulo: Artemeios, 2008), 30, translation by Anthony Doyle.
2. Haroldo de Campos, "poesia e modernidade," in *Poesia concreta*, ed. Bandeira and de Barros, 136, translation by Anthony Doyle.
3. Lori Emerson, *Reading Writing Interfaces from the Digital to the Bookbound* (Minneapolis: University of Minnesota Press, 2014), 99–100.
4. Emerson, *Reading Writing Interfaces*, 100.
5. Mary Ellen Solt, introduction to *Concrete Poetry: A World View*, ed. Mary Ellen Solt (Bloomington: Indiana University Press, 1968), 7.
6. "avenidas" translates as: "avenues / avenues and flowers // flowers / flowers and women // avenues / avenues and women // avenues and flowers and women and // an admirer"
7. Quoted in Katharina Abel, "Poem on Berlin College Wall Sparks Sexism Debate," *DW*, September 7, 2017, https://www.dw.com/en/poem-on -berlin-college-wall-sparks-sexism-debate/a-40384180.

6. From *Ursonate* to *Re-Sonate*

1. Karin Orchard and Isabel Schulz, introduction to *Catalog raisonné Kurt Schwitters*, vol. 3, ed. Karin Orchard and Isabel Schulz (Ostfildern-Ruit, Germany: Hatje Cantz, 2006), 33, my emphasis, translation by John Gabriel.
2. Isabel Schulz to the author, email, May 16, 2018.
3. Kurt Schwitters, quoted in Dorothea Dietrich, *The Collages of Kurt Schwitters: Tradition and Innovation* (Cambridge: Cambridge University Press, 1993), 6–7.
4. See "Leaflet Advertising the December Exhibition Held at the Modern Art Gallery Ltd. on 'Masterpieces by Great Masters' Also Featuring 'Paintings and Sculptures by Kurt Schwitters,' 1944," https://www.tate .org.uk/art/archive/items/tga-9510-4-8-1/leaflet-advertising-the-decem ber-exhibition-held-at-the-modern-art-gallery-ltd-on/4.

6. FROM *URSONATE* TO *RE-SONATE*

5. Kurt Schwitters, *Pppppp*, ed. Jerome Rothenberg and Pierre Joris (Philadelphia: Temple University Press, 1993), 235.

6. Schwitters, *Pppppp*, 236.

7. Schwitters, *Pppppp*, 234–35.

8. Schwitters, *Pppppp*, 234–35.

9. Hans Richter, *DADA: Art and Anti-art* (London: Thames and Hudson, 1964), 142–43.

10. George Melly, quoted in Mel Gooding, "Kurt Schwitters: Artist Philosopher," in *Kurt Schwitters: Collages and Assemblages, 1920–1947* (London: Bernard Jacobson Gallery, 2013), 4.

11. Jack Ox, liner notes to Kurt Schwitters, *Ursonate* (Wergo, 1992), 5.

12. Ernst Schwitters, liner notes to Schwitters, *Ursonate*, 1.

13. Ernst Schwitters, in "Kurt Schwitters (1887–1948)," UbuWeb: Sound, n.d., http://www.ubu.com/sound/schwitters.html.

14. Jaap Blonk, "Some Words to Kurt Schwitters' URSONATE," June 2009, http://www.jaapblonk.com/Texts/ursonatewords.html.

15. Blonk, "Some Words to Kurt Schwitters' URSONATE."

16. Tracie Morris, interviewed by the author, April 17, 2018.

17. Tracie Morris, interviewed by the author, April 17, 2018.

18. Through a fluke, Morris did become Nuyorican Poets Cafe Grand Slam Champion in 1993. In 1992, she was at the café when a contestant didn't show up and was asked to fill in the empty slot. She lost, but the next year she quickly won all the preliminary competitions and won the slam. She has also said that she won that grand slam with all new material that was more experimental than what she'd previously written.

19. Tammie Jenkins, "A Case Study of Tracie Morris' Project Princess," Ph.D. diss., Louisiana State University, 2014, https://digitalcommons.lsu.edu/gradschool_dissertations/79/.

20. Tracie Morris, interviewed by the author, April 17, 2018.

21. Tracie Morris, interviewed by the author, April 17, 2018.

22. Tracie Morris, quoted in Frank Mastropolo, "'A Singular Sound, a Singular Force': Artists Remember Jazz Great Cecil Taylor," *Bedford and Bowery*, April 9, 2018, http://bedfordandbowery.com/2018/04/a-singular-sound-a-singular-force-artists-remember-jazz-great-cecil-taylor/.

23. Ulla Dydo, quoted in David Grundy, "'. . . and Not Goodbye': Cecil Taylor (Part 2—Taylor as Poet)," *Streams of Expression* blog, April 29, 2018, http://streamsofexpression.blogspot.com/2018/04/and-not-goodbye-cecil-taylor-part-2.html.

24. Grundy, "'. . . and Not Goodbye.'"

25. Grundy, "'. . . and Not Goodbye.'"

26. Cecil Taylor, quoted in Grundy, "'. . . and Not Goodbye.'"

27. Cecil Taylor, quoted in Fred Moten, "Sound in Florescence: Cecil Taylor's Floating Garden," in *Sound States: Innovative Poetics and Acoustical Technologies*, ed. Adelaide Morris (Chapel Hill: University of North Carolina Press, 1997), copy at UbuWeb, http://ubu.com/papers/moten.html.

28. *Music Overheard* was an audio response to the exhibition *Super Vision* at the Institute of Contemporary Art in Boston in 2007, curated by Damon Krukowski.

29. Henri Chopin, "Why I Am the Author of Sound Poetry and Free Poetry" (1967), UbuWeb, n.d., http://www.ubu.com/papers/chopin.html.

30. John Cage, "Indeterminacy," in *Die Reihe No. 5*, English ed., ed. Herbert Eimert and Karlheinz Stockhausen (Bryn Mawr, PA: Theodore Presser, 1961), 115.

7. People Like Us

1. Vicki Bennett to author, Facebook message, July 28, 2018.

2. Kenneth Goldsmith, "Interview with Vicki Bennett," *Found Footage*, December 2015, http://peoplelikeus.org/wp-content/uploads/2016/04/Found-Footage-Mag2-interview-2016.pdf.

3. Vicki Bennett, conversation with the author, March 17, 2018.

4. Vicki Bennett, conversation with the author, March 17, 2018.

5. Vicki Bennett, conversation with the author, March 17, 2018.

6. Vicki Bennett to author, Facebook message, July 28, 2018.

7. Scott MacDonald, "Kenneth Anger," in *A Critical Cinema 5: Interviews with Independent Filmmakers* (Berkeley: University of California Press, 2006), 38.

8. Vicki Bennett, conversation with the author, March 17, 2018.

9. Stephen Stapleton, quoted in *Wikipedia*, "The Sylvie and Babs Hi-Fi Companion," n.d., https://en.wikipedia.org/wiki/The_Sylvie_and_Babs_Hi-Fi_Companion.

10. Vicki Bennett, conversation with the author, March 17, 2018.

11. Vicki Bennett, "THE ZONE Now Silenced," *People Like Us* blog, January 14, 2013, https://peoplelikeus.org/2013/interview-about-the-zone.

12. Transmediale coordinators, quoted in Bennett, "THE ZONE Now Silenced."

13. Emily Bick, interview with Vicki Bennett, *The Wire*, May 2018, https://www.thewire.co.uk/in-writing/interviews/vicki-bennett-speaks-to-emily-bick-people-like-us.

8. *Aspen*: A "Multimedia Magazine in a Box"

1. Andrew Stafford to the author, email, January 5, 2018.
2. Andrew Stafford to the author, email, January 5, 2018.
3. Matthew Mirapaul, "3-Dimensional Magazine Lives Again in 2 Dimensions," *New York Times*, December 9, 2002.
4. Executive director, Cunningham Dance Foundation, quoted in Mirapaul, "3-Dimensional Magazine Lives Again in 2 Dimensions."
5. Andrew Stafford, quoted in Mirapaul, "3-Dimensional Magazine Lives Again in 2 Dimensions."
6. Author to Jonas Herbsman, email, February 9, 2011.
7. Jonas Herbsman to the author, email, March 2, 2011.
8. John Lennon, "The Lennon Diary 1969," *Aspen*, no. 7 (Spring–Summer 1970): item 8, UbuWeb, http://ubu.com/aspen/aspen7/diary.html.
9. John Hendricks, "Some Notes," *Aspen*, no. 6A (Winter 1968–1969): item 15, UbuWeb, http://ubu.com/aspen/aspen6A/someNotes.html.
10. Ironically, today a copy of issue 6A sells for around $500.
11. Hendricks, "Some Notes."
12. Kate Millett, "*No*," *Aspen*, no. 6A (Winter 1968–1969): item 4, UbuWeb, http://ubu.com/aspen/aspen6A/no.html.
13. The next month Andy Warhol, a close friend of Picard's, asked her if she had something for a movie he was making. Picard ended up re-creating *Construction-Deconstruction-Construction* at the Factory, which Warhol filmed in November 1967. Appearing in the film alongside Picard were Factory superstars Taylor Mead, Viva, and Julian Burroughs.
14. Carolee Schneemann, "*Divisions and Rubble*," *Aspen*, no. 6A (Winter 1968–1969): item 10, UbuWeb, http://www.ubu.com/aspen/aspen6A/divisions.html, October 24, 2018.
15. Schneemann, "*Divisions and Rubble*."
16. Not all the contributions by women were political. In its run, the magazine included a wide range of pieces by women, from a manifesto by Brigid Riley on op art to a psychedelic-correspondence-based photo diary by the avant-garde filmmaker Diane Rochlin. Rochlin's piece was in *Aspen* number 9, "The Psychedelic Issue," which was edited and designed by the musician and filmmaker Hetty Maclise, who was a key figure of the sixties underground world, from the Grateful Dead to Warhol's Factory. Yoko Ono is represented by two spare solo vocal pieces, recorded on a tape recorder, and two collaborations with John Lennon. And Susan Sontag's groundbreaking essay "The Aesthetics of Silence" was commissioned for *Aspen* numbers 5–6, "The Minimalism Issue."

17. Dan Graham, "Folder," *Aspen*, no. 8 (Winter 1970–1971): item 1, Ubu-Web, http://ubu.com/aspen/aspen8/folder.html.

18. Dan Graham, "My Works for Magazine Pages: 'A History of Conceptual Art,'" *Kunst and Museumjournal* 4, no. 6 (1993): no page, reprinted from *Dan Graham*, exhibition catalogue (Perth: Art Gallery of Western Australia, 1985).

19. Mike Metz, interview with Dan Graham, *Bomb*, January 1, 1994, https://bombmagazine.org/articles/dan-graham/.

20. Lynda Benglis ventured into the paid advertisement as artwork when in November 1974 she bought ad space in *Artforum* and published a photograph of herself masturbating with a dildo and wearing nothing but a pair of sunglasses. Originally she wanted the photo to accompany a feature article that was being written about a solo exhibition of her work but was refused due to the photo's pornographic nature. So she instead bought the ad space and ran the image that way.

21. In 1994, the Gap featured a gaggle of celebrities in its "[Insert celebrity name here] wore khakis" campaign, and in 1997 Apple's "Think Different" ad campaign featured seventeen "iconic personalities." Of course, those celebrities had nothing to do with the Gap or Apple; rather, the affiliation with their images lent the corporation credibility that its own products would never have had on their own.

22. Dan Graham, "Exclusion Principle" (1966), in Graham, "Folder."

23. Robert Smithson, "Strata, a Geophotographic Fiction," *Aspen*, no. 8 (Winter 1970–1971): item 12, UbuWeb, http://www.ubu.com/aspen/aspen8/strata.html.

24. Michel Foucault, *The Archaeology of Knowledge* (1972; e-book reprint, New York: Vintage Books, 2010).

25. Robert Smithson, quoted in Edward S. Casey, *Earth-Mapping: Artists Reshaping the Landscape* (Minneapolis: University of Minnesota, 2005), 6.

9. Street Poets and Visionaries

1. Holland Cotter, "Art in Review: Street Poets & Visionaries: Selections from the UbuWeb Collection," *New York Times*, September 16, 2006.

2. Daniels told me his life story when we met for the first time at a digital-poetics conference at the University of Buffalo in 2001. I recount here what I remember him telling me at the time, now many years ago. When I began doing the research for this book, I tried with no success to corroborate his story. I reached out to one of his family members, who refused to talk to me, informing me that he wanted nothing to do with the poet. I attempted to find other contacts—from former communards

to Silicon Valley moguls—but to no avail. Perhaps it was all a fiction of Daniels's making; I wouldn't put it past him. I hope that in time the truth will emerge, at which point I'll amend his story.

3. When viewed as PDFs, Daniels's works extend this metaphor, from the Jacquard loom to the grid of the screen.

4. David Daniels, "2000," in *Years* (N.p.: self-published, 2002), http://www.thegatesofparadise.com/webyears/2000.pdf.

5. James Schevill, *where to go, what to do, when you are Bern Porter* (Gardiner, ME: Tilbury House, 1992), 208.

6. Joel Lipman, "The Sciart Origins of Bern Porter's Found Poems," in Bern Porter, *Found Poems* (Callicoon, NY: Nightboat, 2011), xv.

7. David Byrne, foreword to Bern Porter, *Found Poems*, ii.

8. Mark Melnicove, introduction to *"Wisdom of the Questioning Eye*: Five Books from the 1960s, by Found Poet Bern Porter," n.d., UbuWeb, http://www.ubu.com/historical/porter/porter_5books.html.

9. Melnicove, introduction to *"Wisdom of the Questioning Eye."*

10. Bern Porter, "The Last Acts of St. Fuck You," MP3, UbuWeb, http://ubu.com/sound/porter.html.

11. Bern Porter, *The Last Acts of Saint Fuck You* (West Lima, WI: Xexoxial Editions, 2008).

12. Schevill, *where to go, what to do, when you are Bern Porter*, 7.

13. Hilton Als, "Christopher Knowles: In a Word Gallery Guide," Eleanor Biddle Lloyd Gallery, September 16–December 27, 2015, http://static.icaphila.org/pdf/gallery-notes/2015_fall/christopher_knowles_gallery guide.pdf.

14. Robert Wilson, quoted in Eric Konigsberg, "Encore," *New Yorker*, April 8, 2013, https://www.newyorker.com/magazine/2013/04/15/encore-4.

15. Christopher Knowles, "I FEEL THE EARTH MOVE," in *Typings (1974–1977)* (New York: Vehicle Editions, 1979), unpaginated.

16. Gertrude Stein, "If I Told Him: A Completed Portrait of Picasso" (1923), http://www.english.upenn.edu/~jenglish/Courses/Spring02/104/steinpicasso.html.

17. Robert Wilson, *"A Letter for Queen Victoria,"* n.d., http://www.robertwilson.com/lqv/.

18. T. E. Kalem, "Exquisite Anarchy," *Time*, April 7, 1975.

19. Robert Wilson, *A Letter for Queen Victoria: An Opera* (N.p.: /ubu editions, 2007), act 1, scene 4, http://www.ubu.com/ubu/pdf/wilson_opera.pdf, which gives the full text of the opera.

20. Apropos of Bern Porter, Slonimsky claimed that his own recording "Ionisation" was an inspiration to the scientists and engineers who were splitting atoms to make the atomic bomb.

21. Nicolas Slonimsky, in *A Touch of Genius: The Life and Times of Nicolas Slonimsky*, documentary, ed. John Huszar and Michael York (Film America, 1994), YouTube, https://www.youtube.com/watch?v=oLYSdo5BbOg.

22. John Cage, in *A Touch of Genius*.

23. *The 365 Days Project*, UbuWeb, http://www.ubu.com/outsiders/365/index.html.

24. Nicolas Slonimsky and Thomas Bertonneau, *Muses and Lexicons Oral History Transcript* (Los Angeles: Oral History Program, University of California), 73–74.

25. Lyrics transcribed by the author.

26. Nicolas Slonimsky, *Writings on Music*, vol. 4 (New York: Routledge, 2005), 343.

27. Frank Zappa, in *A Touch of Genius*.

28. S. Frederick Starr, "From Rimsky to Rock," *Washington Post*, May 8, 1988.

29. In his own way, Frank Zappa moved between inside and out. These shifts are represented on UbuWeb with a recording of him reading a section of William S. Burroughs's *Naked Lunch* called "The Talking Asshole." As is well known, Zappa was a great admirer of avant-garde composers, in particular Edgard Varèse.

30. İlhan Mimaroğlu, liner notes to Jean Dubuffet, *Musical Experiences* (Finnidar Records, 1973).

31. Jean Dubuffet, quoted in Mimaroğlu, liner notes to Dubuffet, *Musical Experiences*.

10. An Anthology of Anthologies

1. John Giorno, quoted in White Columns, "I Love John Giorno VIII: Giorno Poetry Systems," *Brooklyn Rail*, n.d., https://brooklynrail.org/special/I_LOVE_JOHN_GIORNO/giorno-poetry-systems/VIII-GIORNO-POETRY-SYSTEMS.

2. UbuWeb note on *History of Electronic/Electroacoustic Music (1937–2001)*, UbuWeb, 2011, http://ubu.com/sound/electronic.html.

3. Caio Barros, "About the *History of Electroacoustic Music*," *History of Electronic/Electroacoustic Music (1937–2001)*, UbuWeb, 2011, http://ubu.com/sound/electronic.html.

4. Jon Leidecker to the author, email, August 5, 2018.

5. Electra with Emma Hedditch, *Her Noise—the Making Of*, film, 60 minutes (2007), UbuWeb, http://www.ubu.com/film/her_noise.html.

6. poemproducer, *NERDGIRLS Mash*, March 8, 2014, http://nerdgirls.poemproducer.com/.

7. Jon Leidecker to the author, email, August 4, 2018.
8. Justin Lacko to the author, email, November 23, 2012.
9. Luuk de Weert to the author, email, August 27, 2018.
10. Luuk de Weert to the author, email, August 27, 2018.
11. Lloyd Dunn, "*PhotoStatic* Magazine and the Rise of the Casual Publisher," *PhotoStatic*, 2007, http://psrf.detritus.net/other/project.html.
12. Dunn, "*PhotoStatic* Magazine."
13. Robin James, *Cassette Mythos* (New York: Autonomedia, 1992), ix.
14. Dunn, "*PhotoStatic* Magazine."
15. Nico Ordway, "Anarchy, Surrealism, and New Wave," *Search and Destroy*, no. 5 (1978): 27, emphasis in original.
16. From a telephone conversation in 1990 about the preparation of the *RE/Search* edition of *The Atrocity Exhibition* : "J. G. Ballard & V. Vale, 4-13-90," in J. G. Ballard, *J. G. Ballard Conversations*, ed. V. Vale (San Francisco: RE/Search Publications, 2005), 259.
17. Jon Savage, introduction to the "Industrial Culture Handbook" issue, *RE/Search*, nos. 6–7 (1983): 4.
18. Andrea Juno and V. Vale, introduction to the "Angry Women" issue, *RE/Search*, no. 13 (1991): 4.
19. Juno and Vale, introduction to the "Angry Women" issue, 4.
20. Diamanda Galás, quoted in Juno and Vale, introduction to the "Angry Women" issue, 7.
21. Juno and Vale, introduction to the "Angry Women" issue, 4, emphasis in original.

Coda: The Ghost in the Algorithm

1. See Shoshana Zuboff, *The Age of Surveillance Capitalism: The Fight for a Human Future at the New Frontier of Power* (New York: PublicAffairs, 2019).
2. *John Cage About Silence*, YouTube, n.d., https://www.youtube.com/watch?v=pcHnL7aS64Y.
3. Guy Debord, "Theory of the *Dérive*" (1956), trans. Ken Knabb, *Situationist International Online*, https://www.cddc.vt.edu/sionline/si/theory.html.
4. Charles Bernstein, conversation with the author, September 24, 2017.

ACKNOWLEDGMENTS

Thanks to those who generously gave their time, allowing me to interview them about their practices about this book, including Amy Adler, Dominic Angereme, Dušan Barok, Derek Beaulieu, Vicki Bennett, Charles Bernstein, Christian Bök, Tim Davis, Peter Decherney, Sean Dockery, Cheryl Donegan, Lloyd Dunn, Ben Fino-Radin, Al Filreis, Otis Fodder, Ken Freedman, Chris Hughes, Peter Jaszi, Andrew Lampert, Jon Leidecker, Sebastian Luetgert, Marcell Mars, Tomislav Medak, Tracie Morris, Clive Phillpot, Rick Prelinger, Seth Price, Anna Ramos, Jim Roche, Keith Sanborn, Jason Schultz, Dubravka Sekulic, Don Share, Chelsea Spengemann, Andrew Stafford, Marvin Taylor, V. Vale, Luuk de Weert, and Lori Zippay.

My gratitude to the many people and organizations who over the years contributed to UbuWeb in innumerable ways, including Eylül Fidan Akıncı, Manuel Alcala, Artmob, the Avant-Garde Project, Laura Beiles, Bidoun, Marcus Boon, Mathieu Cenac, CENTRO, Roc Jiménez de Cisneros, Rosemary Coomb, Continuo, Mathieu Copeland, Pierre-Eduoard Couton, CPCW, Lou Davenport, David Desrimais, Lloyd Dunn, Craig Dworkin, Lina Dzuverovic, Pamela Echeverria, Jean Boîte Éditions, the Electronic Poetry Center, Electra, Max Fenton, Jeremy

ACKNOWLEDGMENTS

Fisher, Bettina Funcke, Jan Gerber, Claudia Gould, Otis Fodder, Colby Ford, Gabriel René Franjou, Loss Pequeño Glazier, Frank Hentschker, Homie3, Bill Kennedy, Justin Lacko, Tiffany Malakooti, Ilan Manouach, Colin Marshall, Chus Martinez, Steve McLaughlin, Mark Melnicove, David Meurer, Rachel Morrison, Anne Hilde Neset, Ingo Niermann, PennSound, Marjorie Perloff, Alexandra Perloff-Giles, Francesco Urbano Ragazzi, Irene Revell, David Hilmer Rex, Amelia Robertson, Jerome Rothenberg, Kerstin Scheuch, Emily Segal, Danny Snelson, Olivia de Smedt, Patrick Stein, John Strausbaugh, Sara Vanderbeek, Stephen Vitiello, Matt Wellins, Darren Wershler, WFMU, Rob Young, and Zarcrom.

Portions of this book previously appeared in *Parkett*, *Harriet*, *THEORY*, *The New Concrete*, and *OnCurating*.

A main motivation for wanting to do this book was to have the opportunity once again to work with Philip Leventhal at Columbia University Press, the most careful and incisive editor I've ever had the pleasure to work with. Many thanks also to editor Michael Haskell at Columbia University Press and copy editor Annie Barva for their careful proofreading and helping to shape this text in innumerable ways.

And finally to Cheryl Donegan, who, when I said I can't go on, made me go on.

INDEX

INDEX

INDEX

INDEX

INDEX

INDEX

INDEX

INDEX

INDEX

INDEX

INDEX

INDEX

INDEX